People weekly

CELEBRATES THE

80s

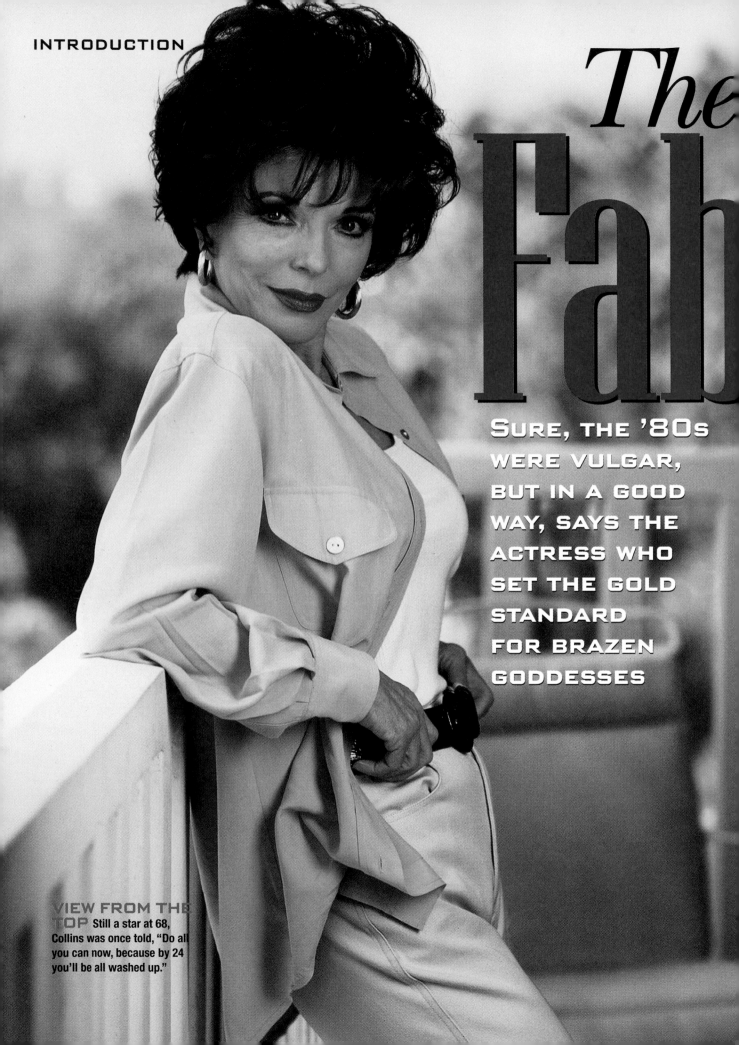

The Fab

SURE, THE '80s WERE VULGAR, BUT IN A GOOD WAY, SAYS THE ACTRESS WHO SET THE GOLD STANDARD FOR BRAZEN GODDESSES

VIEW FROM THE TOP Still a star at 68, Collins was once told, "Do all you can now, because by 24 you'll be all washed up."

Years of Living Fabulously

BY JOAN COLLINS

AST CARS, GORGEOUS CLOTHES, LUXURIOUS holidays—the '80s were the decade of total excess, which *Dynasty* epitomized. The credo was: If you've got it, flaunt it. *Dynasty* had it. On the set we would use only fresh flowers, the finest caviar, Baccarat crystal, Limoges dishes, as well as real silver, linen and lace sheets. We wanted to depict a lifestyle people had not seen on TV before. Michael Douglas captured the mood of the times brilliantly in his "Greed Is Good" speech in *Wall Street*. I've seen that movie about nine times.

It annoys me when people whinge about "the vulgar, gaudy '80s" and the hideousness of the clothes. The clothes were certainly not hideous. I have endless photograph albums of my friends and myself at parties, dinners and on the beach, where everyone looks great. It's not even a question of dressing up; it's a question of dressing well, and that doesn't happen today. The age of glamour and good grooming is gone.

The 1920s were branded as vulgar, too, because of Prohibition and women rolling up their stockings, shortening their skirts and smoking cigarettes. A certain vulgarity characterized the '80s, but it was a

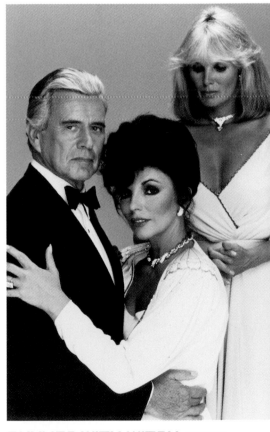

RHYMES WITH WITCH *Dynasty* was languishing in the ratings until Collins (as cunning Alexis) joined John Forsythe (as her tycoon ex-husband, Blake) and Linda Evans (as his decorous new wife, Krystle) in 1982.

The Alexis look was big shoulders, a *lot* of cleavage . . .

jaunty, jolly sort of vulgarity. People felt they were embarking on a grand adventure. Suddenly restaurants were theaters. Supermarkets became palaces of temptation. People would take the Concorde to Paris for the weekend. Today's vulgarity is more about the triumph of rude and crude.

AS A SYMBOL OF ALL THAT WAS rapacious and unabashed in the '80s, Alexis was huge fun to portray. She wasn't particularly over-the-top at first. I wore some rather prim clothes, actually—little blouses, rather like Princess Diana—before we found the Alexis look, which was big shoulders, a *lot* of cleavage, tight short skirts with extremely high heels, masses of jewelry, big hair and supreme confidence.

At one point I said, "I'm not wearing this little tweed suit with the boxy jacket and the little mink collar, thank you very much." Nolan Miller, *Dynasty*'s wonderful costume designer, had worked with Lana Turner, Joan Crawford and Barbara Stanwyck. These women knew what they wanted, sartorially speaking. So he was

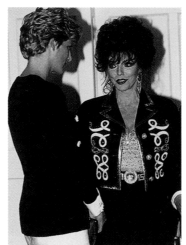

STAR SHINE Old acquaintances, Princess Diana and Collins chatted in London in 1992.

pleased that I was so interested in what I was wearing and how the character should look.

I used to spend Saturdays schmoozing around Neiman-Marcus and Saks, telling the saleswomen, "Hold this. And this. And this. And this." Then Monday at the studio there would be a rack of clothes that the wardrobe designer had picked up for me. Once they realized I knew what I was talking about, they went along with what I suggested, and I had great input.

All the actresses had to watch their weight. No one would go near the craft service [the catered food provided on-set]. The crew would gain about 12 to 14 pounds each season. But the actresses needed to be 10 pounds lighter to look good in our costumes. I'd have a tuna salad sandwich for lunch and save my appetite for dinner. We all *lived* at Spago back then—the original one, on Sunset Boulevard. You'd see masses of friends whenever you'd go. It was wall-to-wall with famous faces, and the food was superb. Wolfgang Puck, the chef and owner, was friendly and funny and warm, and always

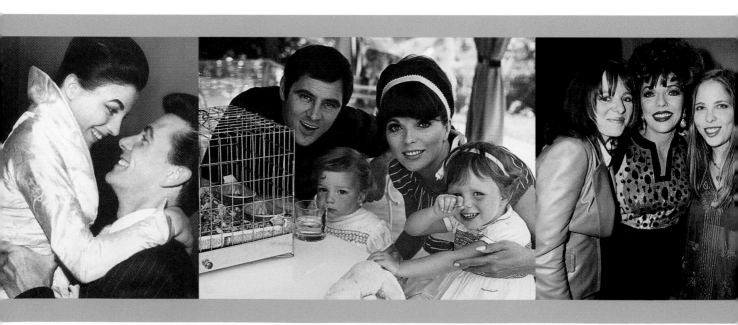

sent over smoked-salmon-and-caviar pizzas on the house.

The men's clothes on *Dynasty* were, of necessity, conservative. For sharp clothes I watched *Miami Vice* occasionally to see what Don Johnson was wearing. I loved Richard Gere in *American Gigolo*. Gorgeous. Remember that brilliant opening sequence where he was choosing his ties and jackets and shirts? They were all muted colors, which set a trend for men.

I had some concern that I would be attacked by somebody

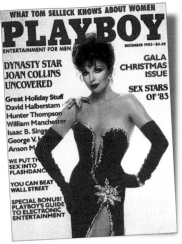

NAKED HUNCH "They want me to show my body?" Collins says of her 1983 *Playboy* cover. "Why not? It looked good. I was 49 when I did that and I didn't have any qualms about it."

because Alexis was so devilish. But I used to say, "Blake has murdered two people. Alexis hasn't killed anyone, so why is *she* the baddie? She just does what all men do in business,

J.R. IN A DRESS *Dallas* fan Collins remembers thinking in the early '80s, "Wouldn't it be great to do a Larry Hagman–type character—except female?" When Alexis was later offered to her as "a female J.R.," Collins exclaimed, "That's exactly what I want to do!"

which is to be vindictive, manipulative and devious." Leona Helmsley, the Queen of Mean, probably wasn't the nicest woman on the block, but she certainly created an empire. To get attention, women sometimes have to be stronger and harder and better at what they do than men.

Roger Moore, a big fan of the show, often called me to ask, "Joanie, how could you do that to poor Cecil Colby?" Cecil was Blake's oil tycoon rival. The funniest plot line was when Alexis screwed Cecil Colby to death. We were having sex in his hospital bed, and just when he's supposed to be climaxing he starts to have a heart attack. And I yell, "Don't you die on me, Cecil! Don't you *dare* die on me!" I could not stop laughing between takes, because his toupee kept falling off.

I think Linda Evans found it hard to be friendly with somebody she had to hate on the screen. The first time we had a scene together, I held back during rehearsal. But when we shot the scene, I really gave it to her. "You stupid, ignorant little stenographer!" I hissed. "Why don't you go back to that hick town you came from? You have no class at all!" Linda's pupils dilated. When the director yelled "Cut!" she asked, "Did you mean that?"

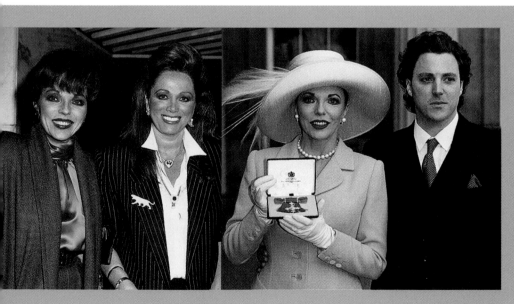

FAMILY TIES From left: Collins was 19 when she married British film star Maxwell Reed. • With second husband Anthony Newley (in 1967) the actress had two children, Sacha (left) and Tara. • In 1986, Collins posed with daughters Tara Newley (left) and Katy Kass. (Six years earlier, Katy had nearly died after being hit by a car.) • Describing the bond she and her sister share, Collins told PEOPLE in 1984, "I really feel with Jackie that when the chips are down, she'll always be there for me." • In March 1997, Collins (with Sacha) received the prestigious Order of the British Empire.

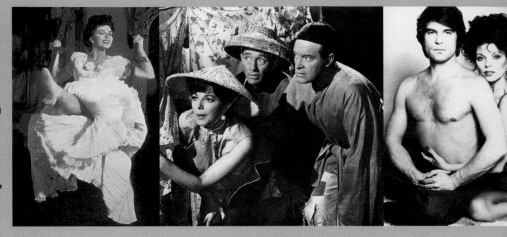

JOAN'S ARC From left: Collins played femme fatale Evelyn Nesbit in *The Girl in the Red Velvet Swing* in 1955. • She hit *The Road to Hong Kong* with Bing Crosby and Bob Hope in 1962. • Cuddling with Oliver Tobias in *The Stud* in 1979 got her voted sexiest woman in the world in a poll of Englishmen. • She starred in the 1986 miniseries *Sins* with Gene Kelly. • In 1988, her first novel, *Prime Time*, became a best-seller. • The star launched her own perfume, Scoundrel, in 1995. • *The Flintstones in Viva Rock Vegas* gave her a yabba-dabba-doozy of a role in 2000.

I thought Krystle was a total wimp, a Goody Two-shoes

"What do you mean, did I mean that? Of course Alexis meant that."

"It sounded so real, it was scary," she said.

"Well, that's the way it's going to be," I told her.

We despised each other's characters. A lot of the female characters on *Dynasty* were saying, "I'm feminine and I'm sexy, but don't mess with me in business. I can have it all: the children, the job, the power, the clothes and the hairstyles." But I always thought Krystle was a total wimp. She was so Goody Two-Shoes. I don't happen to dig people like that. And I think Linda felt Alexis was overly ballsy and vicious.

In our famous fight scene in the pool, Krystle was supposed to hit Alexis. Actors are trained to pull their punches, but in this case, by accident, Linda's fist hit my jaw. I ended up at the chiropractor for a week. In all the scenes after that, where you see us falling down in the mud, it was Linda and my stand-in. As Alexis, I used my tart tongue, not my fists.

Heather Locklear, who played Sammy Jo

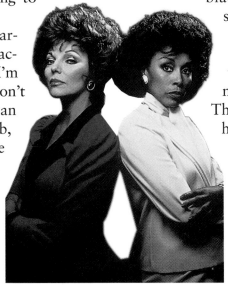

FASHION FACE-OFF Rival vixens on *Dynasty*, Collins and Diahann Carroll are real-life friends.

Dean, made an excellent little baby bitch, and when Diahann Carroll came in as Dominique Deveraux, she said, "I'm going to be the first black bitch on television." She started to dress in the highest of haute couture. But Aaron Spelling told Nolan, "Alexis is the one who has to have the most over-the-top clothes." That's when my wardrobe went haywire. My clothes had to outdo Diahann's in flashiness. Sometimes they could look ludicrous.

AS AN ANTIDOTE TO THE glamour of Alexis and Dominique, the blue-collar grittiness of *Roseanne* provided welcome comic relief at the end of the '80s. I played Roseanne's cousin for one episode in 1993. I had been wanting to get away from the Alexis image. But *Roseanne* turned out to be the most terrifying experience of my life. The producers kept changing the dialogue all through rehearsal, handing me new lines five minutes before we started shooting in front of a live audience. I never want to try that again.

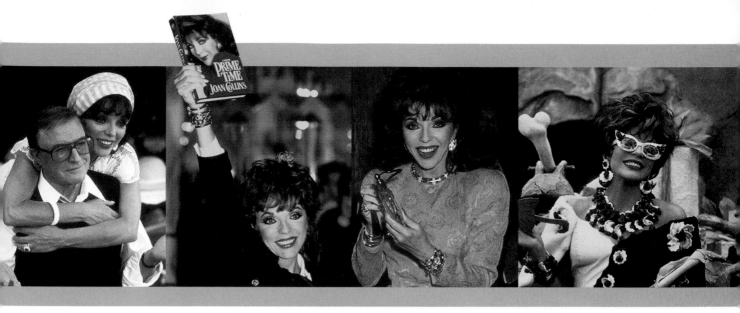

In 1982 I appeared on a magazine cover, where one of the cover lines read, "Mysterious Cancer That's Killing Gay Men." AIDS did not yet have a name. By 1985, when Rock Hudson appeared on *Dynasty,* AIDS was still little understood. I was sitting in the makeup room, and Rock was in the next chair, when the hairdresser whispered to me, "Don't go near him, don't use his comb, and we're going to wipe the chair off after he gets up." I said, "Why?" After Rock left the room, the hairdresser said, "I hear he's got AIDS." "How is it spread?" I asked. He didn't know. Nobody knew. For six months, there was complete panic in Hollywood over AIDS. Everybody at dinner parties would

CANDLE WITH CARE
Nancy and Ronald Reagan smooched on their 33rd wedding anniversary in 1985.

CHEMISTRY LESSON "Cybill Shepherd and Bruce Willis were magical together," says Collins of the *Moonlighting* duo.

use plastic cutlery instead of silverware. Suddenly, no actress would kiss an actor suspected of having even herpes or a cold sore.

Linda Evans had a love scene with Rock, and everyone was whispering, "She's crazy to kiss him." Afterwards she went back to her dressing room and scrubbed her mouth and her tongue with toothpaste and mouthwash. Even the gay men on the set were terrified. The ignorance at that time was astonishing.

The '80s were full of larger-than-life personalities, and I am fortunate to have met many of them. Michael Jackson came on the set in about 1982 or 1983. He was so shy, he just stood in a corner for hours, watching, and didn't say a word. Then, last year, I saw him at Elizabeth Taylor's AIDS benefit at the Royal Albert Hall in London. He was so humble. The greatest pop star of all time said, "Do you remember me? I came on the *Dynasty* set."

"How could we forget you?" I said with a smile. "None of us could remember our lines, we were so in awe of you watching us."

No one was more closely scrutinized in the '80s than Prince Charles and Princess Diana. I first met them in Palm Beach in 1984 or 1985. Armand Hammer was hosting a charity ball.

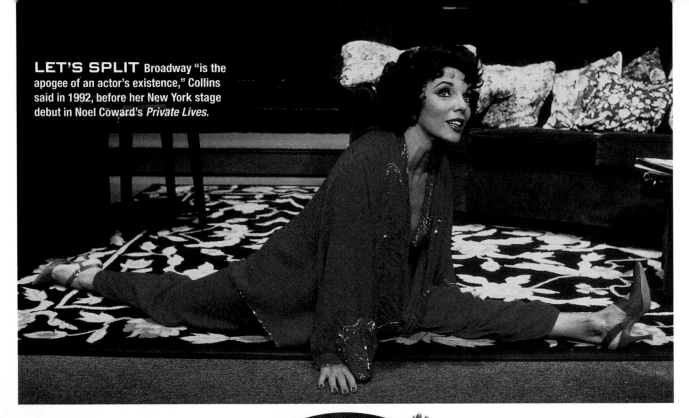

LET'S SPLIT Broadway "is the apogee of an actor's existence," Collins said in 1992, before her New York stage debut in Noel Coward's *Private Lives*.

Diana was sweet—tall and willowy, with eyes the most amazing shade of blue. She seemed kind of naive yet shrewd, which is an interesting combination. Charles is a typical Englishman. He is slightly on the inhibited side, but extremely charming, knowledgeable and interested in show business. And he has the most wonderful voice. I think he'll be a good king.

When I met Fergie, she was an outgoing, big, rambunctious, hockey-playing redhead. I had lunch with her when the press was calling her the Duchess of Pork. She was really mortified about that.

In 1984, I visited Ronald and Nancy Reagan at the White House, which was glamorous beyond belief. They couldn't have been more gracious. All that nonsense about him dying his hair! It doesn't work for men to dye their hair—it goes orange. You can always tell whether it's been dyed, and his was not.

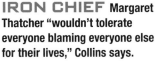

IRON CHIEF Margaret Thatcher "wouldn't tolerate everyone blaming everyone else for their lives," Collins says.

Jackie Kennedy was my idol. She handled herself so well. Marrying Mr. Onassis was not the cleverest idea in the world, but she turned her life around. And even though she was stalked by paparazzi all her days, which must have been terribly hard for her, she never complained.

This may surprise you, but Margaret Thatcher was a physically attractive woman. A lot of politicians fancied her. She was a man's woman, but she was friendly enough to women. She was the complete opposite of what our government today stands for, which is a welfare state. Nobody wants to do anything for themselves anymore. But if your house was falling down, Maggie would say, "Go buy yourself some bricks and mortar and get on a ladder and fix it yourself." Which is the way I feel about life. You are responsible for your own destiny. You do it yourself. You don't wait for other people to do it for you.

SPECIAL EDITION PHOTO CREDITS
Neal Preston/Corbis Outline (ii); Photofest (iii); Rex Features, Globe Photos, Rex Features, Richard Young/Rex USA (iv); MPTV, Kobal Collection (v); Lester Glassner Collection/Neal Peters Collection, Photofest, Neal Peters Collection (vi); Photofest, Duncan Raban/Stills/Retna, Galella Ltd., Neal Peters Collection, Corbis Sygma, Mario Casilli/ABC/MPTV (vii); Neal Peters Collection, Peter Jordan/Liaison (viii)

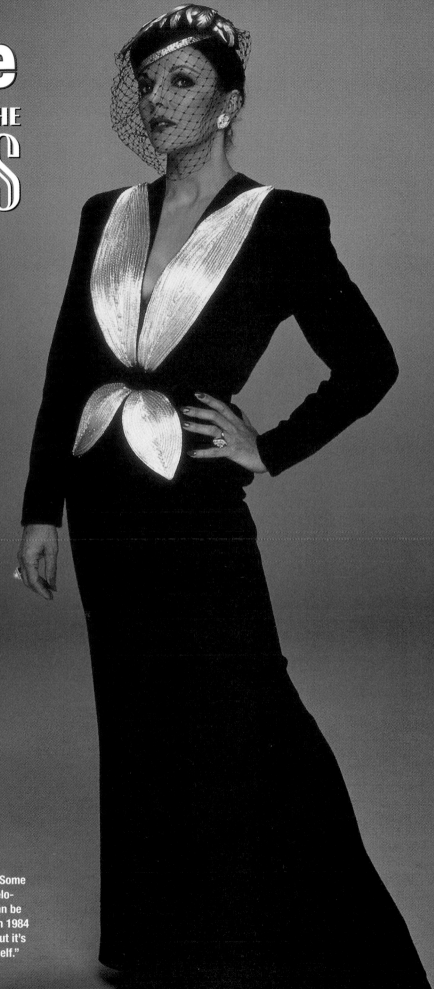

CELEBRATES THE
80s

DYNASTY'S DIVA "Some of it is over-the-top, it's overly melo-dramatic, it's larger than life, it can be unbelievable," Joan Collins said in 1984 of her signature role as Alexis. "But it's given me a chance to stretch myself."

STAFF FOR THIS BOOK

EDITOR: Eric Levin
EXECUTIVE EDITOR: Kelly Knauer
DESIGNER: Sue Ng
PICTURE EDITOR: Patricia Cadley
CONTRIBUTING WRITERS: Connie Dickerson, Jon Young
COPY EDITOR: Bruce Christopher Carr
EDITORIAL RESEARCH: Matt Fenton
RESEARCH ASSOCIATE: Denise Lynch
DESIGN CONSULTANT: Anthony Wing Kosner
SPECIAL THANKS TO: The PEOPLE Research Library

TIME INC. HOME ENTERTAINMENT

PRESIDENT: Rob Gursha
VICE PRESIDENT, BRANDED BUSINESSES: David Arfine
EXECUTIVE DIRECTOR, MARKETING SERVICES: Carol Pittard
DIRECTOR, RETAIL & SPECIAL SALES: Tom Mifsud
DIRECTOR OF FINANCE: Tricia Griffin
MARKETING DIRECTOR: Kenneth Maehlum
MARKETING DIRECTOR: Maarten Terry
PRODUCT MANAGER: Dennis Sheehan
EDITORIAL OPERATIONS MANAGER: John Calvano
ASSOCIATE PRODUCT MANAGER: Sara Stumpf
ASSISTANT PRODUCT MANAGER: Linda Frisbie
SPECIAL THANKS TO: Victoria Alfonso, Suzanne DeBenedetto, Robert Dente, Gina Di Meglio, Peter Harper, Roberta Harris, Natalie McCrea, Jessica McGrath, Jonathan Polsky, Emily Rabin, Mary Jane Rigoroso, Steven Sandonato, Tara Sheehan, Meredith Shelly, Bozena Szwagulinski, Marina Weinstein, Niki Whelan

Copyright ©2001 Time Inc. Home Entertainment
Published by

Time Inc.
1271 Avenue of the Americas
New York, NY 10020

All rights reserved. No part of this book may be reproduced in any form or by any electronic or mechanical means, including information storage and retrieval systems, without permission in writing from the publisher, except by a reviewer, who may quote brief passages in a review.

First Edition
ISBN: 1-929049-30-7

We welcome your comments and suggestions about PEOPLE BOOKS. Please write to us at:
PEOPLE BOOKS
Attention: Book Editors
P.O. Box 11016
Des Moines, IA 50336-1016

If you would like to order any of our hardcover Collector's Edition books, please call us at 1-800-327-6388 (Monday through Friday, 7:00 a.m.–8:00 p.m., or Saturday, 7:00 a.m.–6:00 p.m., Central Time).
Please visit our Web site at www.TimeBookstore.com

PRINTED IN THE UNITED STATES OF AMERICA

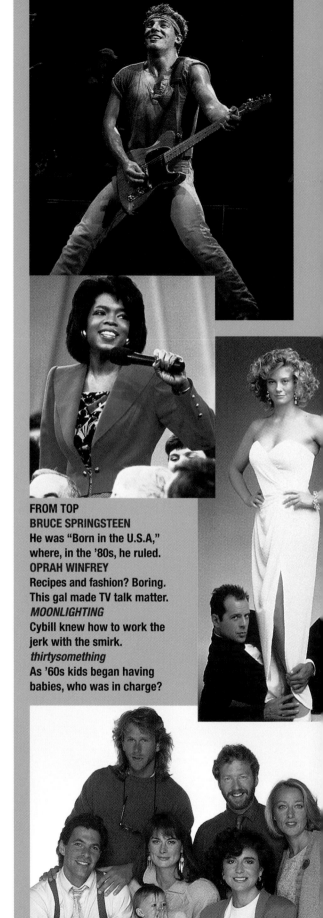

FROM TOP
BRUCE SPRINGSTEEN
He was "Born in the U.S.A," where, in the '80s, he ruled.
OPRAH WINFREY
Recipes and fashion? Boring. This gal made TV talk matter.
MOONLIGHTING
Cybill knew how to work the jerk with the smirk.
thirtysomething
As '60s kids began having babies, who was in charge?

Contents

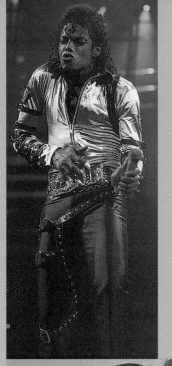

FROM TOP
MICHAEL JACKSON
The *Bad* man could move!
JIM & TAMMY FAYE BAKKER
Praise the Lord and paste the lashes.
EDDIE MURPHY
He copped laughs (and hearts) in *Beverly Hills Cop.*
KEVIN COSTNER
If he filmed it, we would come.

It Was 20 Years Ago

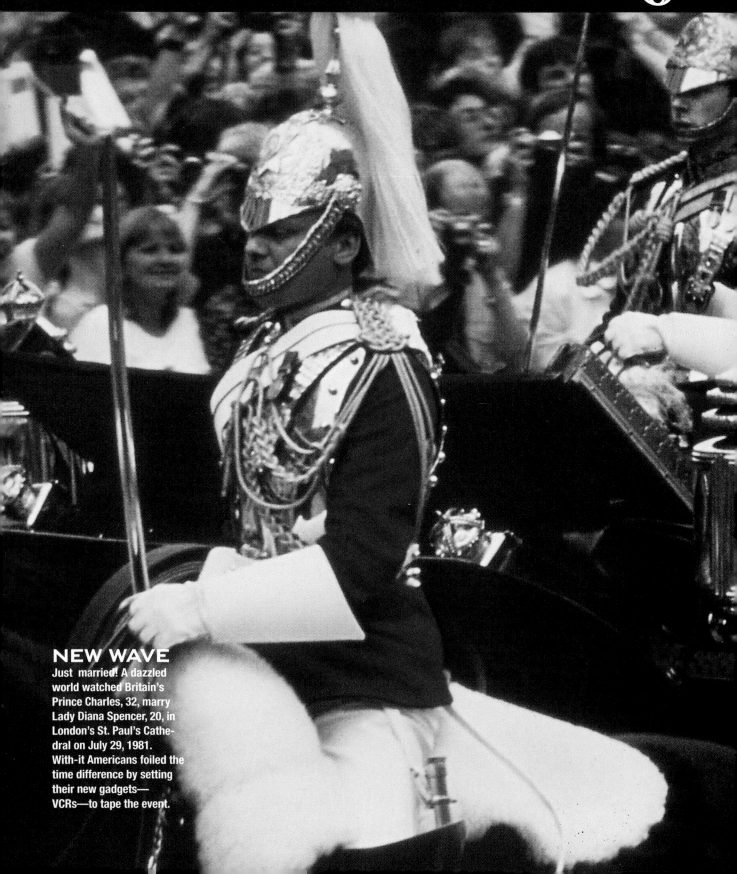

NEW WAVE
Just married! A dazzled world watched Britain's Prince Charles, 32, marry Lady Diana Spencer, 20, in London's St. Paul's Cathedral on July 29, 1981. With-it Americans foiled the time difference by setting their new gadgets—VCRs—to tape the event.

Today

BUT IT SEEMS LIKE AGES: MOONWALK WITH US BACK TO AN ERA WHEN ROYALS STOLE HEARTS, MADONNA WAS A TART, AND ELVIS WAS A GEEKY BRITISH ROCKER

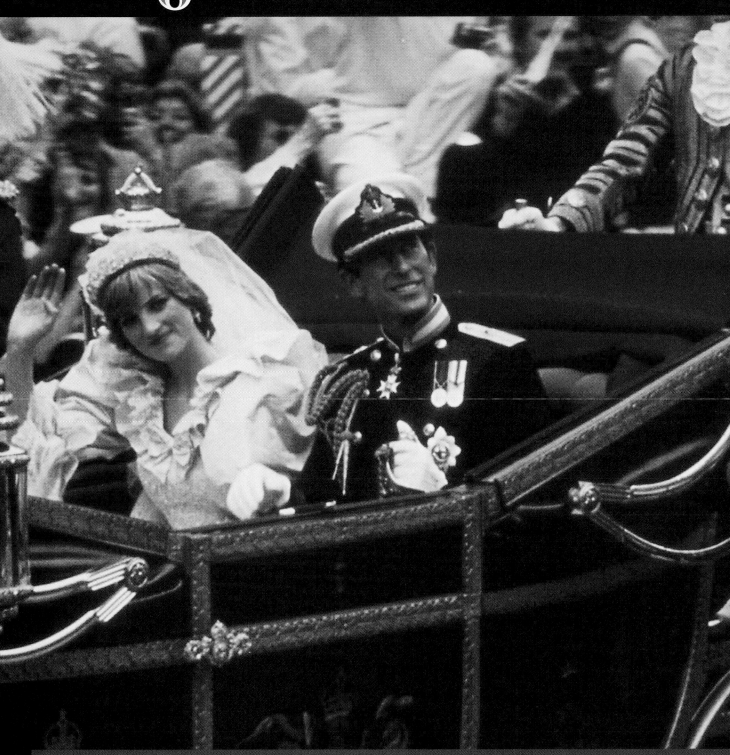

We believed in happily-ever-afters ...

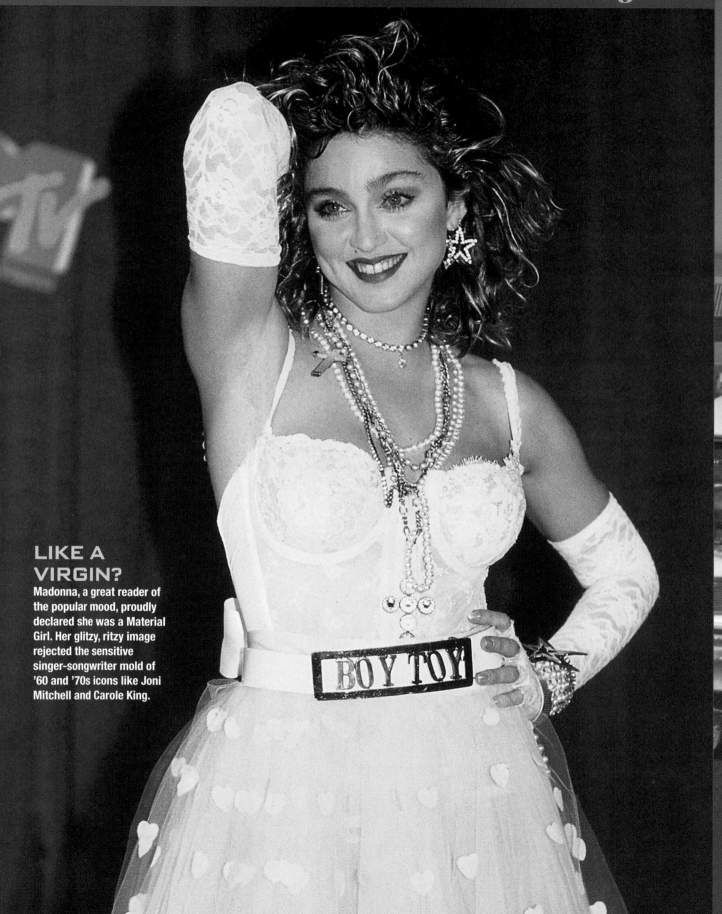

We fell in love with material things:

LIKE A VIRGIN?

Madonna, a great reader of the popular mood, proudly declared she was a Material Girl. Her glitzy, ritzy image rejected the sensitive singer-songwriter mold of '60 and '70s icons like Joni Mitchell and Carole King.

BOY TOY

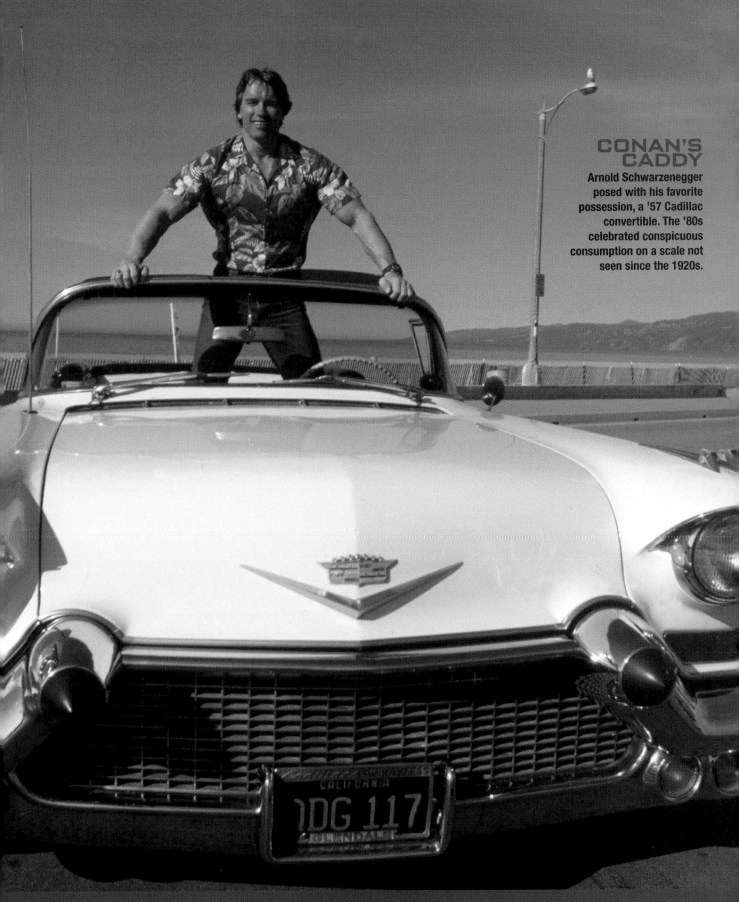

CONAN'S CADDY
Arnold Schwarzenegger posed with his favorite possession, a '57 Cadillac convertible. The '80s celebrated conspicuous consumption on a scale not seen since the 1920s.

Boys had toys, and girls were "Boy Toys"

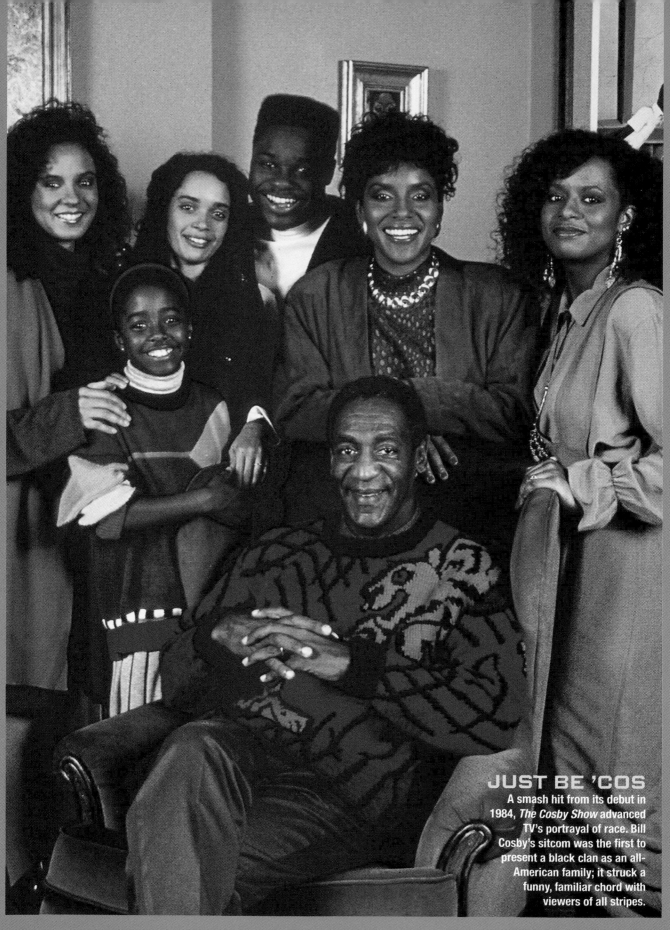

JUST BE 'COS
A smash hit from its debut in 1984, *The Cosby Show* advanced TV's portrayal of race. Bill Cosby's sitcom was the first to present a black clan as an all-American family; it struck a funny, familiar chord with viewers of all stripes.

We turned right: it was hip to be square

... family values were everywhere

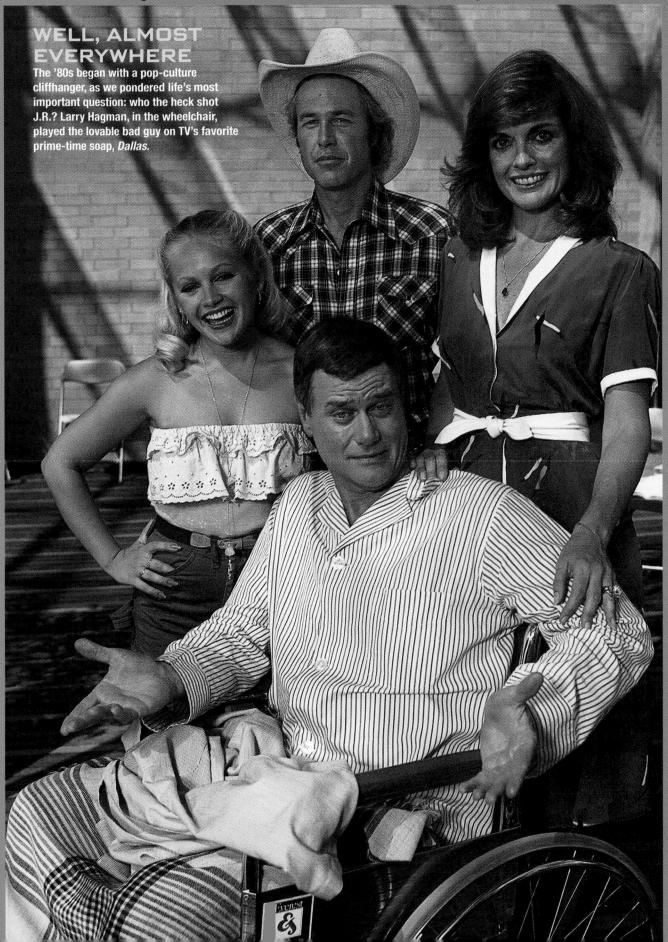

WELL, ALMOST EVERYWHERE

The '80s began with a pop-culture cliffhanger, as we pondered life's most important question: who the heck shot J.R.? Larry Hagman, in the wheelchair, played the lovable bad guy on TV's favorite prime-time soap, *Dallas*.

We celebrated in the land of the free ...

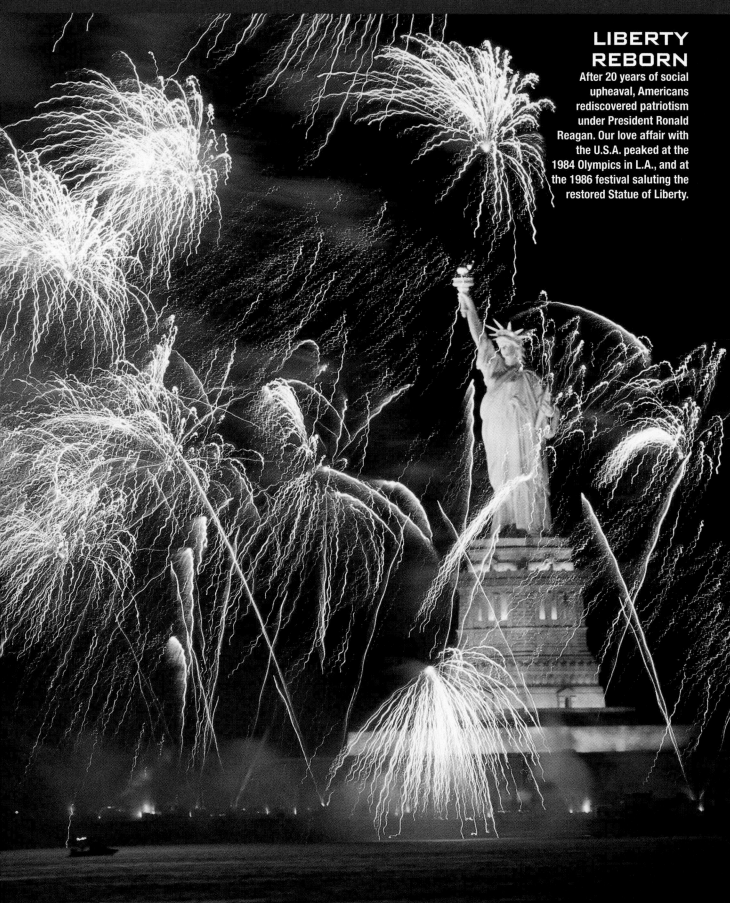

LIBERTY REBORN

After 20 years of social upheaval, Americans rediscovered patriotism under President Ronald Reagan. Our love affair with the U.S.A. peaked at the 1984 Olympics in L.A., and at the 1986 festival saluting the restored Statue of Liberty.

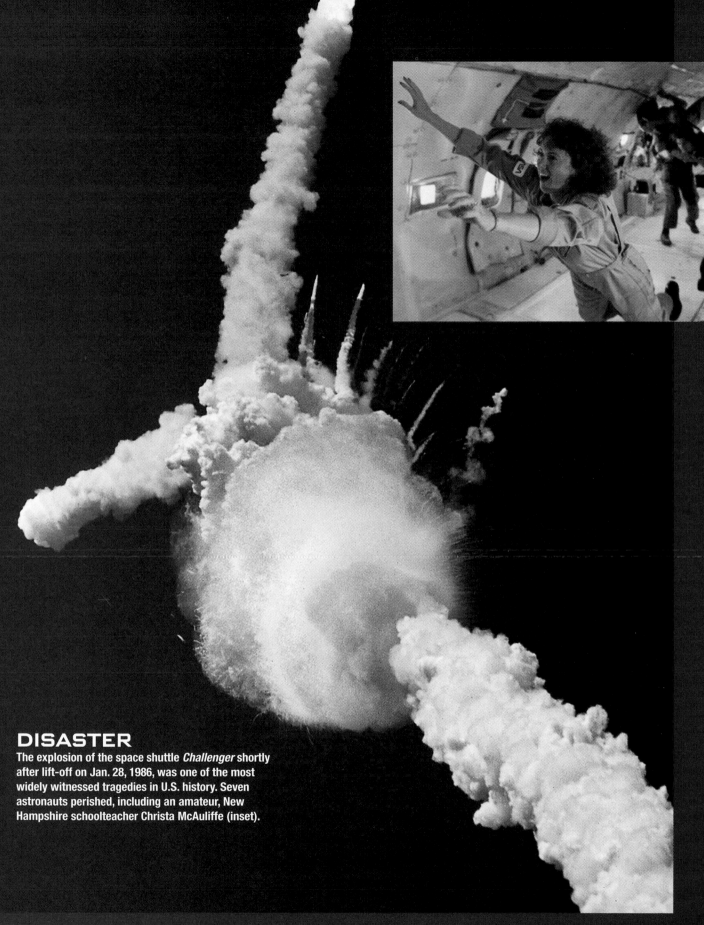

DISASTER

The explosion of the space shuttle *Challenger* shortly after lift-off on Jan. 28, 1986, was one of the most widely witnessed tragedies in U.S. history. Seven astronauts perished, including an amateur, New Hampshire schoolteacher Christa McAuliffe (inset).

and wept in the home of the brave

We learned our heroes were mortal ...

"I READ THE NEWS TODAY, OH BOY"

On Dec. 8, 1980, John Lennon autographed a record album for the man who would shoot him only hours later. The assassin, who was found to be mentally unstable, later said one reason he killed the former Beatle was to gain notoriety—reason enough for us to withhold his name here.

but you couldn't kill their dreams

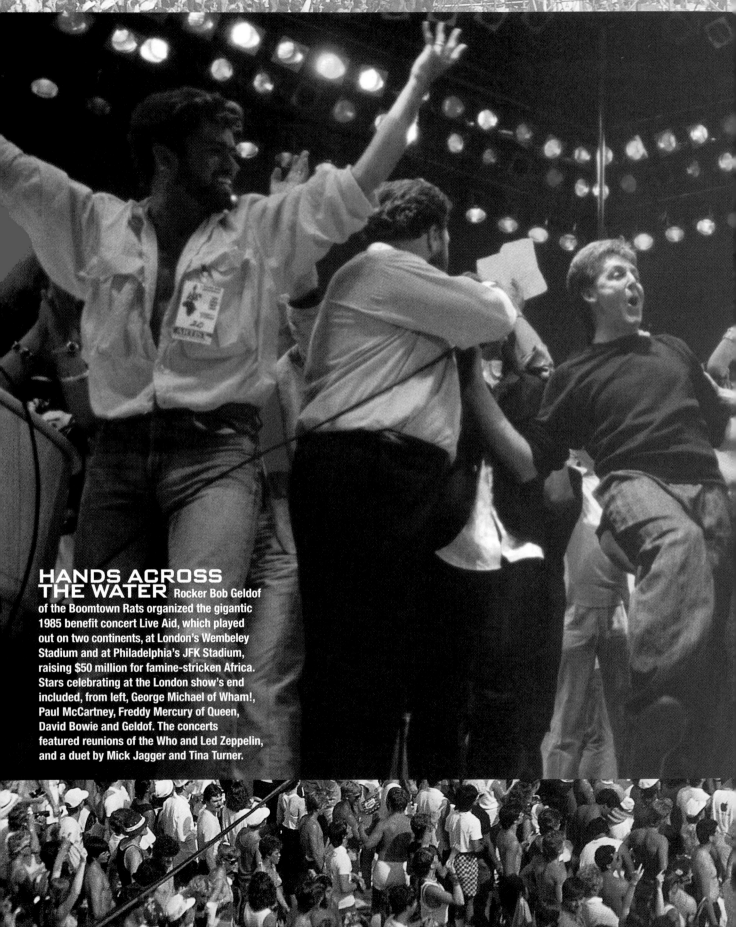

We raised our voices for a better world

HANDS ACROSS THE WATER Rocker Bob Geldof of the Boomtown Rats organized the gigantic 1985 benefit concert Live Aid, which played out on two continents, at London's Wembeley Stadium and at Philadelphia's JFK Stadium, raising $50 million for famine-stricken Africa. Stars celebrating at the London show's end included, from left, George Michael of Wham!, Paul McCartney, Freddy Mercury of Queen, David Bowie and Geldof. The concerts featured reunions of the Who and Led Zeppelin, and a duet by Mick Jagger and Tina Turner.

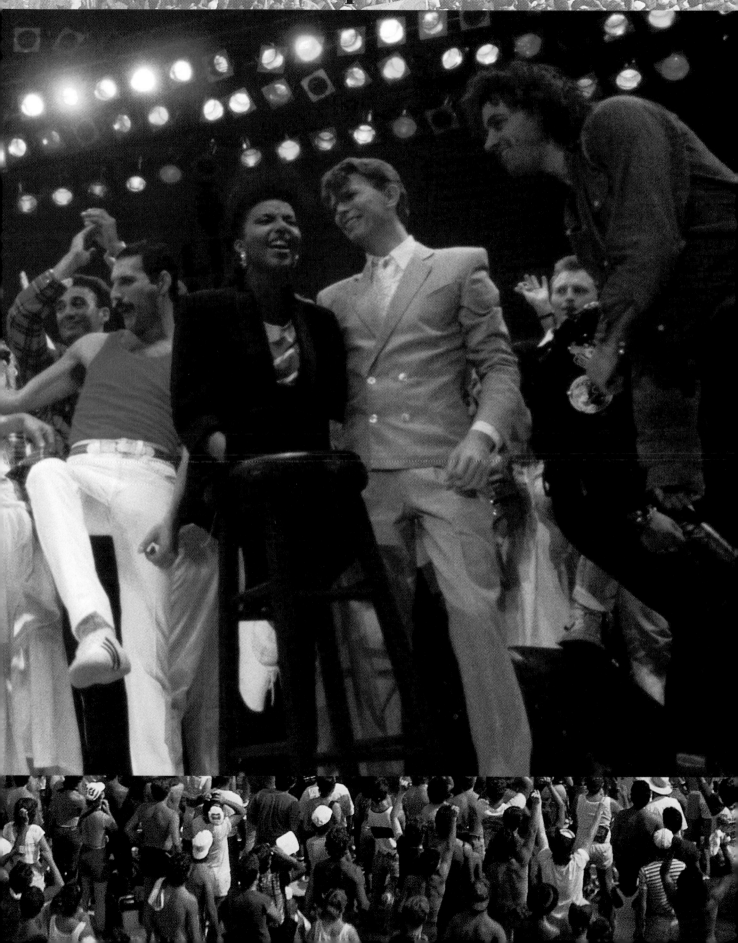

... with a little help from our friends.

Thriller

FROM CDS TO
MUSIC VIDEOS,
THE '80S GAVE
STARS NEW
WAYS TO
SHAKE,
RATTLE
AND
ROLL

Michael JACKSON

A tale of two Michaels: A complex genius reigned as our King of Pop

He was a one-man pop sensation who shattered the barriers between black and white audiences in the '80s to become one of the most beloved stars in the history of American pop culture. Yet Michael Jackson's dazzling, dancing form seemed to house two personalities—one a brilliant showman, the other a notorious eccentric. And in a transformation that mirrored the self-portrait he created in his "Thriller" video, his image evolved over the decade: "Michael"—a gifted, winning, ultra-innocent entertainer— became (in tabloid speak) "Jacko"—a weirdo whose shy façade masked a dark, obsessive persona.

Michael Joseph Jackson was born in 1958 in the steeltown of Gary, Ind., the seventh of nine children of Jehovah's Witnesses Katherine and Joe Jackson. The superstar began as a child sensation: hard-working Michael—driven by his dad—was fronting the Jackson 5 by age 9, and made the group one of the biggest

PUTTIN' ON THE GLITZ

Michael studied film of Fred Astaire for his act. After seeing "Billie Jean" on TV, the legendary hoofer told the young star, "You are a hell of a mover."

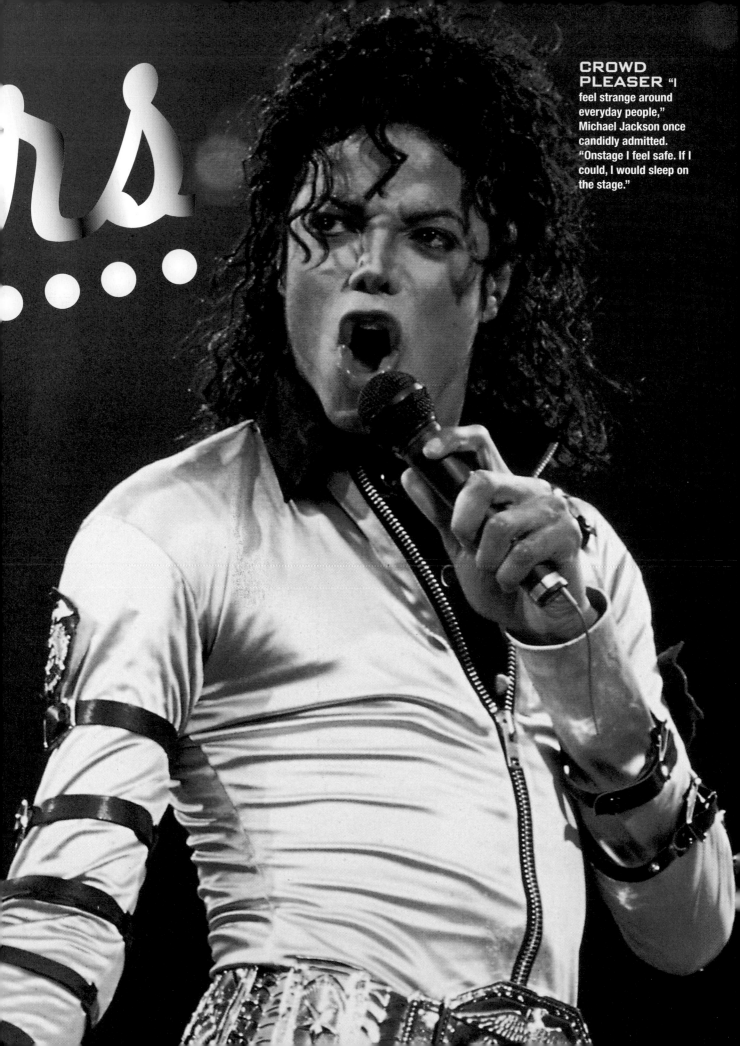

CROWD PLEASER "I feel strange around everyday people," Michael Jackson once candidly admitted. "Onstage I feel safe. If I could, I would sleep on the stage."

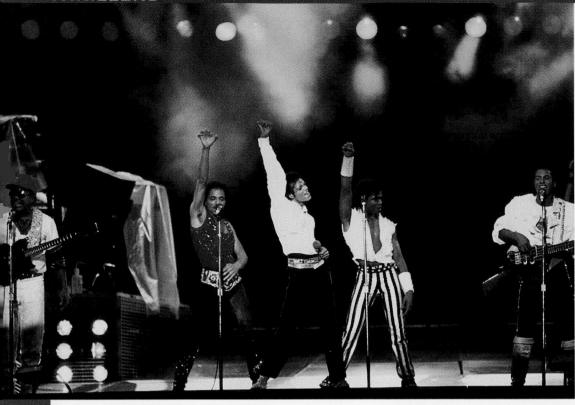

WE ARE FAMILY The Jacksons first sang as the Ripples & Waves Plus Michael. His brothers hitched a ride on Michael's fame when they reunited for 1984's Thriller tour.

acts in Motown Records history. Michael's career flourished after he declared his independence from his brothers, his father and Motown boss Berry Gordy and teamed with producer Quincy Jones to craft a daring, solo hybrid of rock and R&B, 1979's smash *Off the Wall. Thriller,* released in 1982, was a greatest-hits album all by itself, spawning an astounding seven Top 10 singles. The best-selling record in history, *Thriller* has sold more than 46 million copies—so far.

But Michael was far more than a hit crafter: he was a magnetic dancer and born showman whose talents had to be seen as well as heard. His eye-fooling moves—like his signature moonwalk—entranced fans, and his performances of "Beat It" and "Billie Jean" marked the arrival of music video as a true art form. America, then the world, fell in love with the incandescent star: by the mid-'80s, he ruled over pop culture as had no performer since the Beatles. His every foible was hyped, from his single glove to his odd pets to his fixation on childhood (which the former child star claimed he had missed).

Fascinated by aliens, Jackson recorded the *E.T.* storybook album in 1982. "It's a nice place Michael comes from," director Steven Spielberg said. "I wish we could all spend some time in his world." A tireless humanitarian, Michael raised millions for the United Negro College Fund and co-wrote and sang on the '86 benefit song "We Are the World" for the USA for Africa famine relief fund. There were a few setbacks: His endorsement deal with Pepsi got off to a rocky start in 1984 when he suffered second-degree burns while filming a commercial.

WELCOME TO THE DOLLHOUSE
Jackson created his own kingdom, zoo and theme park when he bought the 2,700-acre Neverland Ranch in Santa Ynez, Calif.

But increasingly, Michael's bizarre lifestyle became difficult to overlook: He was compared to Greta Garbo for his reclusiveness, Boy George for his androgyny and Howard Hughes for all-around weirdness. His menagerie ranged from llamas to boas. His face underwent a transformation in shape and color (new nose, chin, eyes and bleached skin)—a female impersonator called him "Diana Ross in drag." Tabloid stories had

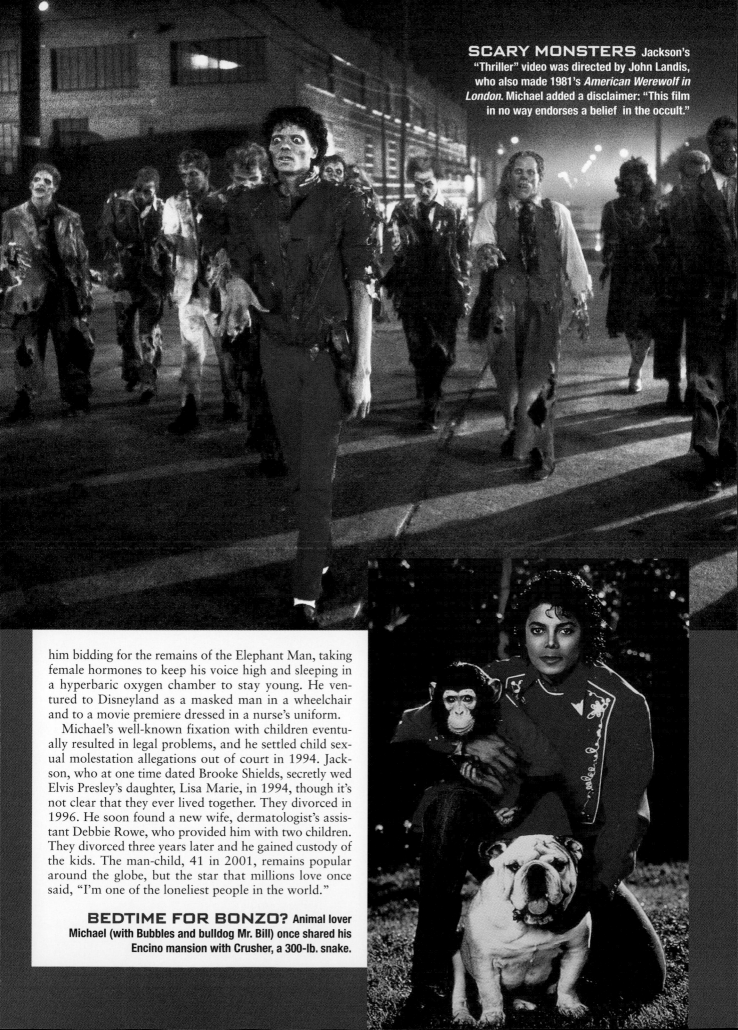

SCARY MONSTERS Jackson's "Thriller" video was directed by John Landis, who also made 1981's *American Werewolf in London*. Michael added a disclaimer: "This film in no way endorses a belief in the occult."

him bidding for the remains of the Elephant Man, taking female hormones to keep his voice high and sleeping in a hyperbaric oxygen chamber to stay young. He ventured to Disneyland as a masked man in a wheelchair and to a movie premiere dressed in a nurse's uniform.

Michael's well-known fixation with children eventually resulted in legal problems, and he settled child sexual molestation allegations out of court in 1994. Jackson, who at one time dated Brooke Shields, secretly wed Elvis Presley's daughter, Lisa Marie, in 1994, though it's not clear that they ever lived together. They divorced in 1996. He soon found a new wife, dermatologist's assistant Debbie Rowe, who provided him with two children. They divorced three years later and he gained custody of the kids. The man-child, 41 in 2001, remains popular around the globe, but the star that millions love once said, "I'm one of the loneliest people in the world."

BEDTIME FOR BONZO? Animal lover Michael (with Bubbles and bulldog Mr. Bill) once shared his Encino mansion with Crusher, a 300-lb. snake.

Jodi FOSTER

A would-be assassin cast a cloud over her rising star

Just as the self-possessed teen star of *Taxi Driver* put her career on hold to blend in with the crowd as a freshman at Yale, disturbed stalker John Hinckley shot President Ronald Reagan in an attempt to impress her. Undaunted, Foster graduated, then appeared in a dozen or so mostly forgettable flicks, saying, "I feel old about the business," before reigniting her stardom with an Oscar-winning portrayal of a gang-rape victim in 1988's *The Accused*. Ten years and many hits later, she became a single mom—and another baby's due late in 2001.

BLONDE AMBITION
The foxy prodigy matured into a brainy beauty with a 1985 Yale degree in lit; she described herself in college as "kind of a loner, a bookworm."

TOM TERRIFIC
Cruise matched a bankable smile with a can-do attitude. "Guys want to be like him, and girls want to be with him," said one movie biggie.

Tom CRUISE

Flying high in Top Gun, *he ignited a career that has yet to slow down*

Wearing little more than an air guitar and dark shades, Thomas Cruise Mapother IV hit big in the 1983 sizzler *Risky Business*. Morphing from teen heartthrob to heroic hunk, he scored again with the frothy *Cocktail* and the searing drama *Born on the Fourth of July*. This intensely earnest dreamboat, who spent time in a Franciscan seminary, also hustled alongside Paul Newman in *The Color of Money* and held his own with Dustin Hoffman in *Rain Man*. His marriage to actress and fellow Scientologist Mimi Rogers ended just as he shifted into high gear with Nicole Kidman on the set of *Days of Thunder*.

THE EYES HAVE IT
And the rest ain't bad either: In 1985 PEOPLE named Mel our first-ever Sexiest Man Alive. Sigourney Weaver, his co-star in 1983's *The Year of Living Dangerously*, deemed him "the most gorgeous man I've ever met."

Mel GIBSON

One look—and gals were all Mel's belles

He came from a land Down Under to conquer America's screens (and hearts). But Mel Gibson was born in upstate New York in 1956; his father transplanted the 5-year-old and his siblings to Australia—where the locals called him "Yank." The shy youth drifted into drama, starring onstage in 1976 as Romeo opposite Judy Davis's Juliet. In 1979 he answered a cattle call and won the title role in George Miller's apocalyptic thriller *Mad Max;* 1981's *Gallipoli* and 1987's fanny-flashing *Lethal Weapon* sealed his stardom. But we love him best because he's stayed a jolly, down-to-earth, happily married father of seven.

Arnold
SCHWARZENEGGER

Bodybuilder … barbarian … cyborg outlaw … Kennedy in-law

Hollywood know-it-alls liked everything about the iron-pumping prodigy from Austria—except his name. They swore Americans would never take to the man with the mouthful of a moniker. So … we just called him Arnold! He was 21 when he arrived in America in 1968, a champion bodybuilder hoping to make his fortune by running gyms. But after he starred in 1977's *Pumping Iron,* which captured him cleaning-and-jerking his way to a Mr. Olympia title, he was cast as Conan the Barbarian, and his career took off. His unforgettable turn as the cyborg killing machine in *The Terminator* made him a star for everyone to love—including Maria Shriver, who met the Reagan Republican at a 1977 tennis benefit in New York City. They married in 1986.

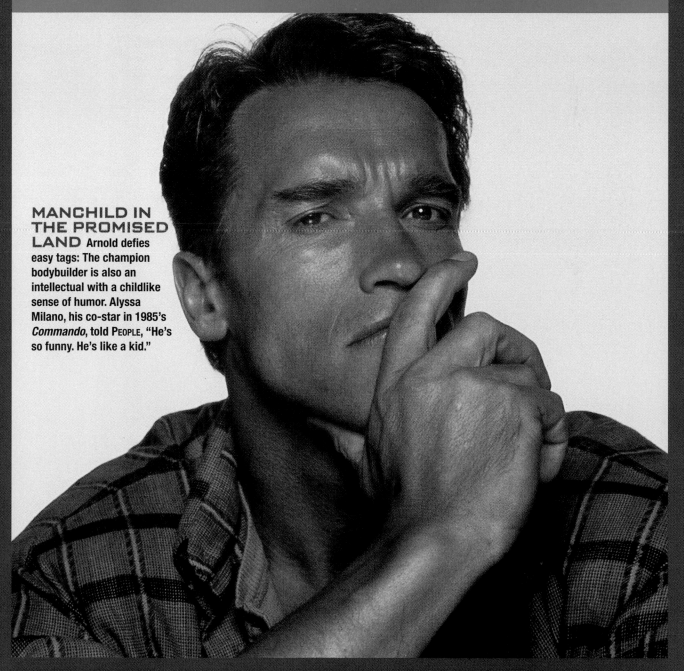

MANCHILD IN THE PROMISED LAND Arnold defies easy tags: The champion bodybuilder is also an intellectual with a childlike sense of humor. Alyssa Milano, his co-star in 1985's *Commando,* told PEOPLE, "He's so funny. He's like a kid."

CYNDI IN THE PARK WITH GIRLS Proudly displaying her true colors with her wacky wardrobe and madcap makeup, Lauper called herself "a fashion maven, that's what I am."

Cyndi LAUPER

A loopy, lovable misfit, she bopped till she dropped

Decked out in flea-market fashions of fluorescent magenta and orange, this ditzy Betty Boop with a four-octave range preached a romantic yet sturdy feminist message. The childlike New Yorker hit it big in her 30s (coy about her age, she once asked, "What am I, a car?"). After overcoming major throat problems, she scored eight Top 10 singles in the decade, including "Girls Just Want to Have Fun," "Time After Time" and the theme song for *The Goonies*.

A music-video pioneer and MTV mainstay with a curious love for pro wrestling, Lauper didn't translate to the big screen when she played a screwball hairdresser opposite Jeff Goldblum in 1988's *Vibes*. She married actor David Thornton in 1991, in a ceremony officiated by Little Richard, and later became a fortysomething mom.

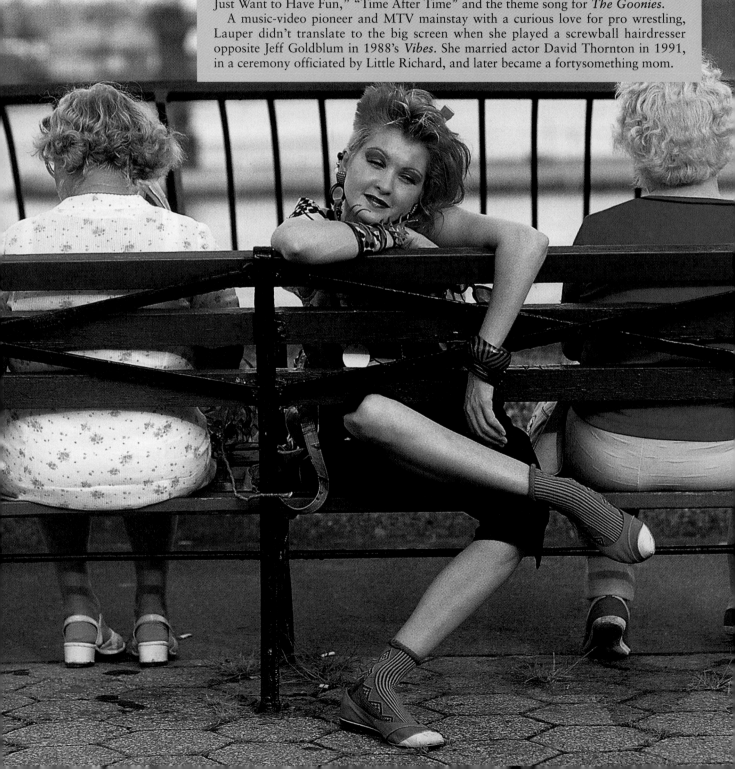

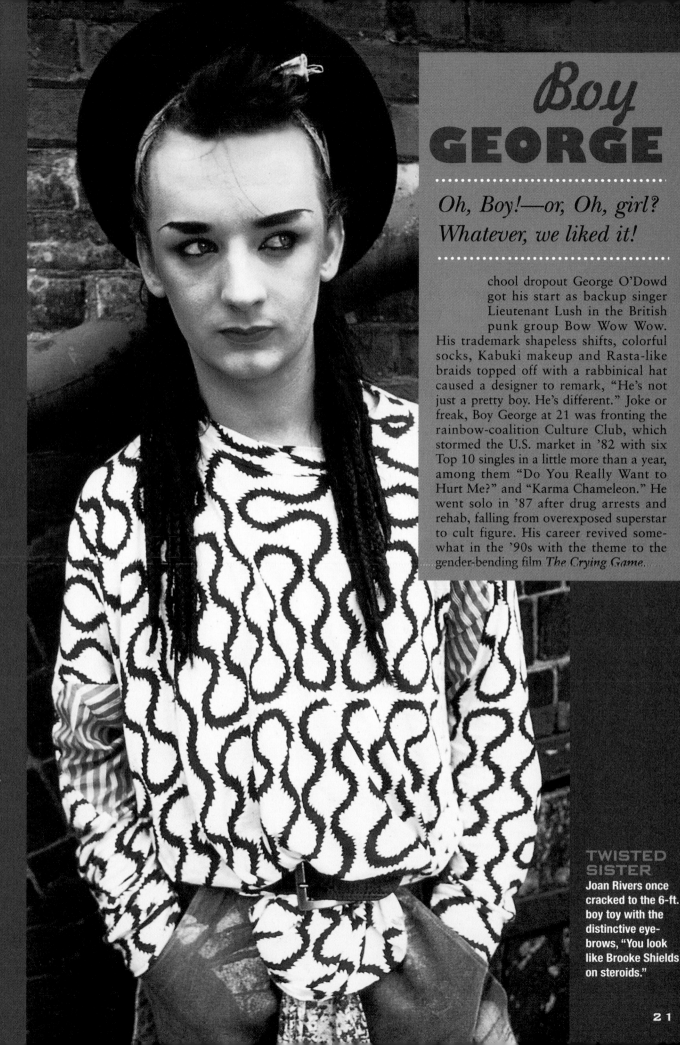

Boy GEORGE

Oh, Boy!—or, Oh, girl? Whatever, we liked it!

chool dropout George O'Dowd got his start as backup singer Lieutenant Lush in the British punk group Bow Wow Wow. His trademark shapeless shifts, colorful socks, Kabuki makeup and Rasta-like braids topped off with a rabbinical hat caused a designer to remark, "He's not just a pretty boy. He's different." Joke or freak, Boy George at 21 was fronting the rainbow-coalition Culture Club, which stormed the U.S. market in '82 with six Top 10 singles in a little more than a year, among them "Do You Really Want to Hurt Me?" and "Karma Chameleon." He went solo in '87 after drug arrests and rehab, falling from overexposed superstar to cult figure. His career revived somewhat in the '90s with the theme to the gender-bending film *The Crying Game.*

TWISTED SISTER
Joan Rivers once cracked to the 6-ft. boy toy with the distinctive eyebrows, "You look like Brooke Shields on steroids."

21

Yoda

Cool way! Backwards to talk taught us did he

He's not your standard matinee idol: his ears are bigger than Clark Gable's, he's shorter than Danny DeVito, he has more wrinkles than Katharine Hepburn ... he's even older than Joan Rivers. But when the scaly, 900-something Jedi Master hit the big screen as Mark Hamill's gnomic guru in 1980's smash hit *The Empire Strikes Back* (second in George Lucas's *Star Wars* series), Yoda stole the show and snagged a PEOPLE cover story. Yoda's alter ego was Frank Oz, the longtime Muppet-meister who was also the spirit moving another movie star of the early '80s: Miss Piggy.

LUKE'S COOL HANDLER Yoda's vital stats: he's 26 inches tall; six different models were used in filming; his eyes were modeled after Albert Einstein's.

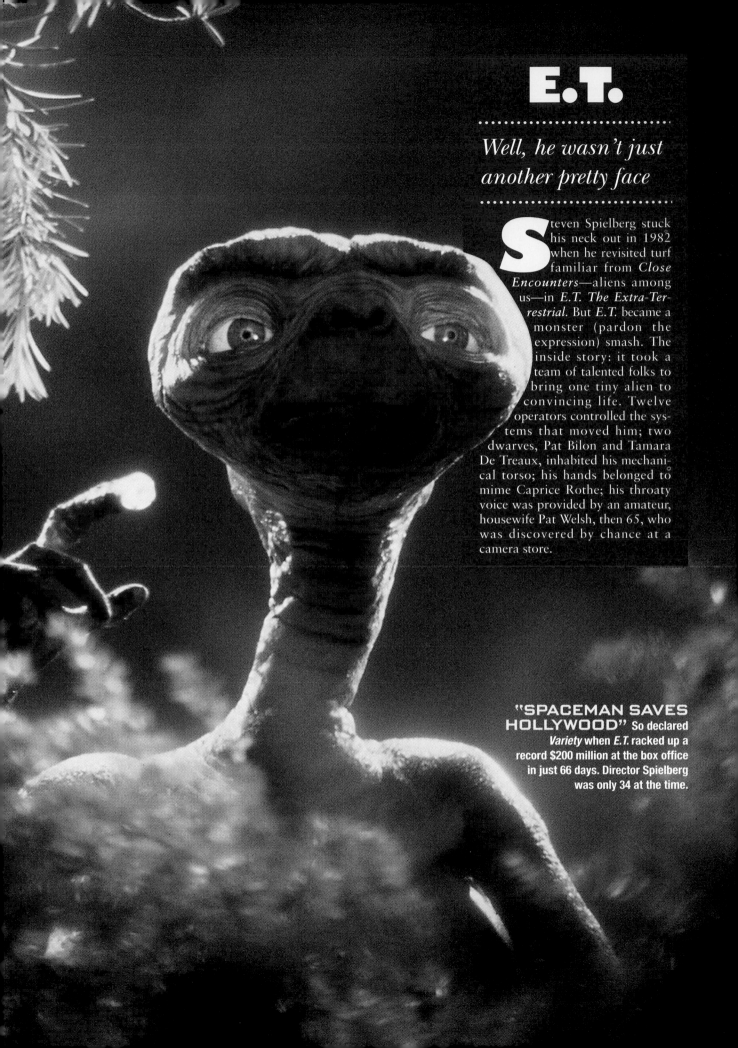

E.T.

Well, he wasn't just another pretty face

Steven Spielberg stuck his neck out in 1982 when he revisited turf familiar from *Close Encounters*—aliens among us—in *E.T. The Extra-Terrestrial*. But *E.T.* became a monster (pardon the expression) smash. The inside story: it took a team of talented folks to bring one tiny alien to convincing life. Twelve operators controlled the systems that moved him; two dwarves, Pat Bilon and Tamara De Treaux, inhabited his mechanical torso; his hands belonged to mime Caprice Rothe; his throaty voice was provided by an amateur, housewife Pat Welsh, then 65, who was discovered by chance at a camera store.

"SPACEMAN SAVES HOLLYWOOD" So declared *Variety* when *E.T.* racked up a record $200 million at the box office in just 66 days. Director Spielberg was only 34 at the time.

Richard GERE

*Hello, handsome—
and hello, Dalai*

How exactly does one acquire the smoldering intensity that marks the authentic Hollywood hunk? According to Richard Gere's older sister Susan, the secret is an early start: "If you looked at his baby pictures, you would see that he was brooding at the age of 2." Bursting onto the screen (and out of his shirt) in 1980's *American Gigolo,* Gere first dazzled us as pure beefcake, then proved he could act in such films as *An Officer and a Gentleman.* By the end of the decade, he was surprising us as an activist, ardently embracing Buddhism and championing the cause of the Dalai Llama and the oppressed people of Tibet.

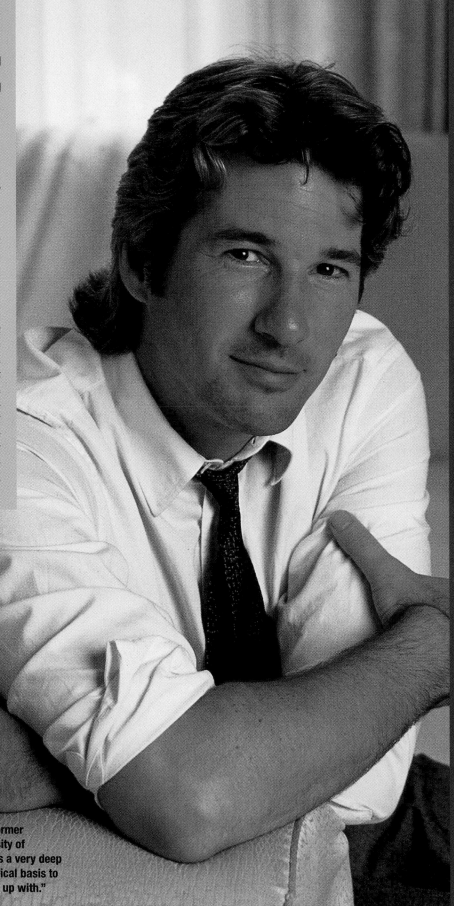

WANT TIBET? The former philosophy major at the University of Massachusetts argued, "There's a very deep and strict philosophical and logical basis to the system that [Buddha] came up with."

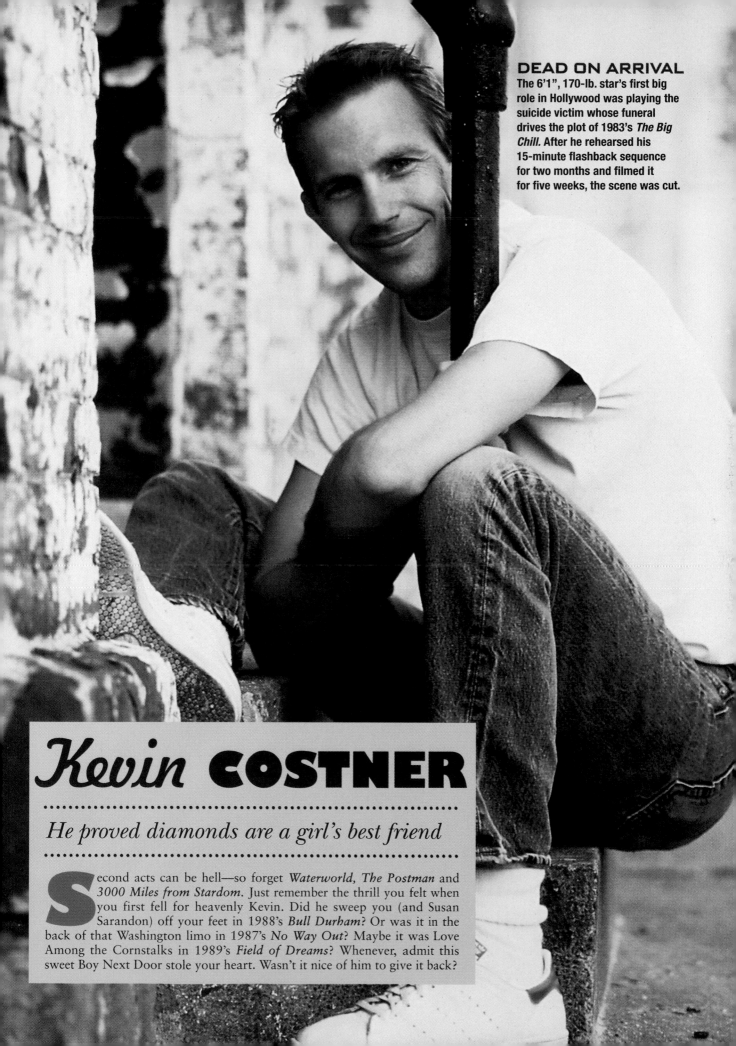

DEAD ON ARRIVAL
The 6'1", 170-lb. star's first big role in Hollywood was playing the suicide victim whose funeral drives the plot of 1983's *The Big Chill.* After he rehearsed his 15-minute flashback sequence for two months and filmed it for five weeks, the scene was cut.

Kevin COSTNER

He proved diamonds are a girl's best friend

Second acts can be hell—so forget *Waterworld, The Postman* and *3000 Miles from Stardom.* Just remember the thrill you felt when you first fell for heavenly Kevin. Did he sweep you (and Susan Sarandon) off your feet in 1988's *Bull Durham*? Or was it in the back of that Washington limo in 1987's *No Way Out*? Maybe it was Love Among the Cornstalks in 1989's *Field of Dreams*? Whenever, admit this sweet Boy Next Door stole your heart. Wasn't it nice of him to give it back?

"I PITY THE FOOL!" Mr. T's appeal is based on a wink: we know his bluster and brag conceal a heart of gold. Now 48, he's doing commercials and cameos while he battles his toughest foe: lymphoma.

Mr. T

He huffed and he puffed—and we loved it

Lawrence Tureaud—Mr. T to you—always claimed, "God did it all!" But his rise from a Chicago ghetto to Hollywood glory proves his own grit. One of 12 children abandoned by their father, he dubbed himself "Mr. T, the world's greatest bodyguard" at age 22, and soon had a celebrity clientele. After playing Sly Stallone's nemesis Clubber Lang in 1982's *Rocky III*, Mr T mouthed and Mohawked his way through five seasons on NBC's hit *The A-Team*. "I could play Hamlet, even though I look like King Kong," he told PEOPLE.

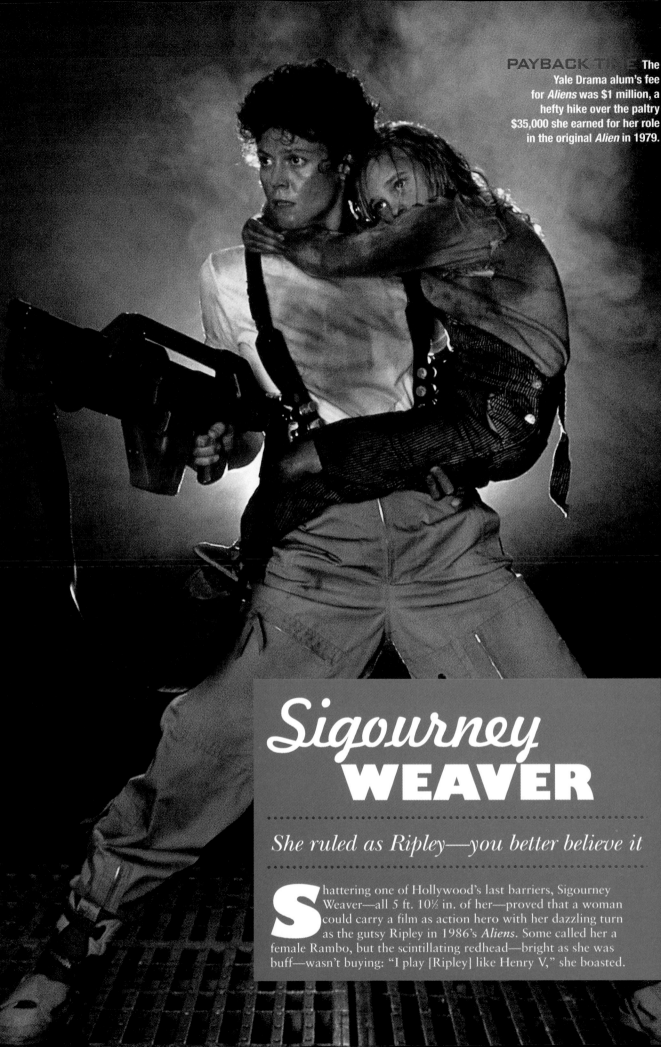

PAYBACK TIME The Yale Drama alum's fee for *Aliens* was $1 million, a hefty hike over the paltry $35,000 she earned for her role in the original *Alien* in 1979.

Sigourney WEAVER

She ruled as Ripley—you better believe it

Shattering one of Hollywood's last barriers, Sigourney Weaver—all 5 ft. 10½ in. of her—proved that a woman could carry a film as action hero with her dazzling turn as the gutsy Ripley in 1986's *Aliens*. Some called her a female Rambo, but the scintillating redhead—bright as she was buff—wasn't buying: "I play [Ripley] like Henry V," she boasted.

MEMBERS ONLY Left to right, alienated teens Nelson, Estevez, Sheedy, Ringwald and Hall spent a Saturday in high school detention for John Hughes's trend-setting 1985 hit, *The Breakfast Club*.

The Brat PACK

A flock of fresh faces put the kid's scene onscreen

They were young, attractive and, for a little while, the hottest faces in Hollywood, thanks to movies like *The Breakfast Club* and *St. Elmo's Fire*. They also brought plenty of attitude along with their high-profile publicity pros. Dubbed the Brat Pack, this cohort of tyros included Emilio Estevez, Rob Lowe, Andrew McCarthy, Mare Winningham, Judd Nelson, Ally Sheedy, Demi Moore and Anthony Michael Hall. While Tom Cruise, Nicolas Cage and Sean Penn emerged from the Brat Pack's ranks to become enduring stars, most of the gang failed to sustain the buzz. "You can be hot and be a shamelessly poor actor," admitted Nelson. "It's such a strange thing, to try and build a career on this heat."

BURNING BRIGHT
Clockwise from top right, Lowe, McCarthy, Winningham, Nelson, Sheedy, Estevez and Moore faced adulthood in 1985's *St. Elmo's Fire,* directed by Joel Schumacher.

SISTER OF THE BRIDE
Awkward Molly Ringwald longed for hunky dreamboat Michael Schoeffling in the high school comedy-drama *Sixteen Candles*.

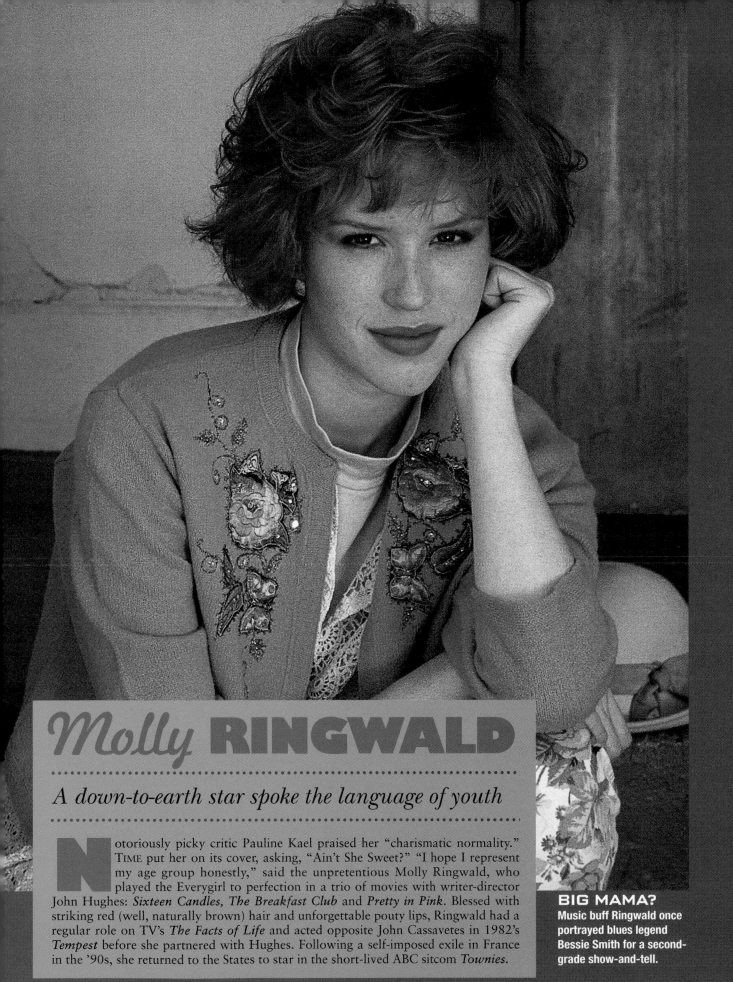

Molly RINGWALD

A down-to-earth star spoke the language of youth

Notoriously picky critic Pauline Kael praised her "charismatic normality." TIME put her on its cover, asking, "Ain't She Sweet?" "I hope I represent my age group honestly," said the unpretentious Molly Ringwald, who played the Everygirl to perfection in a trio of movies with writer-director John Hughes: *Sixteen Candles, The Breakfast Club* and *Pretty in Pink*. Blessed with striking red (well, naturally brown) hair and unforgettable pouty lips, Ringwald had a regular role on TV's *The Facts of Life* and acted opposite John Cassavetes in 1982's *Tempest* before she partnered with Hughes. Following a self-imposed exile in France in the '90s, she returned to the States to star in the short-lived ABC sitcom *Townies*.

BIG MAMA?
Music buff Ringwald once portrayed blues legend Bessie Smith for a second-grade show-and-tell.

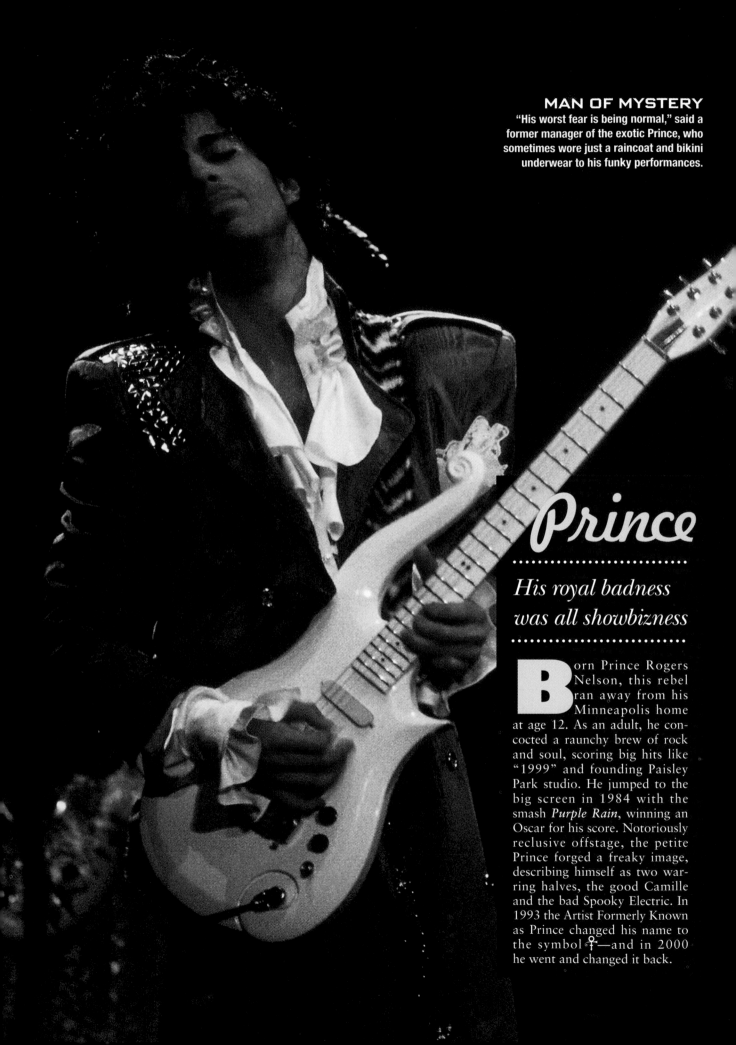

MAN OF MYSTERY
"His worst fear is being normal," said a former manager of the exotic Prince, who sometimes wore just a raincoat and bikini underwear to his funky performances.

Prince

*His royal badness
was all showbizness*

Born Prince Rogers Nelson, this rebel ran away from his Minneapolis home at age 12. As an adult, he concocted a raunchy brew of rock and soul, scoring big hits like "1999" and founding Paisley Park studio. He jumped to the big screen in 1984 with the smash *Purple Rain*, winning an Oscar for his score. Notoriously reclusive offstage, the petite Prince forged a freaky image, describing himself as two warring halves, the good Camille and the bad Spooky Electric. In 1993 the Artist Formerly Known as Prince changed his name to the symbol ⚦—and in 2000 he went and changed it back.

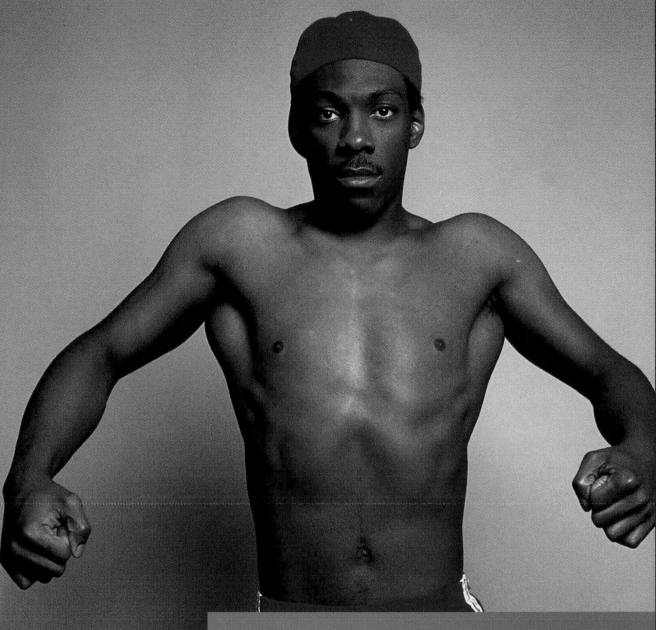

Eddie MURPHY

At the multiplex, box office muscle he did flex

PUMP IT UP

The former teenage standup comic said, "I don't want people to say a few years from now, 'Whatever happened to Eddie Murphy?'" Not much chance of that, with his first seven movies grossing more than $1 billion before he turned 30. He also collaborated with funkmaster Rick James on a 1985 hit record.

From rubbery Gumby skits on *Saturday Night Live* to big-screen superstardom in 1982's *48 HRS.*, Long Island native Murphy was the undisputed king of '80s bad-boy comedy. The *Beverly Hills Cop* franchise solidified Murphy's status as one of the hottest names in Hollywood. But he closed out the decade on a sour note, making his directorial debut in the disappointing *Harlem Nights*, a 1930s gangster yarn, reportedly clashing with co-star and idol Richard Pryor during filming. His potty-mouthed, streetwise public image—which sparked accusations of woman hating and gay bashing—was at odds with his private self. "I'm very prudish," claimed Murphy, who eventually settled down to family life.

Indiana JONES

He made us wish there was a Ford in our future

Part of it was the hat: Who knew a fedora could be so sexy? Part of it was the whip—retro cool. Part of it was that memorable first name, snitched from George Lucas's malamute. But mostly it was the man: Harrison Ford was terrific as Han Solo in Lucas's 1977 *Star Wars*, but when he marched onscreen as Indiana Jones in *Raiders of the Lost Ark*, the result was popcorn nirvana. Co-creators Steven Spielberg and Lucas called on all their love of old-time movies to craft this 1981 hit, still the best Saturday-afternoon feature ever made. As for the hat, it was given to the Smithsonian in 1989—a good fit for an American classic.

HAT TRICKS The movies' greatest-ever box office draw, Ford is the master of three-parters, starring in the first three *Star Wars* films and three Indiana Jones adventures. And he's done two stints as Tom Clancy's CIA spook, Jack Ryan.

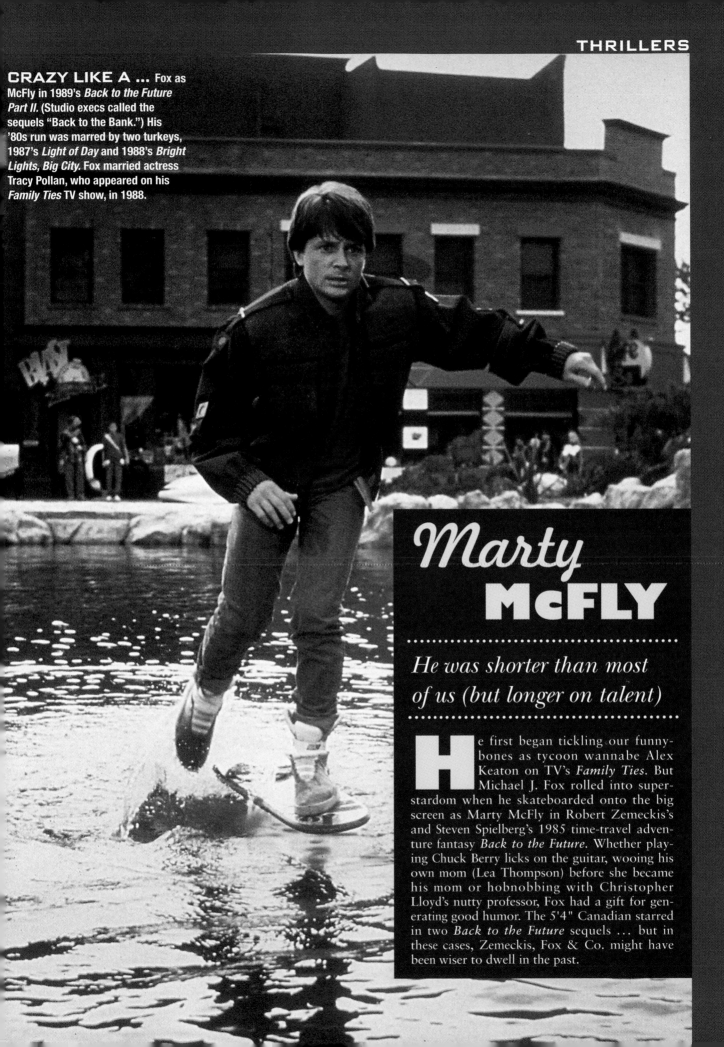

CRAZY LIKE A ... Fox as McFly in 1989's *Back to the Future Part II*. (Studio execs called the sequels "Back to the Bank.") His '80s run was marred by two turkeys, 1987's *Light of Day* and 1988's *Bright Lights, Big City*. Fox married actress Tracy Pollan, who appeared on his *Family Ties* TV show, in 1988.

Marty McFLY

He was shorter than most of us (but longer on talent)

He first began tickling our funny-bones as tycoon wannabe Alex Keaton on TV's *Family Ties*. But Michael J. Fox rolled into super-stardom when he skateboarded onto the big screen as Marty McFly in Robert Zemeckis's and Steven Spielberg's 1985 time-travel adventure fantasy *Back to the Future*. Whether playing Chuck Berry licks on the guitar, wooing his own mom (Lea Thompson) before she became his mom or hobnobbing with Christopher Lloyd's nutty professor, Fox had a gift for generating good humor. The 5'4" Canadian starred in two *Back to the Future* sequels ... but in these cases, Zemeckis, Fox & Co. might have been wiser to dwell in the past.

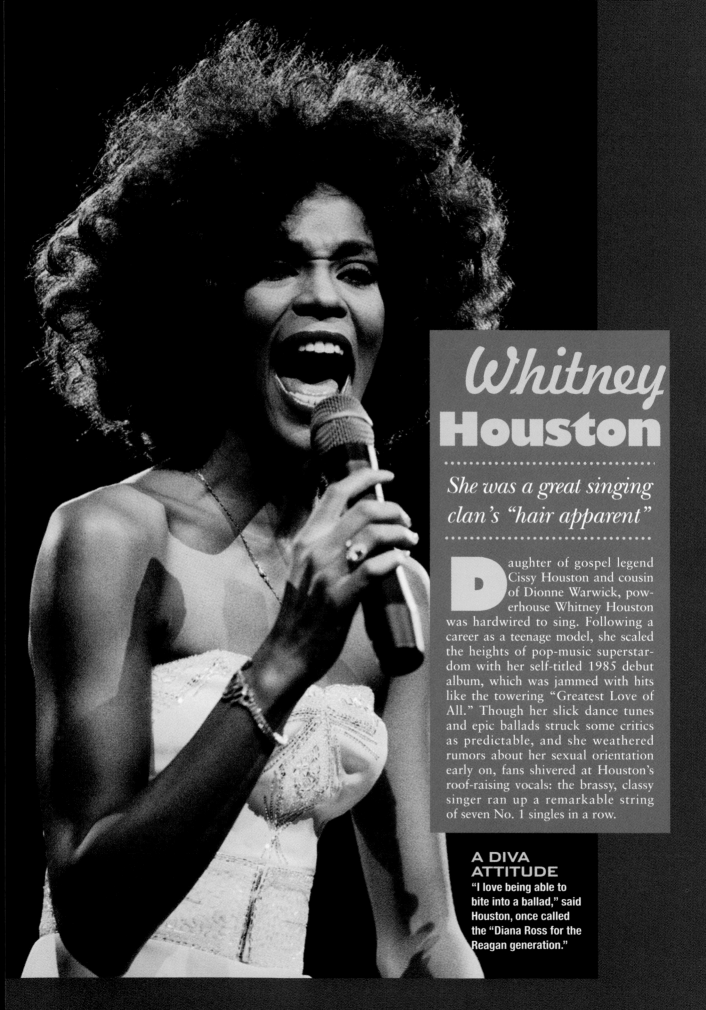

Whitney Houston

She was a great singing clan's "hair apparent"

Daughter of gospel legend Cissy Houston and cousin of Dionne Warwick, powerhouse Whitney Houston was hardwired to sing. Following a career as a teenage model, she scaled the heights of pop-music superstardom with her self-titled 1985 debut album, which was jammed with hits like the towering "Greatest Love of All." Though her slick dance tunes and epic ballads struck some critics as predictable, and she weathered rumors about her sexual orientation early on, fans shivered at Houston's roof-raising vocals: the brassy, classy singer ran up a remarkable string of seven No. 1 singles in a row.

A DIVA ATTITUDE

"I love being able to bite into a ballad," said Houston, once called the "Diana Ross for the Reagan generation."

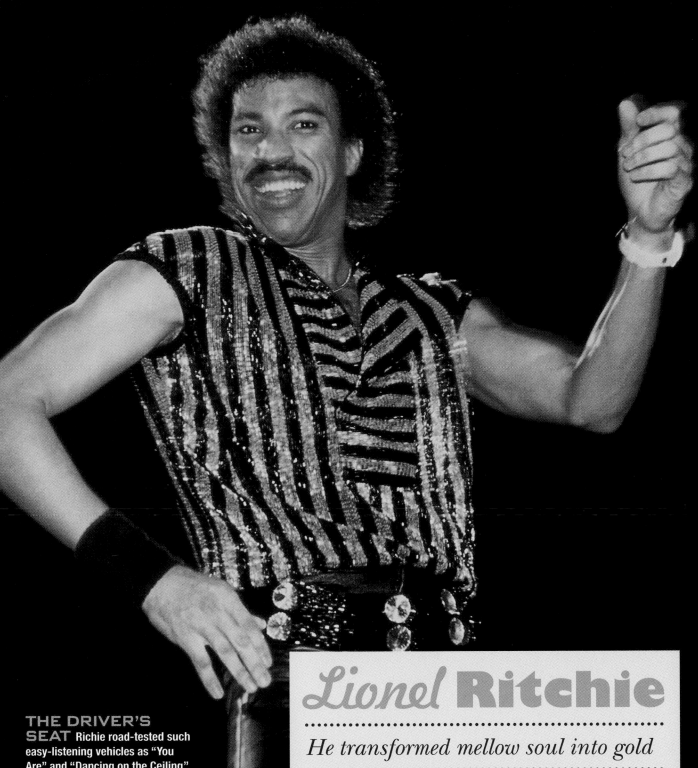

THE DRIVER'S SEAT Richie road-tested such easy-listening vehicles as "You Are" and "Dancing on the Ceiling" while driving the Pacific Coast Highway in his luxury car.

Lionel Ritchie

He transformed mellow soul into gold

Alabama-born Lionel Ritchie, who studied economics in college, first displayed his tuneful gifts with the Commodores, crooning squeeze-me ballads like "Three Times a Lady" and "Easy." Going solo in '81, he became a dependable hit machine, churning out such soothing standards as "Hello" and "Truly." Ritchie also produced Kenny Rogers' "Lady," teamed with Diana Ross on "Endless Love," co-wrote "We Are the World" with Michael Jackson and won an Oscar for "Say You, Say Me," from 1985's *White Nights*.

SAMURAI
SWASHBUCKLER
Chamberlain, who looked
kingly in his *Shogun* kimono,
claimed he felt out of place in
contemporary roles. "Without
costumes, I felt naked," he said
of his 1988 role as the modern-day
amnesiac in Robert Ludlum's
TV thriller *The Bourne Identity.*

Richard CHAMBERLAIN

Trading scalpel for sword, he mastered the miniseries

After sharpening his acting chops in London, the former Dr. Kildare traded his '60s scrubs for period costumes. In the '70s this impossibly handsome drama king, an L.A. native, broke hearts as dreamy Aramis in *The Three Musketeers.* Soon he was the costumed colossus of several blockbuster miniseries: He played the lusty priest in *The Thorn Birds,* the seaman shipwrecked in Japan in *Shogun,* the courageous diplomat in *Wallenberg.* Although he once claimed disdain for short sleeves, the spiritual Chamberlain, 77 in 2001, heeded his guru and moved to tropical Hawaii, where the big event of his day is "watching the sunset."

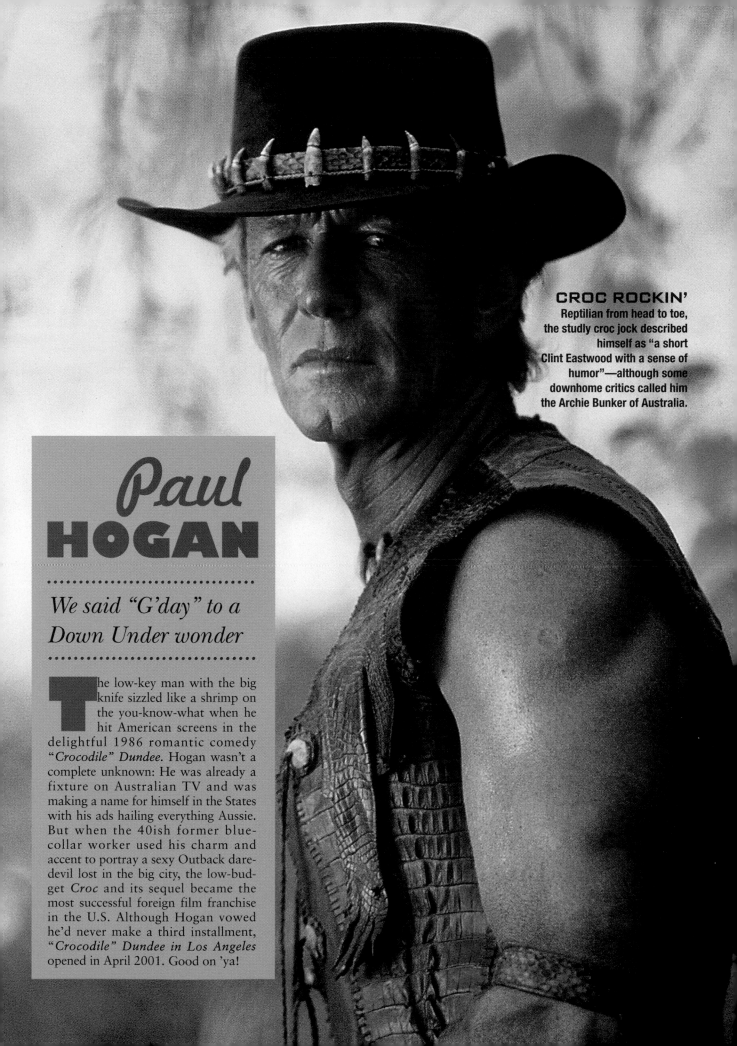

CROC ROCKIN'
Reptilian from head to toe, the studly croc jock described himself as "a short Clint Eastwood with a sense of humor"—although some downhome critics called him the Archie Bunker of Australia.

Paul HOGAN

We said "G'day" to a Down Under wonder

The low-key man with the big knife sizzled like a shrimp on the you-know-what when he hit American screens in the delightful 1986 romantic comedy *"Crocodile" Dundee.* Hogan wasn't a complete unknown: He was already a fixture on Australian TV and was making a name for himself in the States with his ads hailing everything Aussie. But when the 40ish former blue-collar worker used his charm and accent to portray a sexy Outback daredevil lost in the big city, the low-budget *Croc* and its sequel became the most successful foreign film franchise in the U.S. Although Hogan vowed he'd never make a third installment, *"Crocodile" Dundee in Los Angeles* opened in April 2001. Good on 'ya!

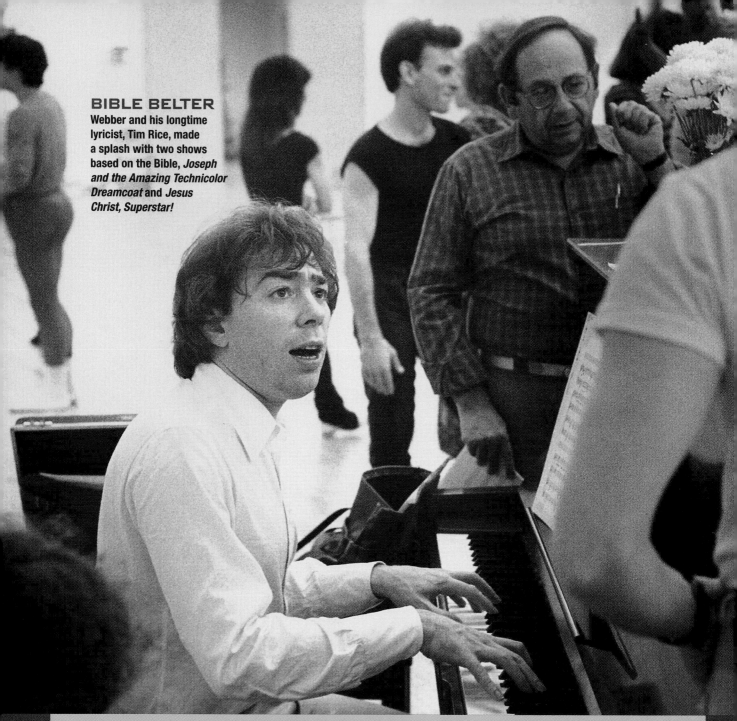

BIBLE BELTER
Webber and his longtime lyricist, Tim Rice, made a splash with two shows based on the Bible, *Joseph and the Amazing Technicolor Dreamcoat* and *Jesus Christ, Superstar!*

Andrew Lloyd WEBBER

His songs turned The Music of the Night *into* The Sound of Money

Ou might not take our word for it—so lend an ear, dear, to the august *Times* of London, which decreed in 1989, "The 1980s have been the most triumphant decade in the history of the British musical theatre, at home and abroad." Right you are, guv'nor! And the man leading the '80s British Invasion was Andrew Lloyd Webber, crafter of memorable melodies, mastermind of splendid stage spectacles, husband of star soprano Sarah Brightman (well, up until 1990)—and rich, rich, rich. With lyricist Tim Rice, Lloyd Webber first struck a nerve in the '70s: *Jesus Christ, Superstar* (1971) proved rock and Broadway could mix, and 1978's *Evita* left us (and Argentina) crying. The '80s were better: 1981's rollicking *Cats* made audiences purr (it ran for almost 20 years on Broadway); Webber topped it with his haunting 1988 *Phantom of the Opera*—still running.

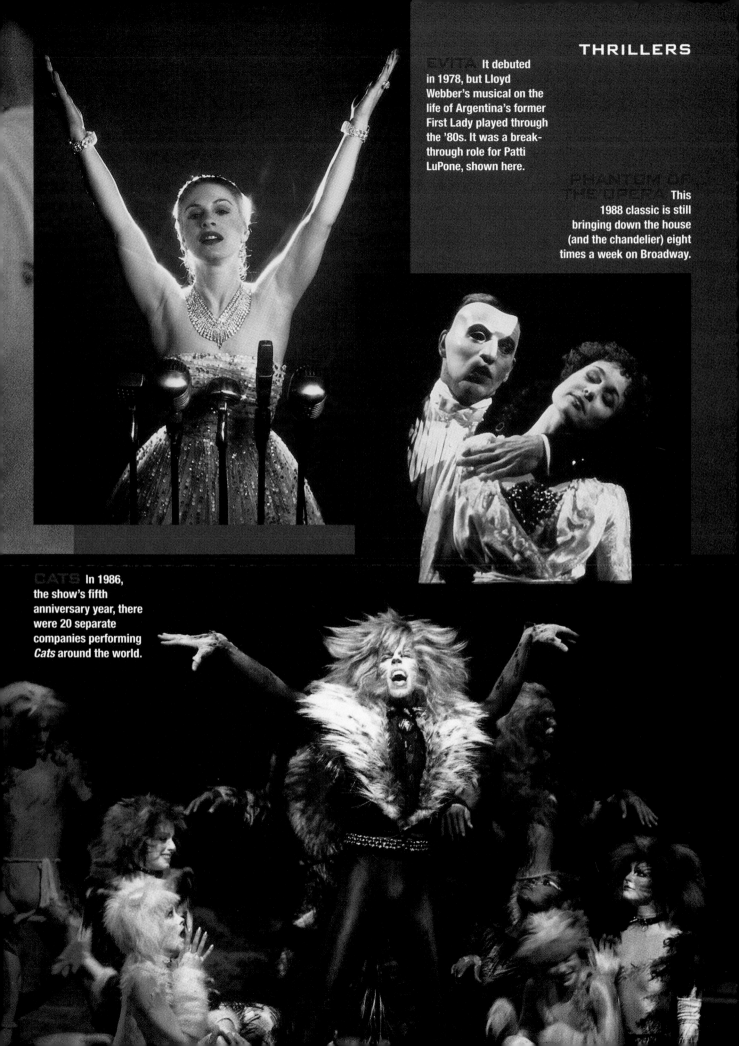

EVITA It debuted in 1978, but Lloyd Webber's musical on the life of Argentina's former First Lady played through the '80s. It was a breakthrough role for Patti LuPone, shown here.

PHANTOM OF THE OPERA This 1988 classic is still bringing down the house (and the chandelier) eight times a week on Broadway.

CATS In 1986, the show's fifth anniversary year, there were 20 separate companies performing *Cats* around the world.

Once Upon a Tiara

A ROYAL WEDDING
AND TEARS OF JOY
IN ENGLAND; A
ROYAL FUNERAL
AND TEARS OF
SORROW IN MONACO

Charles & Diana

Their nuptials entranced the world

Not so very long ago, and not so very far away, in a green and glorious kingdom by the sea, a thoughtful prince, heir to the throne, searched long and hard before he found a suitable woman to be his princess and the future queen. She was beautiful and pure, and her blood was even bluer than his. But marriage is a fragile institution, even when it is so carefully arranged. Sadly, clouds settled over their land: They

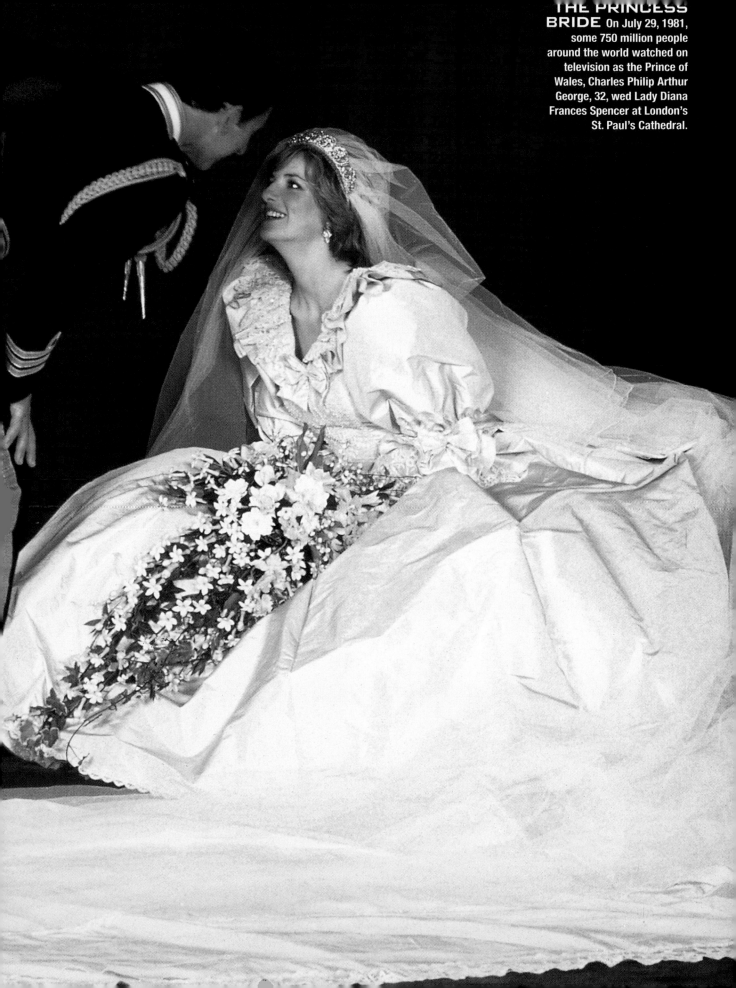

THE PRINCESS BRIDE On July 29, 1981, some 750 million people around the world watched on television as the Prince of Wales, Charles Philip Arthur George, 32, wed Lady Diana Frances Spencer at London's St. Paul's Cathedral.

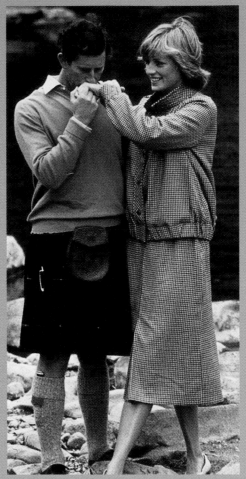
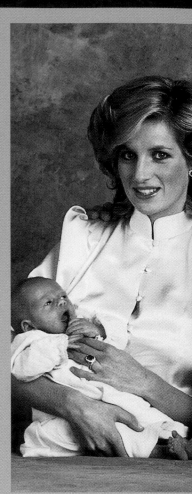

FROM SHUNNING TO STUNNING The shy kindergarten assistant, left, was all too revealing in a print skirt; when she posed for the press later at Balmoral Castle, she wore a plaid suit. In 1983 the family was completed with the addition of Henry Charles Albert David ("Harry"), younger brother of William Arthur Philip Louis ("Wills"). At far right, the Princess excelled at her public duties (here in Australia in 1988), but enjoyable personal moments like her 1985 White House dance with John Travolta were all too rare.

did not live happily ever after, and many hearts were broken. The romance of Charles, Prince of Wales and heir to British throne, and Lady Diana Spencer had all the qualities of a fairy tale—but reality intruded all too soon.

Diana Frances Spencer was born on July 1, 1961, the third daughter of the Earl Spencer (hence her title). Her family had been neighbors of the royal family at their country homes for many years; Charles's younger brother Andrew was Diana's childhood playmate, and Charles had dated Diana's older sister Sarah. As a schoolgirl, Diana kept Charles's picture above her bed, and once confessed to a friend, "I would love to be Princess of Wales." The prince first took notice of Diana when he was invited for a weekend at her family's estate in November 1977 (she was just 16, and he was 29). Charles's interest in Diana was further encouraged by a helpful suggestion from his grandmother, the Queen Mother, who knew of Diana's interest in him.

Diana left school early; by 19, she shared an apartment with three pals in a fashionable London neighborhood, taught kindergarten and lived the life of a Sloane Ranger—shopping, clubbing and looking for Mr. Right Pedigree. Soon enough, he called: Diana was invited to be a guest at the royal family's Balmoral Castle in Scotland, where

Charles was vacationing. In an eerie coincidence, Charles proposed to Diana just outside the garden of the estate of Camilla Parker Bowles—his once and future lover. Hopes were high in February 1981 when Buckingham Palace announced the engagement. "At the age of 19, you think you're prepared for everything," Diana said later.

Their wedding on July 29, 1981, captivated the world. It was the first opportunity since Queen Elizabeth's investiture in 1952 for the British royals to do what they do best: put on a show. Hundreds of thousands of people lined the route from Buckingham Palace to St. Paul's Cathedral, where an audience of 2,500 oohed and aahed at Diana's off-white silk taffeta dress and its 25-foot train. Her veil was held in place by the Spencer family tiara; she carried a bouquet of gardenias, lilies of the valley, white freesia, golden roses, white orchids and stephanotis. Diana was attended by five bridesmaids; in lieu of a best man, Charles's two brothers served as his "supporters," following a royal custom. When the newlyweds rode in an open carriage to a grand reception at Buckingham Palace, a hand-lettered sign on its rear boasted, "Just Married."

There was joy in the kingdom—and more joy, when, less than a year after their spectacular wedding, a 41-gun

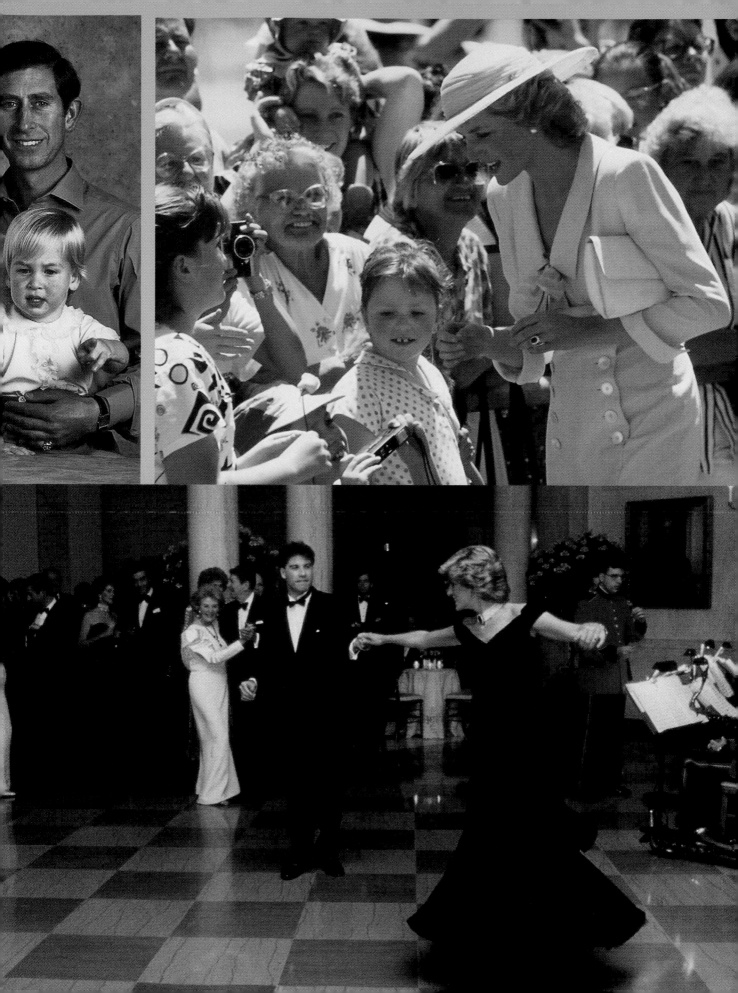

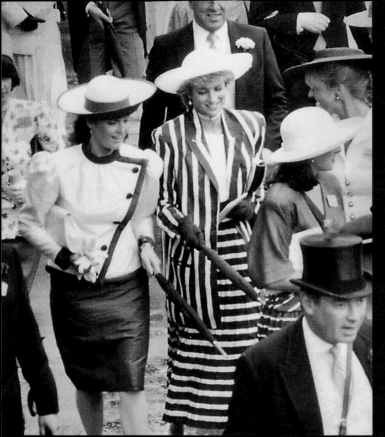

MERRY WIVES OF WINDSOR Fergie and Di, best of friends in 1987, enjoyed a giggle while strolling at Ascot and trying to catch an acquaintance's attention with their "brollies."

salute greeted the announcement of the birth of William, the first royal heir apparent born in a hospital instead of a palace. Charles, who was present at the birth, joked that the young prince "has the good fortune not to look like me." Just 24 hours later, Diana took her son home to their renovated apartments on three floors of Kensington Palace; a country place, Highgrove House, awaited in Gloucestershire. Two years later, a second son, Harry, was born. Both parents were relatively involved (aided by a child-care staff of three) in their sons' upbringing, trying perhaps to right some wrongs from their own pasts: Charles had suffered a lonely childhood, and Diana had been scarred by her parents' divorce. Together they shook the mothballs out of the stiff-upper-lip tradition of British royal child rearing.

From the moment her engagement was announced, the inexperienced "Shy Di" had a love-hate relationship with the press. She resented the constant scrutiny, especially after William's birth. When Charles and Diana attempted to enjoy a skiing vacation in the Alps in 1983, she defied the paparazzi by covering her photogenic face with her gloves. Charles, a veteran at dealing with the press, offered his wife no support. Instead, he was heard to tell her, "Please, Diana, don't do that. You're being stupid."

It was a rare misstep: Soon Diana matured into the most popular member of the royal family, delighting the public with her refreshing lack of reserve. Her imperfections only served to humanize her—she couldn't stop biting her fingernails, she was obsessively neat, she boasted she was "thick as a plank." Secretly, she suffered from the eating disorder bulimia. At times she seemed depressed; years later she acknowledged halfhearted suicide attempts. In fact, Diana was plagued by her deteriorating, unhappy

marriage. To many the marital breakdown was no surprise. In addition to their large age gap, the two had little in common. He liked polo, opera, meditation, the cello; she liked shopping, pop music, dancing and chatting.

Rumors of divorce surfaced in 1985, then faded in 1986 when the couple seemed to have come to an understanding to pursue "separate lives." But again in 1987 the tabloids drummed the "Can This Marriage Be Saved?" beat, while the couple looked increasingly estranged at their joint appearances. "I had tremendous hopes in my heart," Diana said of the marriage, but as it turned out, Charles's heart may always have belonged to Camilla. By the time the royal couple officially separated in 1992, Diana had developed her own roving eye. After Charles admitted in 1994 in a BBC television program that he had committed adultery, the once unthinkable divorce was inevitable.

Stripped of the title Her Royal Highness and sent off with a $26 million settlement in 1996, Diana continued to travel the world for causes dear to her, campaigning to ban land mines and reaching out to AIDS patients. Keeping her glamor without losing the common touch, she remained the public's favorite among the royal family.

And that is how a girl of noble birth met and married a prince, just as in the fairy tales. But her story has an unhappy ending: Princess Diana lost her prince and then met a fate so at odds with her radiant personality ... that we'll save it for another day. Goodnight, Diana. Goodnight, moon.

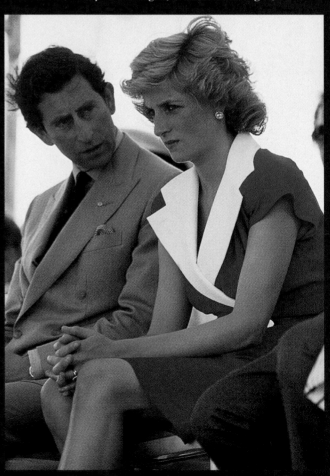

SCENE FROM A MARRIAGE By the end of the decade, the couple's body language revealed the tensions that were driving them apart, as in this trip to Australia in 1988.

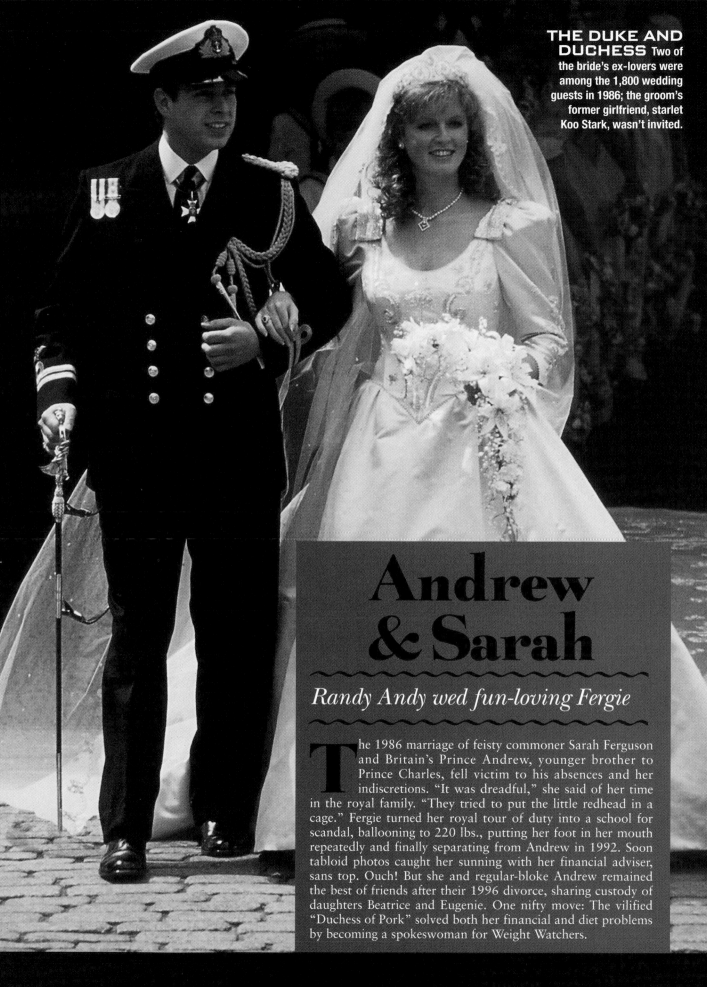

THE DUKE AND DUCHESS Two of the bride's ex-lovers were among the 1,800 wedding guests in 1986; the groom's former girlfriend, starlet Koo Stark, wasn't invited.

Andrew & Sarah

Randy Andy wed fun-loving Fergie

The 1986 marriage of feisty commoner Sarah Ferguson and Britain's Prince Andrew, younger brother to Prince Charles, fell victim to his absences and her indiscretions. "It was dreadful," she said of her time in the royal family. "They tried to put the little redhead in a cage." Fergie turned her royal tour of duty into a school for scandal, ballooning to 220 lbs., putting her foot in her mouth repeatedly and finally separating from Andrew in 1992. Soon tabloid photos caught her sunning with her financial adviser, sans top. Ouch! But she and regular-bloke Andrew remained the best of friends after their 1996 divorce, sharing custody of daughters Beatrice and Eugenie. One nifty move: The vilified "Duchess of Pork" solved both her financial and diet problems by becoming a spokeswoman for Weight Watchers.

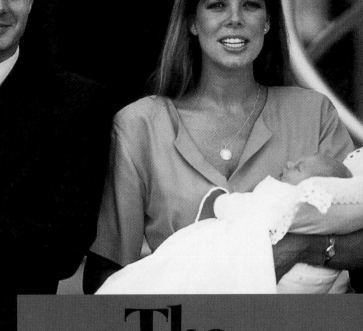

NOW WE ARE FIVE Princess Caroline and husband Stefano Casiraghi, holding daughter Charlotte, stood together at the baptism of son Pierre in 1987. Not pictured is oldest son Andrea.

PARTY GAL Princess Stephanie hit the slopes with Paul Belmondo, son of French star Jean-Paul Belmondo, in 1983.

The Grimaldis

The death of Princess Grace sent the world into mourning

Monaco's royal family was shattered when the serene Princess Grace was killed in a car crash in September 1983, after she apparently suffered a stroke while driving with daughter Stephanie. Her husband, Prince Rainier, was plunged into gloom that only time alleviated. After the embarrassment of her 1978 marriage to French playboy Philippe Junot, which lasted only 27 months, Princess Caroline wed wealthy Italian-born businessman Stefano Casiraghi late in 1983. Though three months' pregnant at the time, she settled into a life of stability and service to her country. Older brother Albert also worked hard at his royal duties and remained single, though he dated many eligible women. It was youngest daughter Stephanie who kept the tabloids busy. She dated playboys, race-car drivers, stars (Rob Lowe) and sons of stars (Paul Belmondo, Anthony Delon), modeled, released pop records, started a swimwear line, moved to Hollywood and otherwise acted, well, like a princess.

GOOD FRIENDS Prince Albert, heir to the throne of the vest-pocket principality, squired Brooke Shields in 1983.

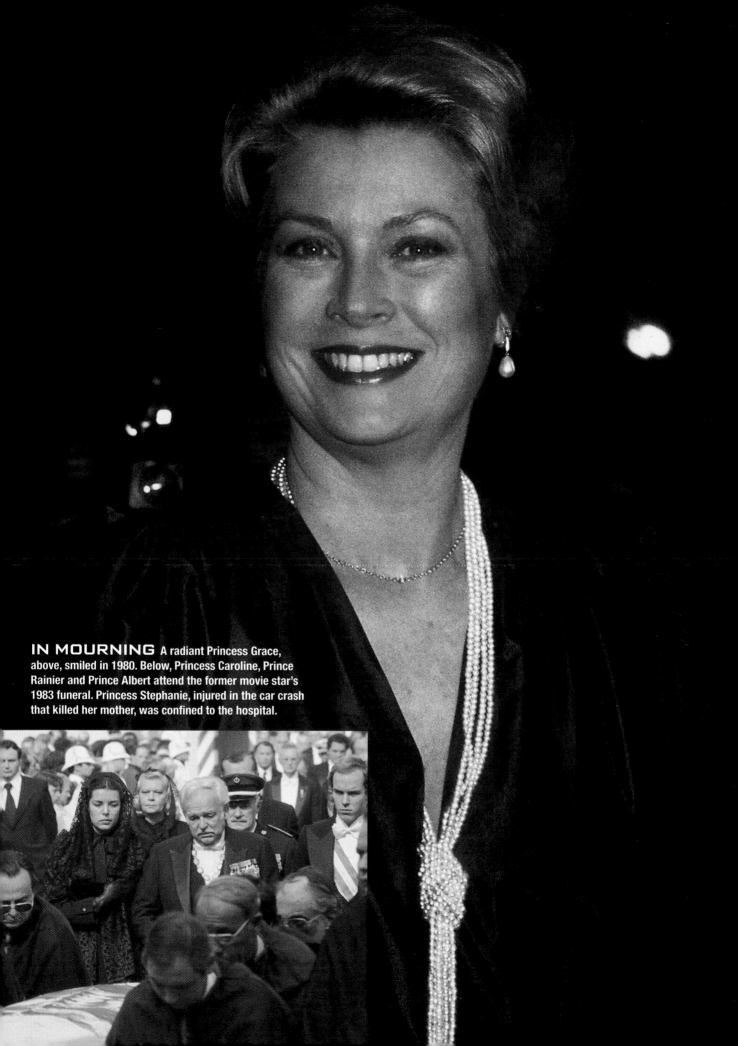

IN MOURNING A radiant Princess Grace, above, smiled in 1980. Below, Princess Caroline, Prince Rainier and Prince Albert attend the former movie star's 1983 funeral. Princess Stephanie, injured in the car crash that killed her mother, was confined to the hospital.

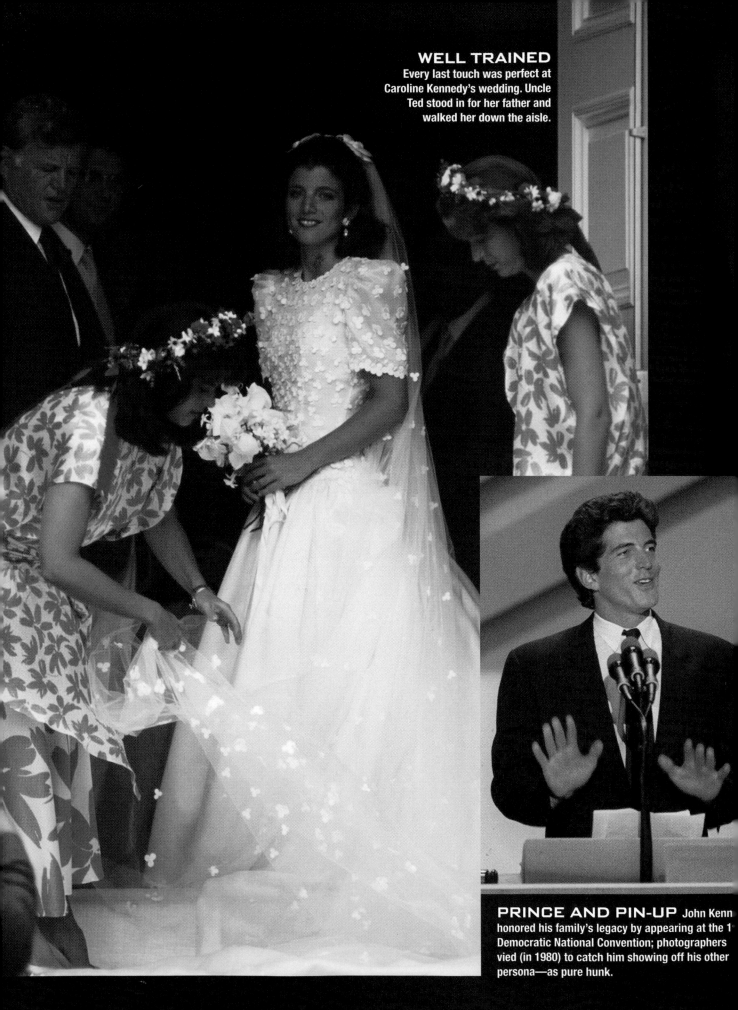

WELL TRAINED
Every last touch was perfect at Caroline Kennedy's wedding. Uncle Ted stood in for her father and walked her down the aisle.

PRINCE AND PIN-UP John Kenn honored his family's legacy by appearing at the 1 Democratic National Convention; photographers vied (in 1980) to catch him showing off his other persona—as pure hunk.

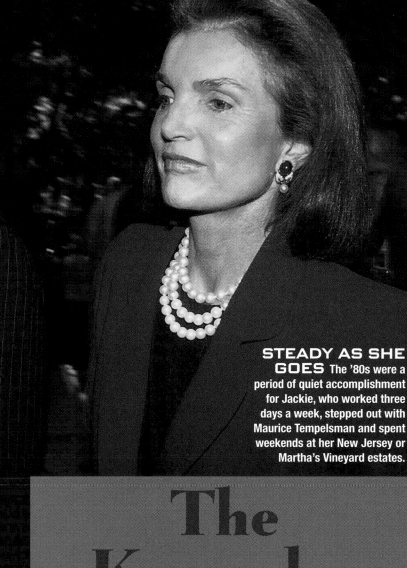

STEADY AS SHE GOES The '80s were a period of quiet accomplishment for Jackie, who worked three days a week, stepped out with Maurice Tempelsman and spent weekends at her New Jersey or Martha's Vineyard estates.

The Kennedys

Jackie jogged, and the kids were all right

The torch was passed to a new generation in the family of the late President John F. Kennedy in the 1980s, as Caroline and John Jr. spread their wings as young adults. Jacqueline Kennedy Onassis, 50 in 1980, prospered in her editor's job—bagging the rights to *Moonwalk,* Michael Jackson's autobiography—while she jogged, was active in New York City charities and often was seen on the arm of diamond mogul Maurice Tempelsman. At center stage, daughter Caroline completed her law degree at Columbia and married designer-artist Edwin Schlossberg in a beautiful Hyannis Port ceremony in 1986. When PEOPLE named John Kennedy Jr. Sexiest Man Alive (tough call!) in 1988, he was studying law at New York University, living on the city's Upper West Side and charming Manhattanites with his low-key jaunts: rollerblading in Central Park or enjoying a burger outdoors with girlfriend Christina Haag, an actress.

Born In T

HAPPY WARRIOR On the campaign trail in 1980, Reagan's buoyant optimism caught the emerging spirit of the '80s, as he vowed America's best days were ahead of it. In contrast, incumbent Jimmy Carter seemed mired in the dead-end days of the '70s; he saw a nation suffering from "malaise."

he U.★S.★A.★

AFTER 20 YEARS OF TURMOIL,
WE WALKED TALL AGAIN UNDER A
PRESIDENT WHO CONVINCED US
IT WAS "MORNING IN AMERICA"

Ronald Reagan

*He won the Presidency by turning
his story into America's story*

We called him the Great Communicator, but we should have been more specific: More than anything else, Ronald Reagan was a Great Storyteller. He got his start as a young Iowa sportscaster, sharing tales of Saturday-afternoon gridiron heroics with avid listeners—and making up plays when the ticker-tape accounts he followed broke down. He went to Hollywood and became the star of more stories—sagas of heroes like Notre Dame's George Gipp. He introduced yarns of the old West on TV's *Death Valley Days*, then crisscrossed the nation spinning optimistic accounts of corporate progress for General Electric. Interested in politics since his days with the Screen Actors Guild, he rode his conservative Midwestern views right into the governorship of

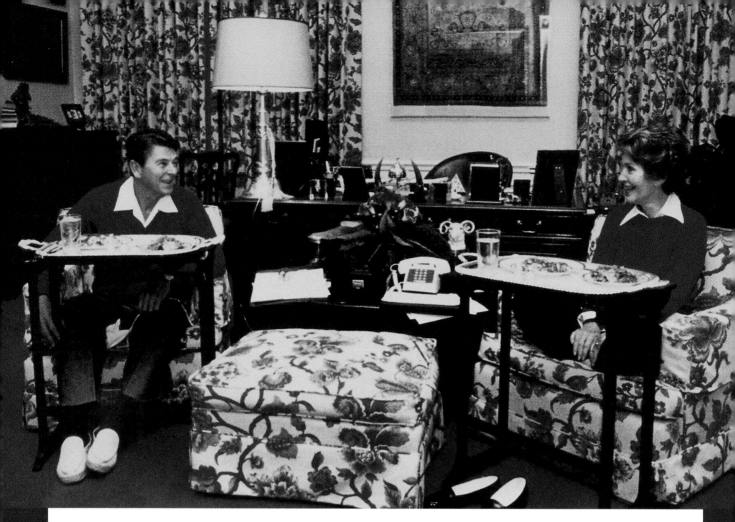

California. And by and by, he merged his own story with the story of his nation—so effectively that Americans twice voted him into the Oval Office.

There were—and are—those who say Ronald Reagan lived in a simplified, storybook world. They may be right, but they miss the point: It was his belief in his simple stories, paired with his skill at presenting them, that made him such a formidable politician.

Ronald Reagan's patriotism, his sympathy for big business, his hatred of communism (he called the Soviet

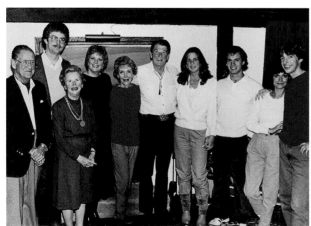

OUR GANG Thanksgiving at the Reagan ranch, 1984: from left, brother Neil, son-in-law Dennis Revell, Neil's wife Bess, daughter Maureen Revell, Nancy, Ron, daughter Patty Davis and husband Paul Grilley, son Ron Jr. and wife Doria.

TV DINNER! The Reagans enjoyed informal meals in the White House residence; they also loved to watch movies in the mansion's intimate theater. When possible, they visited their hideaway, Rancho del Cielo outside Santa Barbara, Calif.

Union "an evil empire"), his distrust of big government, defined the mood of the '80s. True, his personal life often clashed with his public posture: The proponent of family values had strained relations with his kids and was divorced from his first wife, actress Jane Wyman. The God-Bless-America Republican seldom went to church. But he had the rarest of political gifts: a grin-you-down, sunny demeanor that won him good friends (like Democratic speaker of the House Tip O'Neill), even among his political foes. Seriously wounded by a would-be assassin's bullet early in his Presidency, Reagan managed to get off a quip to the doctors—"Please tell me you're Republicans"—even as he was being wheeled into the emergency room. After surgery, he said to wife Nancy: "Honey, I forgot to duck." Some called him a dunce, but even the putdown that stuck described him as "an amiable dunce."

Reagan owed part of his success to his second wife, the former actress Nancy Davis. A petite, gracious—yet tough—lady, she helped engineer his rise to the top. It is Nancy who maintains the torch: Sadly, the man who became President at 69, symbolizing vigorous old age, revealed in 1994 that he was a victim of Alzheimer's. The tale of America's Great Storyteller deserved another ending—"happily ever after."

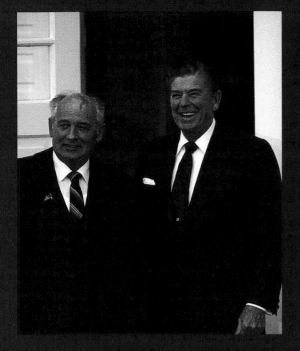

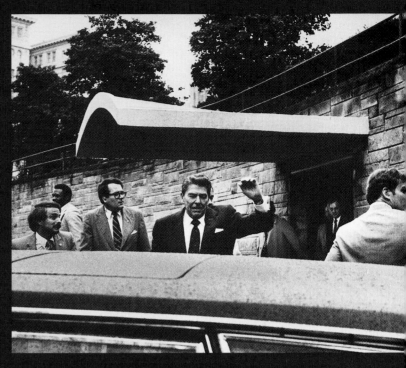

TOUGH TALK Reagan's outspoken anti-communism initially offended his counterpart Mikhail Gorbachev, but after a series of summit meetings like this 1986 talk in Iceland, they became more friendly.

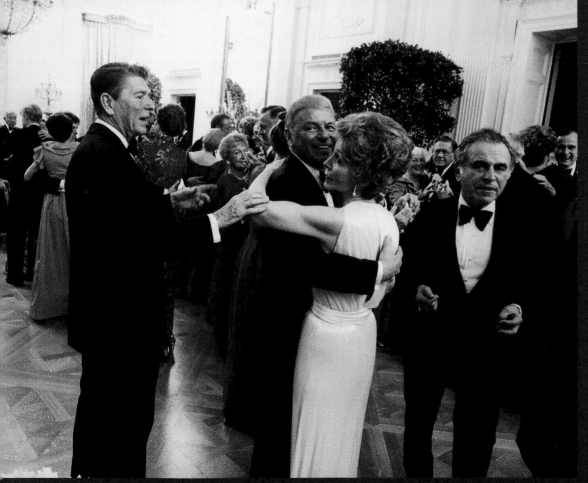

HIT After only two months in office, the President was seriously wounded by bullets fired by a disturbed man who claimed his goal was to impress actress Jodie Foster.

CUTTING IN The Reagans brought Hollywood pizzazz to the White House, though the President seems to be thinking that the D.C.–Beverly Hills relationship had become a little too close for comfort at this 1981 party.

U-S-A! Uncle Sam's kids put the Soviet pros on ice

★ ★ ★ ★ ★ ★ ★ ★ ★ ★ ★ ★ ★ ★ ★ ★ ★

Cold War politics put a damper on sports for a spell in the '80s: After the Soviet Union sent tanks rolling into Afghanistan in 1979, President Jimmy Carter announced the U.S. would boycott the Moscow Summer Games of 1980. The Soviets played tit-for-tat, holding their athletes back from the Los Angeles Summer Games in 1984. But the Cold War also provided one of the unforgettable moments of the '80s: the thrilling upset of the heavily favored (and highly paid) Soviet hockey team by a scrappy group of American underdogs, who won the gold at the 1980 Lake Placid, N.Y., winter games. If you don't remember this picture— you must be a child of the '90s!

YOUNG BLADES To make the U.S. triumph sweeter, the Soviet stars were coddled wards of the state, while the Yanks were mainly college kids.

U.S. HOCKEY TEAM

FALL OF THE BERLIN WALL

After 28 years, the wall came tumbling down

There was no more emblematic symbol of the Cold War than the wall put up in August 1961 to divide the Soviet sector of Berlin—still occupied 16 years after the end of World War II—from the sectors controlled by the U.S., Great Britain and France. Soviet bully-boy premier Nikita Khrushchev took a breather from baring his sole (and pounding his shoe) at the U.N. to order its construction. In 1963 President John F. Kennedy traveled to the city to declare his unity with Berliners; 24 years later, President Ronald Reagan stood next to it and dared his counterpart, "Mr. Gorbachev, tear down this wall." On Nov. 9, 1989, the wall came down at last, as East German officials took no steps to halt a flood of protesters who began to climb over—then destroy—the hated symbol of communism. It was a clear sign that the Cold War was history, and that the good guys had won.

The events that brought down the 28-mile-long wall began in Hungary, when officials allowed refugees to leave without visas. Soon the unrest spread to East Berlin and throughout the Soviet bloc in Eastern Europe.

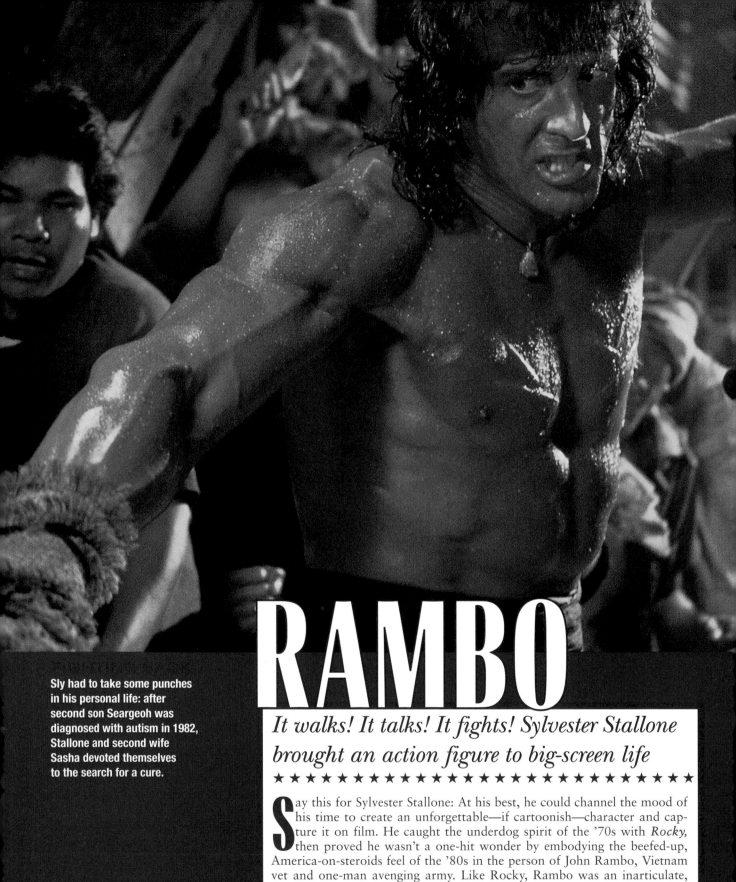

Sly had to take some punches
in his personal life: after
second son Seargeoh was
diagnosed with autism in 1982,
Stallone and second wife
Sasha devoted themselves
to the search for a cure.

RAMBO

*It walks! It talks! It fights! Sylvester Stallone
brought an action figure to big-screen life*

★ ★

S ay this for Sylvester Stallone: At his best, he could channel the mood of
his time to create an unforgettable—if cartoonish—character and cap-
ture it on film. He caught the underdog spirit of the '70s with *Rocky,*
then proved he wasn't a one-hit wonder by embodying the beefed-up,
America-on-steroids feel of the '80s in the person of John Rambo, Vietnam
vet and one-man avenging army. Like Rocky, Rambo was an inarticulate,
musclebound he-man; his triumphs against Cold War bad guys caught all of
Uncle Sam's swagger in the Reagan era. But in his personal life, Stallone
found the '80s rocky. When PEOPLE visited him in 1982, he was living with
second wife Sasha and their two boys, Sage and Seargeoh, in a bustling, pet-
filled Hollywood home. By 1988, he was a single, model-squiring stud, as
unreal as the celluloid heroes he played.

A hunk in trunks, he even made headbands macho

★ ★

For pro wrestlers, image building trumps body building—and even the primo grappler of the '80s didn't get it right at first. The 6'7" brawler who was born Terry Bollea tried on "Sterling Golden" and "Terry Boulder" for size (and even played bad guys) before inventing "Hulk Hogan." Like Mr. T, the Hulkster had his star spangled by Sly Stallone: Hogan starred as Thunderlips in 1982's *Rocky III*. He then teamed up with Vince McMahon to make the World Wrestling Federation America's favorite dope opera, hitting a peak in 1987 when he beat the even bigger Andre the Giant in *Wrestlemania III*.

WHAT'S NOT TO LIKE? A favorite with kids, the man with the 24-in. biceps turned wrestling into mainstream, pop-art entertainment.

HULK HOGAN

TORCHING THE COMPETITION Jackie was a great long jumper as well as heptathlete; she won the gold medal in the long-jump in '92.

JACKIE JOYNER-KERSEE

She beat the best—twice

★ ★ ★ ★ ★ ★ ★ ★ ★ ★ ★ ★ ★ ★ ★ ★ ★ ★

Was she the best female athlete in history? Many people think so. Queen of the heptathlon competition's seven events, she took the silver at L.A. in '84, then took two gold medals in a row, at Seoul in '88 and Barcelona in '92, becoming the first woman to win consecutive Olympic heptathlons. Flo-Jo's sister-in-law excelled at the long jump, and in 1998 she bounded right off the track—to play professional basketball.

FLO-JO

GO WITH THE FLO The sprinter won a silver medal in L.A., then took home three golds and a silver from Seoul.

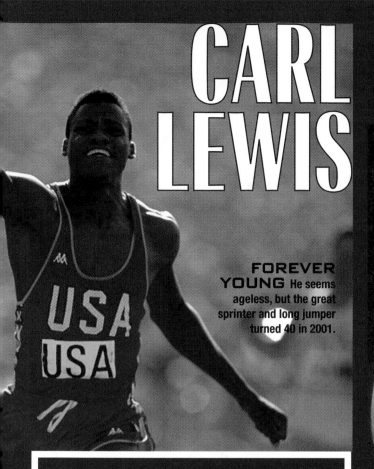

CARL LEWIS

FOREVER YOUNG He seems ageless, but the great sprinter and long jumper turned 40 in 2001.

Lewis won gold in Jesse's mold

He was denied his chance for Olympic gold in 1980, when the U.S. boycotted the Moscow games. By 1984 he was *ready*—and Carl Lewis achieved his goal, winning four gold medals (100 meter, 200 meter, long jump, 4x100 relay) to match the feat of his idol, Jesse Owens. Carl achieved a goal more rare on the track: longevity. He now holds nine Olympic gold medals, two more from '88, two from '92 and one from '96. Whew!

She sprinted into our hearts

What a figure Florence Griffith Joyner cut on the track—long hair streaming behind her, muscular thighs pumping like pistons, running outfit a splash of color that might have escaped from a Van Gogh canvas. And when she slowed down ... well, check out those outrageous fingernails! She thrilled us at Los Angeles in '84 and Seoul in '88—and her death, apparently from a brain seizure, at only 38 in 1998, left her many admirers bewildered and saddened.

She just wanted to pump you up

You have to wonder: What did Wheaties do before Mary Lou came along? This all-American, go-for-it gal was born to adorn their box—and that she did after becoming the first U.S. woman gymnast to win an individual Olympic gold medal. She took first place in the all-around event in dramatic fashion at the L.A. Games, earning perfect scores in her last two events to walk away as the champion. Her victory sent American girls bounding onto balance beams—and sent Mary Lou into a still-thriving career as endorser and role model.

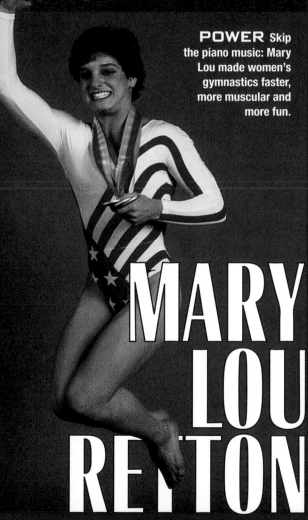

POWER Skip the piano music: Mary Lou made women's gymnastics faster, more muscular and more fun.

MARY LOU RETTON

ROCK'S RAMBO?
Bruce's legendary live shows took on a grandiose air as he played giant arenas in the '80s. But he adapted easily to the MTV age, sharing a memorable dance with a young Courteney Cox in the '84 video of *Dancing in the Dark*.

In the '80s, even Jersey's poet laureate muscled up

★ ★ ★ ★ ★ ★ ★ ★ ★ ★ ★ ★ ★ ★ ★

He was a scruffy rebel in the '70s, the loner who sang of the darkness at the edge of town. But he was also the Boss, the dynamic frontman of the tight E Street Band, the sexy, smiling guy who dared you to join him on his ride to rock 'n' roll glory. But in 1984 Bruce pumped up his pop-star image on his biggest-ever album, *Born in the USA*. As a super-buff Boss bounded around stages in huge stadiums, some felt he'd lost his soul—particularly when he married model Julianne Phillips in 1985 and moved to L.A. Not to worry: Bruce himself took offense when right-wingers mistook the album's title cut—about a Vietnam vet—for a flag-waving salute to jingoism. Oh, yeah: Bruce and the wife split in 1989. His hungry heart met its match in—what else?—a Jersey girl. He wed backup singer Patti Scialfa in 1991.

BRUCE SPRINGSTEEN

JOHN MELLENCAMP

GOOD GENES John's mom was a "Miss Indiana" runner-up in 1946.

A brooding genius, he hurt so good

You know where he was born: in a small town. You know where he was raised: in a small town. You know where he'll make his stand … Okay, we think you've got it. The name of the small town was Seymour, Ind., and its biggest product by far was this energetic, pugnacious rocker, who is also a serious painter. Shrugging off a record company's silly '70s moniker—John Cougar—Mellencamp declared his independence by sticking with his given name, then made his mark with a string of classic singles that put American life into song, from Jack and Diane at the Dairy Queen to the little pink houses in the 'burbs. John, a man of the people, began the Farm Aid benefit shows in 1985.

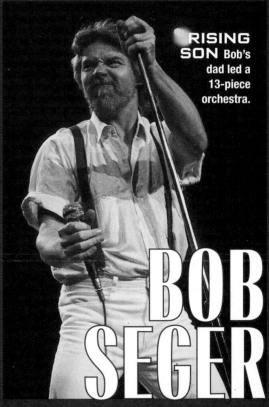

RISING SON Bob's dad led a 13-piece orchestra.

BOB SEGER

He got lucky, and he won't back down

★ ★

A sloe-eyed rocker from Florida's gator country, Tom had hits in the late '70s, but he and his Heartbreakers hit top gear in the '80s, churning out feel-good songs just made for a sunny day with the radio playing and the top down: Think "Runnin' Down a Dream" and "Free Falling." He fought his label to keep album prices low—and the suits gave in. By 1988 he was a superstar, sharing laughs with fellow immortals Bob Dylan, George Harrison and Roy Orbison in the daffy pick-up band that styled themselves the Traveling Wilburys.

TOM PETTY

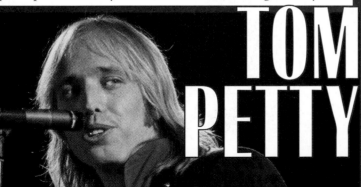

HE SAW ELVIS Alive, no less. When Tom was only a lad, he saw Presley filming *Follow That Dream* in Florida. Seems Tom took the King's advice.

Silver Bullets spun gold

A journeyman rocker from way back in the '60s, Bob Seger was always a beloved star in his native Michigan—even when singing about his adventures in "Katmandu." But Bob and his Silver Bullet Band won fans everywhere with the '77 high-school saga "Night Moves." Seger cruised on to help write the soundtrack of the '80s with roof rattlers like "Old Time Rock 'n' Roll" (mimed memorably by Tom Cruise in *Risky Business)* and slow ballads like "Against the Wind" and "We've Got Tonight." Over the hill? His last tour, in 1996, grossed $26 million—like a rock.

SCADS OF FADS

All these nutty novelties weren't born here—but they did rule here!

Cabbage Patch Kids

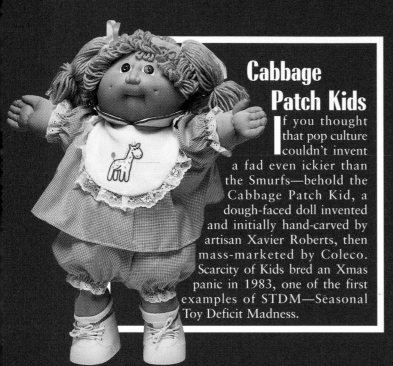

If you thought that pop culture couldn't invent a fad even ickier than the Smurfs—behold the Cabbage Patch Kid, a dough-faced doll invented and initially hand-carved by artisan Xavier Roberts, then mass-marketed by Coleco. Scarcity of Kids bred an Xmas panic in 1983, one of the first examples of STDM—Seasonal Toy Deficit Madness.

Trivial Pursuit

What did we need in the '80s? A game that let us "cocoon" at home—and show up our pals by showing off our smarts. No wonder 1983's Trivial Pursuit became one of the hottest board games since Monopoly.

Smurfs

They invaded from across the ocean—Smurfs came to us from Belgium—and they also weren't born in the '80s. Created in the late '50s by illustrator Pierre "Peyo" Culliford, the little folks enjoyed European success in the '60s and again in the '70s. When NBC based a cartoon show on them in 1982, the cutesy trolls ruled pop culture—Smurfin' U.S.A.!

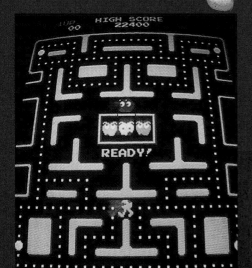

Pac-Man

He came, he saw, he gobbled up his foes—and he conquered the U.S. toy market. Introduced in 1981 by Nintendo, the smilin' yeller chompin' feller (based on an insatiable Japanese folk hero) was America's first video-game star. His enormous success led to the inevitable second act: Ms. Pac-Man.

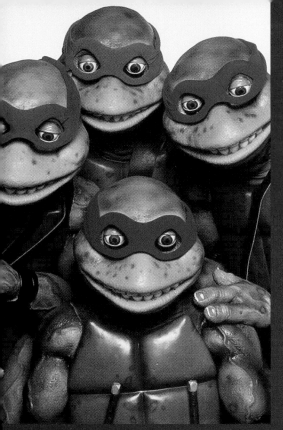

Teenage Mutant Ninja Turtles

What's in a name? In this case, pure genius: Every word contributes to the zany mythos of four cool turtles, exposed to radiation when young, who ... oh, never mind. Cartoonists Kevin Eastman and Peter Laird cooked up this hip idea, which first mastered comic books, then TV and then the big screen. Cool dudes Raphael, Leonardo, Donatello and Michelangelo were the best Fab Four since you-know-who.

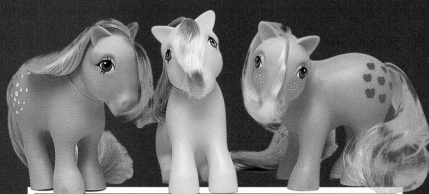

My Little Pony

Older brother may have liked the pizza-tossin' Ninja Turtles, but little sister had her own special friends: the long-maned cutie-pies hawked on TV and at the toy stores as My Little Pony. Though critics decried the synchronized system that marketed Hasbro's toys through TV cartoon shows, girls under ten didn't seem to mind: sales of the ponies, introduced in 1982, were running at $60 million a year by 1987.

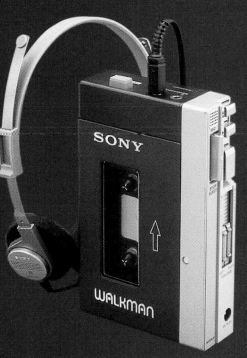

Rubik's Cube

You played with his cube, but do you know who Erno Rubik was? Why, a Hungarian professor of architecture, of course ... who else could think in three dimensions and then create the nifty gizmo inside the cube that let it twist and turn every which way? Introduced in 1980, the Mondrian-colored puzzler took off quickly: More than 100 million copies were sold around the cube ... er, globe.

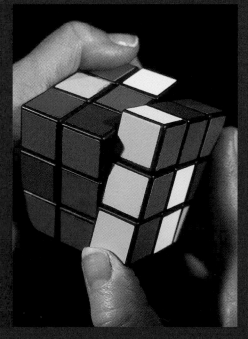

Walkman

Legendary Sony boss Akio Morita cooked up a brilliant recipe just as boom boxes began making a nuisance of themselves: Take a small tape player, add earphones and presto: 1979's portable Walkman. It sold 20 million units by 1986.

Material Girl$

WHO SAYS YOU CAN'T HAVE IT ALL? IN THE '80S WE MET A WHOLE NEW BREED OF TRASH-TALKIN', CASH-STALKIN', FLASHY-WALKIN' GILDED GALS

MADONNA

Lock up your daughters! Here comes the saucy, sexy vixen with the "do-me" attitude

She wasn't the most original singer on the pop scene: Madonna snitched style points from all comers—be it Marlene Dietrich or new wave pioneer Debbie Harry. But if not the most innovative star, she was easily the most ambitious. "I always thought of myself as a star, though I never in my wildest dreams expected to become this big," she said in 1986. When Britney Spears was only a lass of four, this contessa of controversy was conducting navel maneuvers in what she called her "hodgepodge, tongue-in-cheek tart outfits," featuring corsets, crucifixes and lace—and inspiring a generation of teenyboppin' "wannabes." Madonna's message: Sensation sells. "What I do is total commercialism," she admitted, "but it's also art."

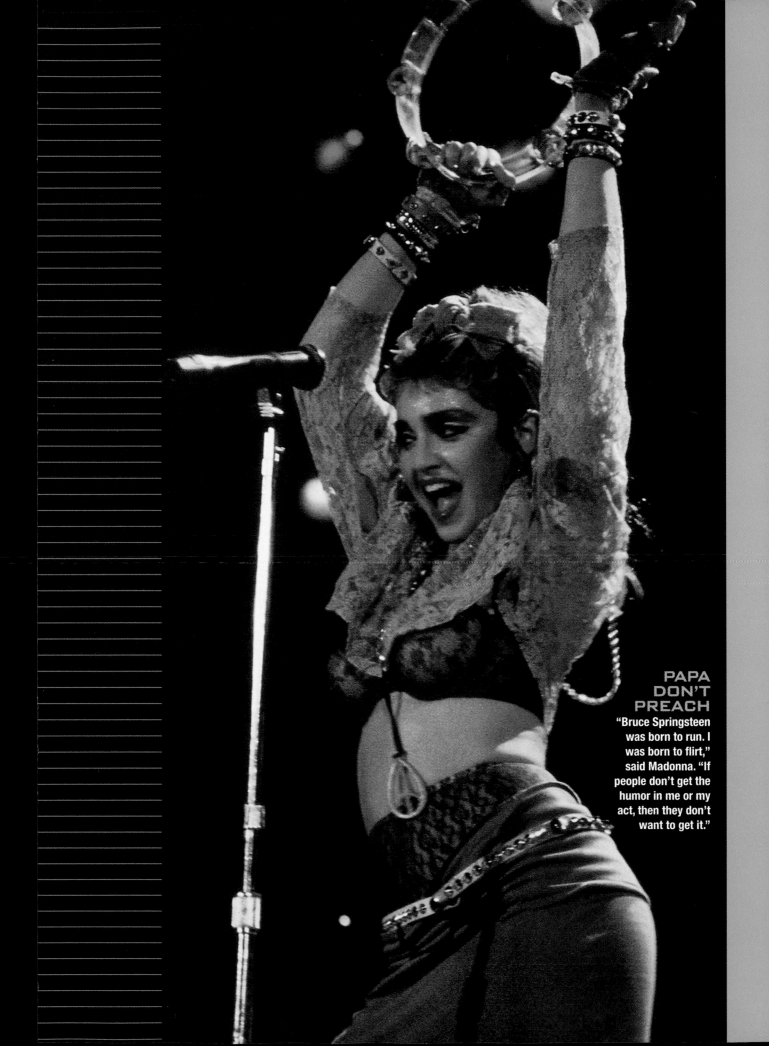

PAPA DON'T PREACH

"Bruce Springsteen was born to run. I was born to flirt," said Madonna. "If people don't get the humor in me or my act, then they don't want to get it."

MATERIAL GIRLS

Born Madonna Louise Veronica Ciccone in Bay City, Mich., in 1958, she was named after her mother, who died of cancer when Madonna was only 6. She and seven siblings were raised by her father, Tony, a Chrysler employee, and a stepmother with whom she never grew close. Too fast for college, she dropped out of the University of Michigan and headed to New York in 1978, where she arranged a legend-worthy entrance, instructing her cabby to drop her off in Times Square. She began studying dance, appeared in a sleazy low-budget film and shook her moneymaker in the town's coolest clubs. In 1982 the ambitious singer/dancer convinced a New York club deejay to pass her tape to Sire Records, which immediately signed her. Early dance singles like "Holiday" and "Lucky Star" showed promise, and 1984's chart-topper "Like a Virgin" fixed an image that—despite her ever-evolving music and persona—would never change: This lady was a campy tramp. Said the candid star: "Being the vixen, the heartbreaker and the incredibly provocative girl is a very marketable image."

With hits coming on a steady basis, Madonna expanded her reach with the title role in the smash film *Desperately Seeking Susan*. A less successful Hollywood venture was her marriage to rising star Sean Penn, held on the Malibu bluffs on Aug. 16, 1985—her 27th birthday. From the beginning, the upbeat Madonna and the intense, jealous Penn found little common ground. After 27 months marked by growing unpleasantness, they split early in 1989. Unfazed, she kept churning out hits and raising a ruckus: her "Like a Prayer" video ignited accusations of blasphemy and killed lucrative endorsements. By 1989 she was saying, "I try to be happy, because life is so sad." The new century found her happy at last, with daughter Lourdes by her former personal trainer Carlos Leon, and baby son Rocco, by her new husband, British director Guy Ritchie.

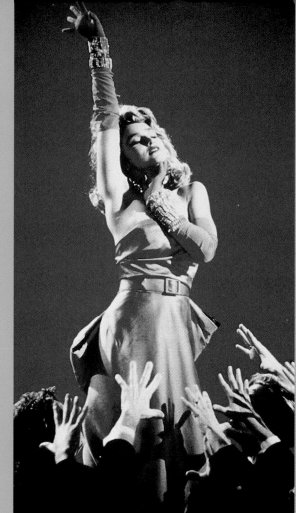

CAUSING A COMMOTION "[She] is nothing like what she portrays," said one old friend. Another snitched that, pre-Material Girl, Madonna wore a turtlenecked bodysuit to make-out parties in junior high, "to protect her virginity." Live and learn!

WHO'S THAT GIRL?
Rosanna Arquette with the singer on the *Susan* set.

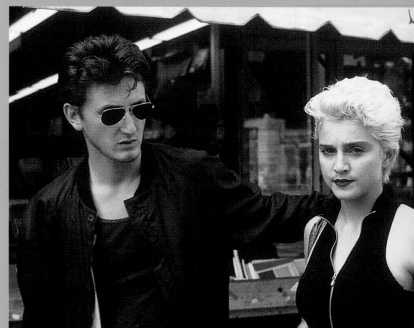

LIVE TO TELL Madonna met Sean Penn during the "Material Girl" video shoot. The combustible duo clashed with the press—then with each other.

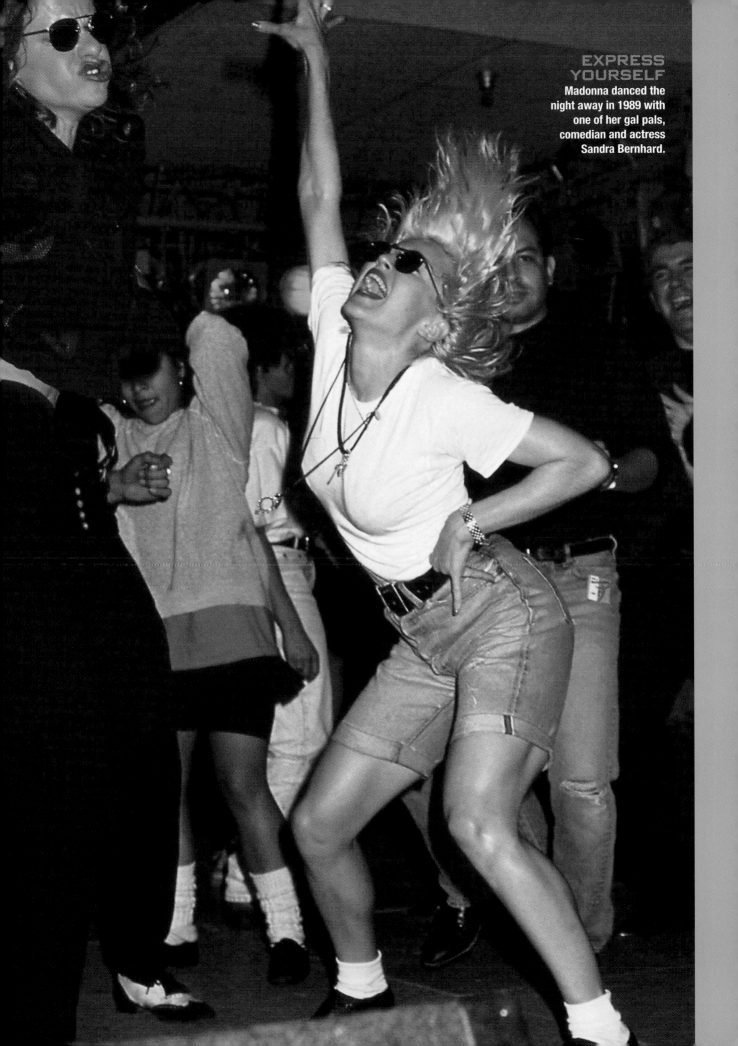

EXPRESS YOURSELF
Madonna danced the night away in 1989 with one of her gal pals, comedian and actress Sandra Bernhard.

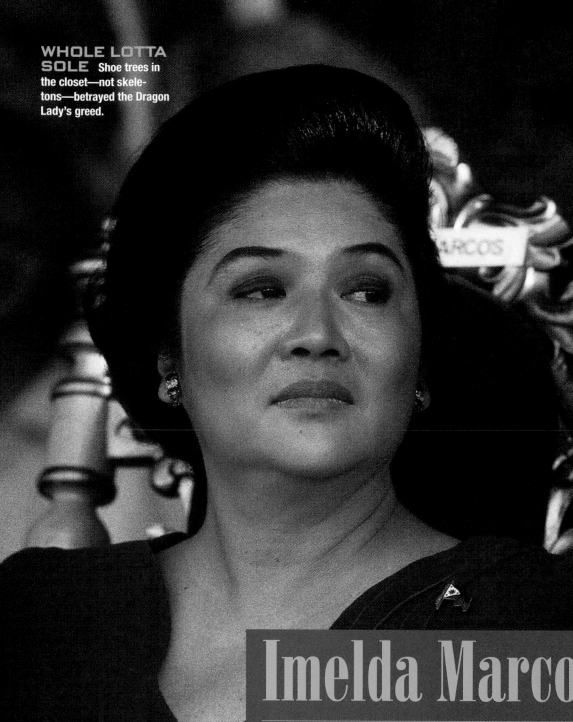

WHOLE LOTTA SOLE Shoe trees in the closet—not skeletons—betrayed the Dragon Lady's greed.

Imelda Marco$

For the want of shoes, a kingdom was lost

Let's start this story at its finish, in 1990, as we see the former First Lady of the Philippines shuffling up the main aisle of New York City's St. Patrick's Cathedral on her (padded) knees, clutching a rosary and praying for forgiveness. Now flashback to 1980: Imelda Marcos reigned supreme with husband Ferdinand over their Pacific nation, where he had been elected President in 1965. Happily for them, there was no need for elections after Ferdinand declared martial law in 1972. But the "Iron Butterfly," a former beauty queen, had lots of needs—symbolized by the extravagant trove of shoes (2,700 pairs) that was found in her closet after the Marcoses were overthrown in the 1986 uprising led by Corazon Aquino. Imelda was tried for graft in the U.S. and found not guilty in 1990. Our question: If she was innocent, why did she go to St. Pat's—and for what sins was she repenting?

Leona Helmsley

Let's see now—what rhymes with "rich"?

Hey, don't take our word for it: When New York City hotel monarch Leona Helmsley was put on trial for tax evasion in 1989, her own defense lawyer called her "abrasive ... demanding ... a tough bitch." You are correct, Sir. But what drove the "Queen of Mean" to berate employees, throw extravagant, foul-mouthed temper tantrums and cheat Uncle Sam? She had it all: The hatmaker's daughter who grew up poor was a smart businesswoman who made a million on her own before marrying husband Harry and presiding over a $100-million hotel and real estate empire. We may never know what demons drove her, but we do know Leona served 18 months in prison for her sins.

LET 'EM EAT CAKE Leona remained aloof and unbending during her trial. "Marie Antoinette was more contrite," PEOPLE said.

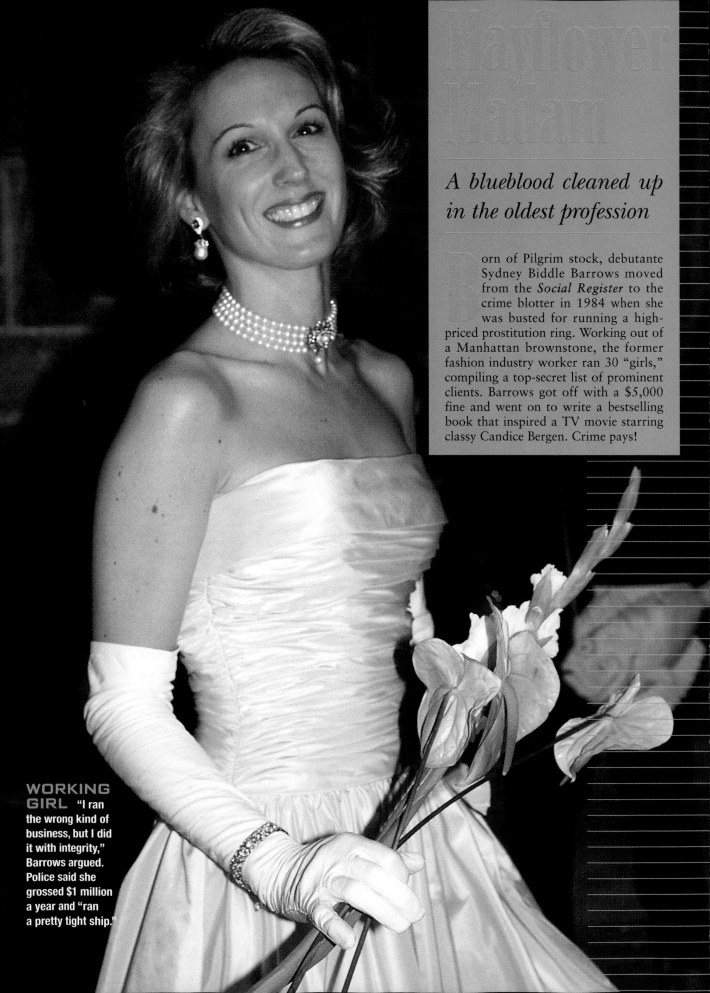

A blueblood cleaned up in the oldest profession

Born of Pilgrim stock, debutante Sydney Biddle Barrows moved from the *Social Register* to the crime blotter in 1984 when she was busted for running a high-priced prostitution ring. Working out of a Manhattan brownstone, the former fashion industry worker ran 30 "girls," compiling a top-secret list of prominent clients. Barrows got off with a $5,000 fine and went on to write a bestselling book that inspired a TV movie starring classy Candice Bergen. Crime pays!

WORKING GIRL "I ran the wrong kind of business, but I did it with integrity," Barrows argued. Police said she grossed $1 million a year and "ran a pretty tight ship."

HE'S OUR MISS AMERICA

EMPRESS'S NEW CLOTHES

"The hurt will never stop," said Williams, after being forced to forfeit her Miss America crown in disgrace.

Vane$$a William$

She should have nixed the birthday-suit competition

Vanessa the Undressa. Mess America. These were only two of the unflattering terms heaped on the former Miss America after scandal ended her reign prematurely on July 23, 1984. Just 10 months before, gorgeous 20-year-old Vanessa Williams had made history by becoming the first African American to capture the formerly lily-white title. Then *Penthouse* published old, grainy nude photographs of Williams cavorting with another woman, leading to the embarrassing resignation, not to mention the loss of $2 million in endorsements. But Williams persevered, launching a successful acting and singing career that includes such chart toppers as "Save the Best for Last." Which is exactly what she's done.

Christie Brinkley

We wished we all could be California girls

This sun-kissed supermodel from L.A. with the sparkling smile and endless legs was—she claims—a chubby-cheeked ugly duckling who wanted to be an artist before fashion found her. She first made waves as a top model in Paris, then bared her formidable charms as cover girl on SPORTS ILLUSTRATED's annual swimsuit issues. She also roused male hearts in *National Lampoon's Vacation* (1983) as Chevy Chase's wordless vision in white. Articulate, outgoing and uncomplicated, the gorgeous blonde was the perfect poster girl for Ronald Reagan's America. Seizing her moment, she jumped on the '80s wealth bandwagon and made a bundle from her line of Brinkley sportswear at J.C. Penney's. Her married life has been less successful, but pal Jill Rappaport told PEOPLE she's "blissfully happy" with fourth hub, architect Peter Cook, and daughter Sailor, now 3.

No dumb blonde jokes, please. Christie's former husband Billy Joel said, "She turned out to be extremely intelligent."

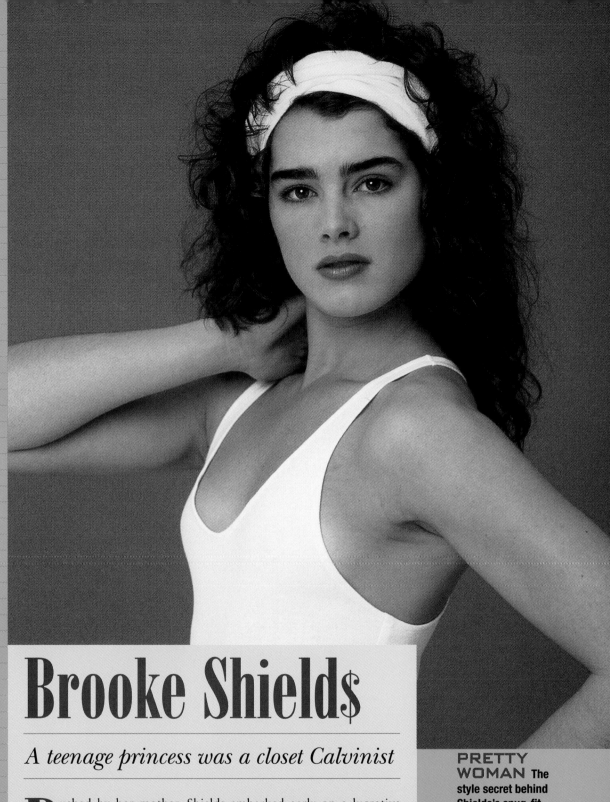

Brooke Shield$

A teenage princess was a closet Calvinist

Pushed by her mother, Shields embarked early on a lucrative modeling and movie career, beginning as an Ivory Snow baby. Her film roles caused a ruckus—she appeared in *Pretty Baby* (1978) as a child prostitute, went native in a loincloth in *Blue Lagoon* in 1980 and inspired *Endless Love* as another eager teen in 1981. But the New Jersey preppie's sexiest role (paying a cool half-mil) involved a tight pair of jeans, Richard Avedon's camera and Calvin Klein's name—with nothing in between (she said). Shunning drugs and vowing to remain a virgin until she was 20, Michael Jackson's pal graduated with honors from Princeton in 1987. In the '90s she married and divorced tennis great Andre Agassi, then starred in the silly sitcom *Suddenly Susan*. She wed writer Chris Henchy in 2001.

PRETTY WOMAN The style secret behind Shields's snug-fit Calvins? "Comfortably, I wear size 7— these were 5."

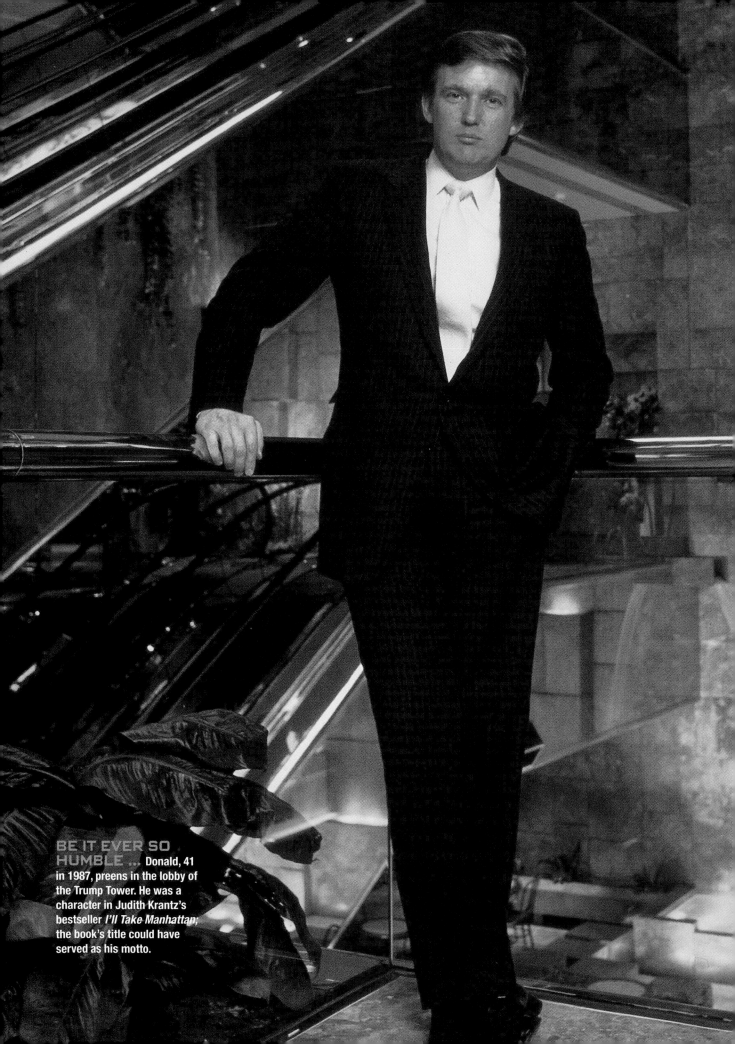

BE IT EVER SO HUMBLE ... Donald, 41 in 1987, preens in the lobby of the Trump Tower. He was a character in Judith Krantz's bestseller *I'll Take Manhattan;* the book's title could have served as his motto.

MASTERS *of the* UNIVERSE

DONALD TRUMP

A billionaire enjoyed the decade's most passionate love affair—with himself

To understand an age, look to its heroes. The 1960s gave us Martin Luther King Jr. and John Lennon. The '70s gave us Jimmy Carter and John Denver. And the 1980s gave us … Donald Trump. Imagine telling '60s radicals Abbie Hoffman and Jerry Rubin that in only two decades, one of the nation's most admired men would be a New York City real estate developer with a colossal flair for self-promotion. But that's what happened: Yippies turned into yuppies, and America went from the "Whee!" decade to the "Me" decade to the "Greed" decade. And the man who personified our dash for the cash was a smug tycoon whose skyscrapers were almost as tall as his ego, Donald Trump.

WHO SAYS YOU CAN'T HAVE IT ALL? IN A NEW GILDED AGE, MONEY STILL COULDN'T BUY YOU HAPPINESS— BUT IT COULD AT LEAST GET YOU A DOWN PAYMENT

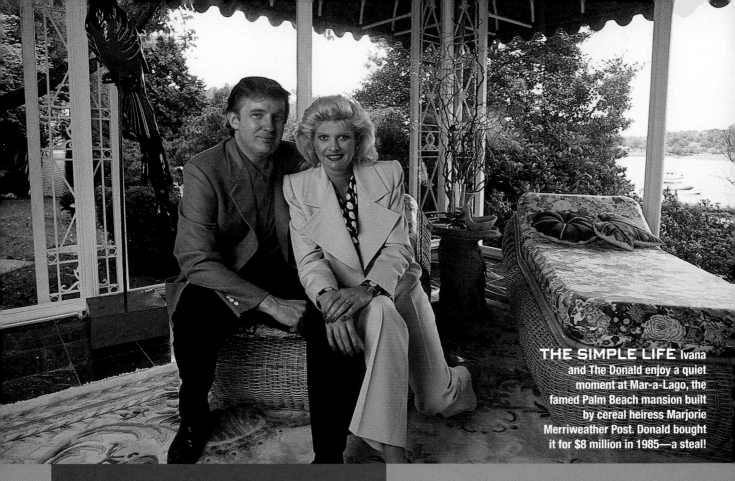

THE SIMPLE LIFE Ivana and The Donald enjoy a quiet moment at Mar-a-Lago, the famed Palm Beach mansion built by cereal heiress Marjorie Merriweather Post. Donald bought it for $8 million in 1985—a steal!

It was an era when bumper stickers proclaimed, "The one with the most toys at the end wins." And there was no doubting that Donald Trump, son of a Queens apartment-rental magnate, had the most toys. Start with his fabulous Trump Tower on Manhattan's Fifth Avenue. Donald himself proclaimed it "The most successful building in the universe," suggesting a familiarity with the luxury market beyond the Milky Way. Its lobby was filled with saw-toothed angles, gleaming brass and a $2 million marble indoor waterfall; its apartments were filled with tenants like Steven Spielberg, Michael Jackson—and Donald himself. He occupied a $20 million double-triplex penthouse with an eagle's eye view of Central Park, the very place where Donald had restored, in four months, the Wollman ice-skating rink that New York City hadn't been able to fix in six years.

And that's just for starters. Donald owned two mansions, one in Greenwich, Conn., another in Florida. There were limousines galore, Trump casinos in Atlantic City, Trump condos in Palm Beach. The only French-made Super Puma jet helicopter in North America had the name Trump emblazoned across it, as did a palatial $30 million yacht. Donald partied with Frank Sinatra and entertained notions of running for President. His 1987 book, *The Art of the Deal,* was a big bestseller.

Impressed yet? Trump's wife, Ivana, a Czech model and skier, certainly was after the two met in Montreal at the 1976 Olympics. She memorably christened her husband "The Donald," reared three children, helped rule his empire and became a major society figure. But they divorced in 1990 and Donald actually weathered some (relatively) hard times in the early '90s. Even so, he's back on top today—and get this, ladies: He's single!

BRACE YOURSELF
Want that power look?
Go for the suspenders—it
worked for Michael Douglas
in *Wall Street*. But we can't
promise you'll win an Oscar,
as Best Actor Douglas did.

WALL STREET

Gekko—and other lizards

Tom Hanks didn't quite bring home the bacon with his portrayal of a Wall Street broker in 1990's *The Bonfire of the Vanities*. No, it was Michael Douglas's brilliant turn as the corrupt Gordon Gekko in director Oliver Stone's hit *Wall Street* (1987) that remains the gold standard for Hollywood's portrayal of yuppies-gone-mad. When Douglas as Gekko proclaimed "Greed is good" to a class of M.B.A. students, he echoed inside-trader Ivan Boesky's commencement speech to the School of Business Administration at Berkeley: "I think greed is healthy. You can be greedy and feel good about yourself."

TOM WOLFE

He turned yuppie greed into one great read

Tom Wolfe is America's thermometer: He takes the temperature of the times and wraps it up in a single memorable phrase. In the 1960s he introduced us to *The Electric Kool-Aid Acid Test.* In the '70s he taught us how astronauts get *The Right Stuff* and christened the era "the Me decade." In the '80s his first novel, *The Bonfire of the Vanities,* skewered America's newfound yearning for earnings. The novel's indelible caricatures included the ultra-thin "Social X-rays," who ruled Manhattan society, and the greedy "Masters of the Universe," baying for Wall Street money. Wolfe's 1987 novel was a huge bestseller, but the much-anticipated 1990 movie (inset), was a rare flop for a miscast Tom Hanks.

SNAPPY! Wolfe, a fabled dandy, was well-suited for the task of sketching the foibles of his fellow New Yorkers of the city's wealthy Upper East Side.

LEE IACOCCA

He restored Chrysler to glory—and Miss Liberty too

The '80s came in like a lion for the auto exec who had given us Ford's sporty Mustang in the '60s. In 1978 Lee Iacocca had left Ford to run Chrysler, then teetering on the edge of bankruptcy. But in 1980 the great salesman convinced Uncle Sam to bail out the company; by 1984 Lee had steered Chrysler into record profits with new models and strong commercials starring ... Lee Iacocca. Then America's favorite boss honored his immigrant heritage by heading up the drive to restore the Statue of Liberty and Ellis Island. His autobiography, *Iacocca,* was a bestseller in 1984; a second bestseller's title, *Talking Straight* (1988), captured his Trumanesque appeal.

PITCHMAN Would you buy a used company from this man? Uncle Sam did—and Lee paid back Chrysler's debt to America before it came due.

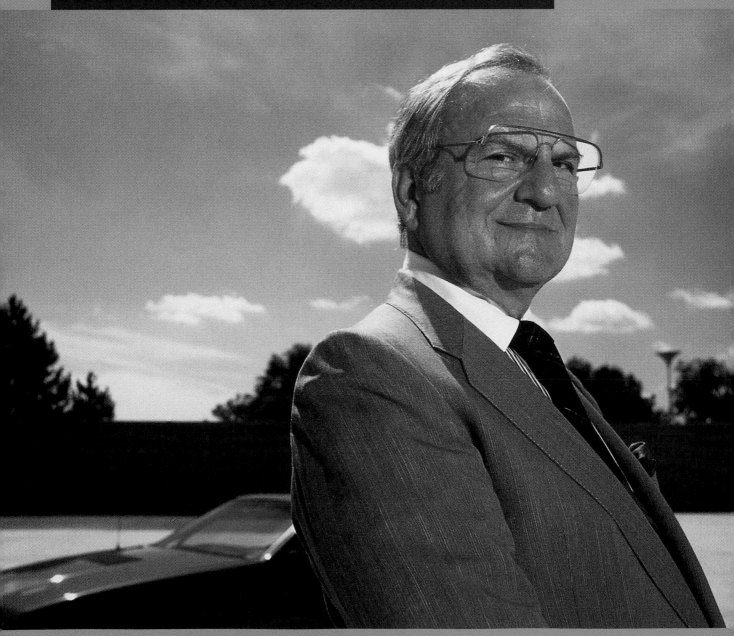

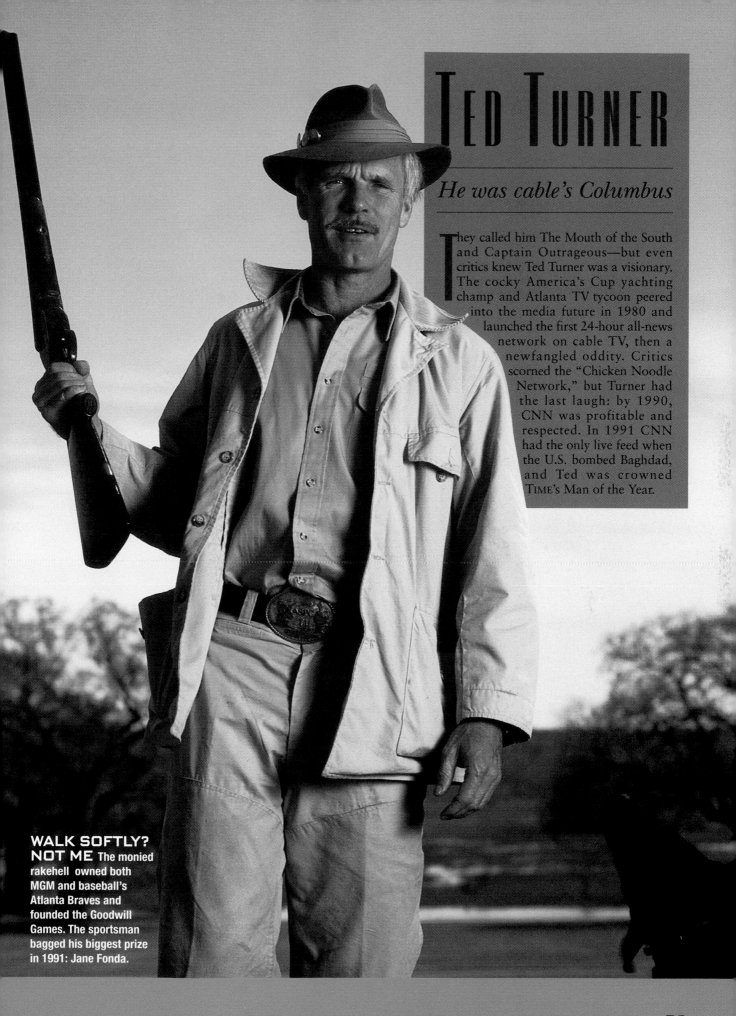

Ted Turner

He was cable's Columbus

They called him The Mouth of the South and Captain Outrageous—but even critics knew Ted Turner was a visionary. The cocky America's Cup yachting champ and Atlanta TV tycoon peered into the media future in 1980 and launched the first 24-hour all-news network on cable TV, then a newfangled oddity. Critics scorned the "Chicken Noodle Network," but Turner had the last laugh: by 1990, CNN was profitable and respected. In 1991 CNN had the only live feed when the U.S. bombed Baghdad, and Ted was crowned TIME's Man of the Year.

WALK SOFTLY? NOT ME The monied rakehell owned both MGM and baseball's Atlanta Braves and founded the Goodwill Games. The sportsman bagged his biggest prize in 1991: Jane Fonda.

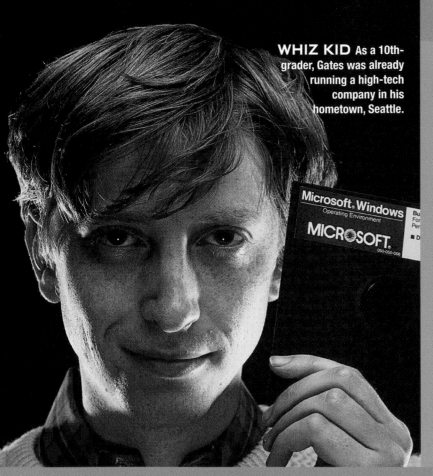

WHIZ KID As a 10th-grader, Gates was already running a high-tech company in his hometown, Seattle.

BILL GATES

His plan: Walk Microsoftly ... and carry a big stick

Yes, kids, there was a time before the Internet—a dark time when you couldn't meet a nice stranger in a chat room, a time when we made fun of geeks like Bill Gates who stared at computer screens 24/7. Bill, a 26-year-old Harvard dropout, struck it rich in 1981 when IBM launched its newfangled personal computers using MS-DOS, an operating system Gates and his pals at Microsoft had acquired second-hand. Gates outfoxed Big Blue: He made IBM license the product, not buy it outright. When MS-DOS became the industry standard—well, Bill became rather well-to-do ... and today, the geeker the chicer.

IVAN BOESKY

He lived for wheelin', dealin'—and stealin'

He had all the glittering prizes Wall Street could bestow in the '80s: a lavish office, a Westchester mansion, an ideal family. In 1984 Ivan Boesky, the son of a Russian immigrant delicatessen owner in Detroit, made $65 million on a single takeover. But in November 1986, Boesky was unmasked by the Securities and Exchange Commission as a cheater who made his bucks illegally, buying advance knowledge of deals. The symbol of the era's ethical bankruptcy did 22 months in jail, paid fines and fees of $100 million and was barred for life from the securities business in America.

CALCULATING MAN Boesky put in 18-hour days; his office had 300 phone lines. "My purse is my master," he once said.

MICHAEL MILKEN

He hit the "junkpot": $550 million in '87

The Midas of the '80s had a boyish face and a tousled toupee. With one brilliant tactic—aggressively helping corporations raise capital with the high-yield junk bonds once favored only by smaller concerns—Michael Milken sparked the frenzy of corporate takeovers that marked the era. No show-off, he lived simply, absorbed in work. But in 1989 his world fell apart: He was indicted on 98 counts of racketeering and securities fraud. Convicted, he served 22 months; in the '90s the tycoon fought prostate cancer and sought to restore his image through extensive charity work.

FAB FOUR Eisner—the one in the middle—thought big: He acquired the rights to the Muppets and hired quintessential '80s architect Michael Graves to design Disney hotels.

MICHAEL EISNER

He made Mickey's kingdom fun again

The year was 1984, and at the Walt Disney Co., not a creature was stirring—not even a mouse. The creative genius who gave the world Mickey Mouse, *Snow White* and Disneyland was long dead, and his company seemed moribund. Enter Michael Eisner. The former TV and film exec took the reins at Disney, and soon he put the magic back in the kingdom: We fell in love with *The Little Mermaid* and went to the new Disney-MGM Studios theme park, while Disney profits quadrupled in five years. We'd say more, but we're going to Disney World.

PERP WALK Milken was arraigned in New York City. His huge salary prompted Donald Trump to remark, "You can be happy on a lot less."

RALPH LAUREN

Ralph to Gatsby: Move over!

Critics called him a Great Pretender—but at least they admitted he was great at it. In fact, like the clothing he so successfully designed and marketed, Ralph Lauren was an American classic, a hard-working, self-made man who, like F. Scott Fitzgerald's Jay Gatsby, projected himself into an invented identity that brought him immense success. One day he was Bronx-born Ralph Lifshitz, hand-running his own dress racks through New York City's Garment District; seemingly overnight, he was Ralph Lauren, living in a Long Island mansion and starring in his own advertisements. Lauren's elegant yet relaxed Polo line of clothing perfectly mirrored the aspirations of '80s social climbers and allowed Ralph to do some climbing himself, living the life his syles embodied. One more thing: Unlike Gatsby, Ralph was a nice guy.

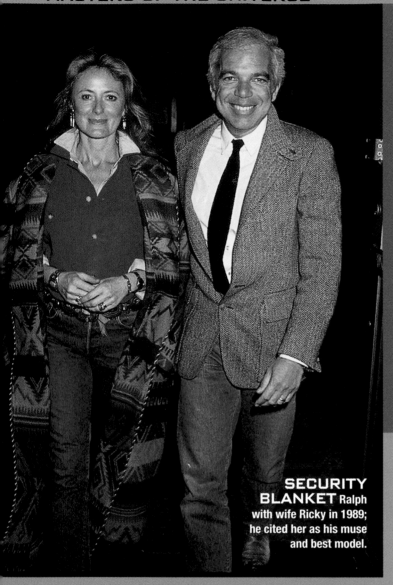

SECURITY BLANKET Ralph with wife Ricky in 1989; he cited her as his muse and best model.

SITTING PRETTY Birnbach's first *Preppy Handbook* sold 1.4 million copies and countless penny loafers.

LISA BIRNBACH

She wrote the Bible of campus cool

The '60s gave us fringed jackets and love beads; the '70s gave us disco and mood rings. In short, there was nowhere to go but up—and it was 24-year-old Brown grad Lisa "Bunny" Birnbach who initiated us into the Age of Reagan with *The Official Preppy Handbook*. The tongue-in-cheek 1980 tome advised college kids on which Top-siders and cable-knit cardigans to buy and clued us in on terms like "brewskies"—too many of which, it warned, could lead to the dread "Technicolor yawn."

JAY McINERNEY

He nailed the downtown scene

You're a young *New Yorker* fact checker who gets fired from the prestigious weekly. But you're ambitious, so you settle down to write the story of a young man in New York City, circa '83. Your style is downtown cool, so you work in scenes at the Heartbreak Club, cite Talking Heads lyrics between chapters and come clean about the "Bolivian marching powder" that keeps you hopping. And for effect, you write the entire book in the second person (like this). Next thing you know, *Bright Lights, Big City* is a bestseller, you're the novel's Next Big Thing, Hollywood is on line 3 and Michael J. Fox is playing ... you. After success like that, you know you're due for a fall. Sure enough, the movie bombs, and your second book doesn't match the success of the first. Oh, well, story of your life.

ESCAPE ACT The novelist in 1989; burnt out on New York City, he moved to Nashville in the '90s, survived the sophomore jinx and built a solid career.

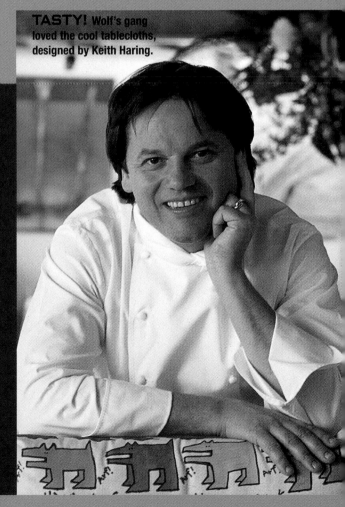

TASTY! Wolf's gang loved the cool tablecloths, designed by Keith Haring.

WOLFGANG PUCK

What's cookin', good lookin'?

The wealth boom of the '80s left many Americans desperately seeking opportunities to savor (and display) just how well-off they'd become. Enter the new age of the status symbol: BMWs ("Beemers") were the vehicle of choice, and even lowly running shoes were pumped up into outsized, overpriced "limousines for the feet." One innovation in wealth display was the notion of the restaurant as theater. Voila! Tomatoes were suddenly sun-dried, iceberg lettuce yielded to endive, and we learned how to pronounce "chevre"(if not to like it). Suddenly, chefs were celebs, and none was more gifted at applying the social Crisco that made '80s restaurants sizzle than the man who opened Hollywood's happenin' Spago in 1982: Wolfgang Puck. The California-meets-Paris cuisine of the handsome, charming Austrian—like his nifty "wood-fired" pizzas—had movie stars begging for takeout boxes.

IN THE '70S WOMEN MARCHED *FOR* EQUALITY; IN THE '80S THEY MARCHED *TO* EQUALITY, FROM TV TALK SHOWS TO THE SUPREME COURT

Girlfriend

WEIGHT AND SEE "My weight is the one thing I get seriously depressed about," said Winfrey, who pulled a red wagon filled with lard on camera in 1988 to symbolize the 67 pounds she lost.

OPRAH WINFREY

An outspoken pioneer made talk on the tube meaningful

Hailed as "the diva of daytime discourse," Oprah Winfrey seemed to explode out of nowhere in the mid-'80s—but her "overnight" success was a long time coming. The product of what she called "a one-day fling under an oak tree," she was born to unmarried parents in 1954 in Kosciusko, Miss. Winfrey's troubled life began to stabilize after she ran away from her mother at age 13 and was sent to live with her father, a Nashville barber. Attending Tennessee State University on a

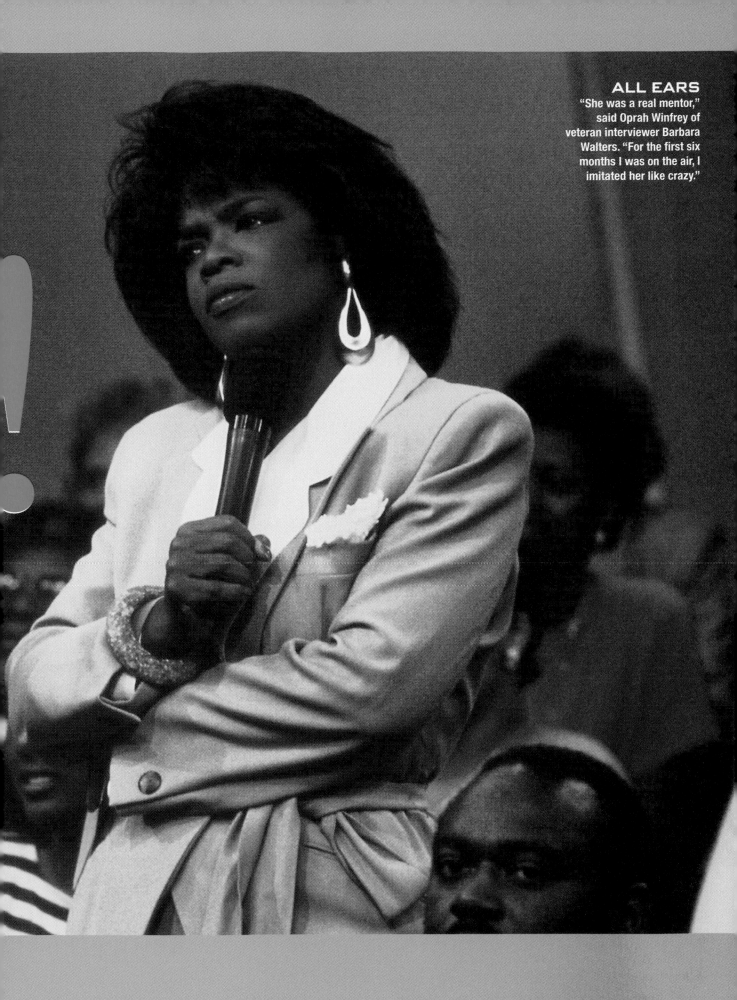

"She was a real mentor," said Oprah Winfrey of veteran interviewer Barbara Walters. "For the first six months I was on the air, I imitated her like crazy."

"The single happiest day of my life," proclaimed Winfrey, recalling when Steven Spielberg cast her in his 1985 screen adaptation of Alice Walker's *The Color Purple*.

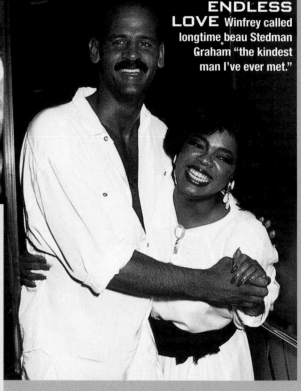

ENDLESS LOVE Winfrey called longtime beau Stedman Graham "the kindest man I've ever met."

scholarship, Oprah worked in radio and TV news in Nashville, followed by a frustrating anchor gig in Baltimore, where the station tried to transform the down-home Winfrey into a glamor-puss. "It was horrible. I cried constantly," she recalled.

Her career shifted into high gear in 1984 when she began hosting a struggling Chicago talk show. Dumping the standard "women's" soft features on food and beauty, she pushed hot-button topics like divorce and racism—and won viewers. When *The Oprah Winfrey Show* went national in 1986, it soon ended Phil Donahue's reign as TV's top daytime chatterbox.

"I have the ability to be myself in front of the camera, which is a gift," said Winfrey, explaining her appeal. Indeed, she was prone to kick off her shoes on-camera if her feet hurt. She made no secret of her long-running struggles to stay slim. On one emotional show, she stunned viewers by revealing that she had been the victim of repeated sexual abuse as a child; later, she confessed to having used cocaine. TV doesn't get more real.

Winfrey was nobody's fool: Her Harpo ("Oprah" backwards) Productions leveraged her fame to earn millions of dollars. She earned a Best Supporting Actress Oscar nomination for her first film role, in 1985's *The Color Purple*. In 1989, she used her clout to star in Gloria Naylor's novel *The Women of Brewster Place* for the small screen, winning high ratings. Later, she laughingly vowed, "No more of those 'nobody-knows-the-trouble-I-seen' roles." She should have heeded her advice: 1999's *Beloved* was a flop.

It was a rare stumble, for Winfrey's dominance continued in the '90s, even as her ongoing engagement to Stedman Graham never seemed to move any closer to the altar. She stormed print: *O*, launched in 2000, was immediately successful. Its secret? You guessed it: It runs on Oprah power.

JANE PAULEY

We loved the reign of Jane

She woke us up all through the '80s, so tears were shed when the popular anchor with the girl-next-door appeal left NBC's *Today* show in 1989. It seemed that the 13-year veteran was being cast aside for the younger, blonder Deborah Norville (whose tenure proved short), but Pauley emerged the bigger winner—she went on to a lucrative assignment on *Dateline*, NBC's first successful prime-time newsmagazine show. As fellow Indiana native David Letterman told her, "You came out smelling like a rose. And you got a lot of money out of those weasels."

IN CONTROL "I don't know what I'm good at. Maybe listening," said Sawyer, who is married to famed director Mike Nichols. She got her start in television as a weathergirl in her Louisville hometown.

D SAWYER

A game dame joined TV's boys' club

merica's Junior Miss and a loyal aide to Richard Nixon: Sawyer's résumé is unique. She rapidly rose through the ranks at CBS to become the first female correspondent on *60 Minutes*. ABC won a hot network competition for her services in 1989, pairing her with Sam Donaldson on *Prime Time Live*. Sawyer compared their on-air chemistry to "a blind date between Emily Dickinson and the Terminator."

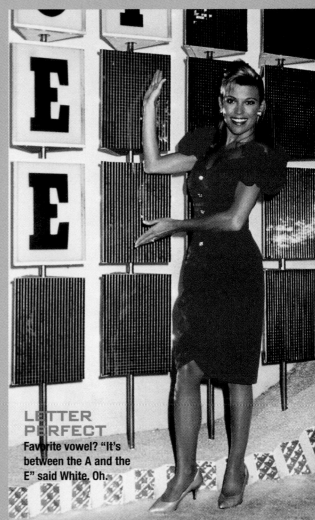

LETTER PERFECT Favorite vowel? "It's between the A and the E" said White. Oh.

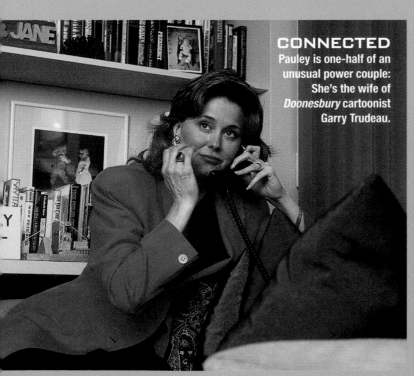

CONNECTED Pauley is one-half of an unusual power couple: She's the wife of *Doonesbury* cartoonist Garry Trudeau.

V ANNA WHITE

She learned her ABCs

he job was hardly challenging, but Vanna White parlayed her skill at turning letters on TV's *Wheel of Fortune* into a long-running career. The former cheerleader and model from South Carolina endorsed products, wrote a book (part diet, part philosophy) and received more than a thousand fan letters a week. Can you spell L-U-C-K-Y?

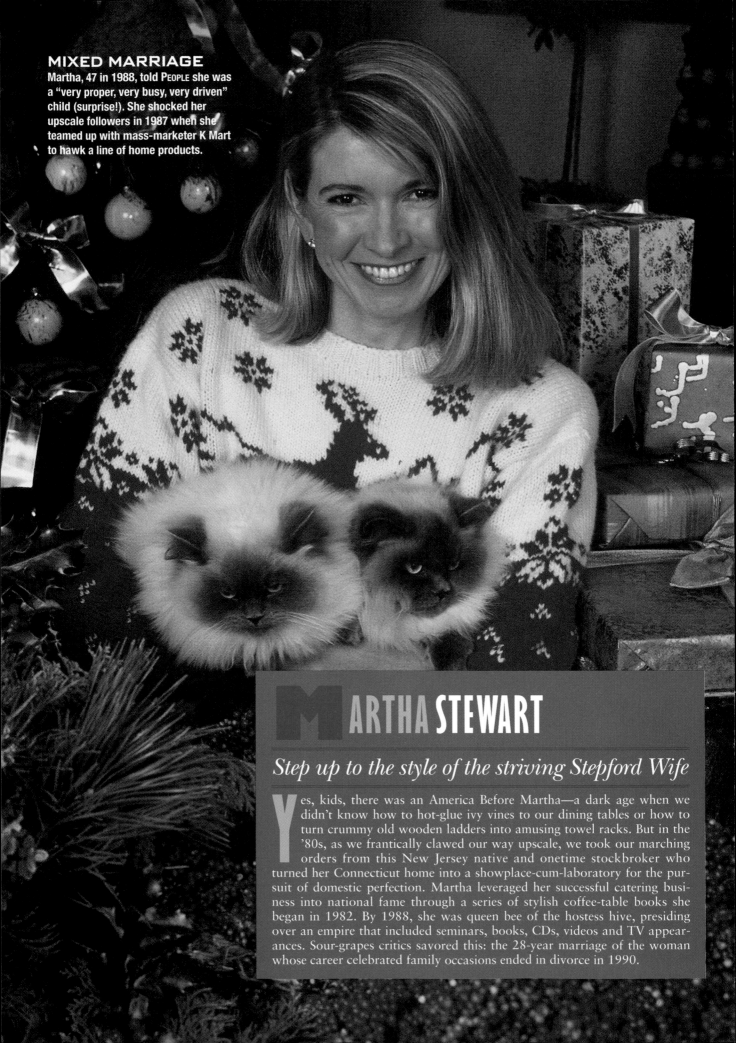

MIXED MARRIAGE
Martha, 47 in 1988, told PEOPLE she was a "very proper, very busy, very driven" child (surprise!). She shocked her upscale followers in 1987 when she teamed up with mass-marketer K Mart to hawk a line of home products.

MARTHA STEWART

Step up to the style of the striving Stepford Wife

Yes, kids, there was an America Before Martha—a dark age when we didn't know how to hot-glue ivy vines to our dining tables or how to turn crummy old wooden ladders into amusing towel racks. But in the '80s, as we frantically clawed our way upscale, we took our marching orders from this New Jersey native and onetime stockbroker who turned her Connecticut home into a showplace-cum-laboratory for the pursuit of domestic perfection. Martha leveraged her successful catering business into national fame through a series of stylish coffee-table books she began in 1982. By 1988, she was queen bee of the hostess hive, presiding over an empire that included seminars, books, CDs, videos and TV appearances. Sour-grapes critics savored this: the 28-year marriage of the woman whose career celebrated family occasions ended in divorce in 1990.

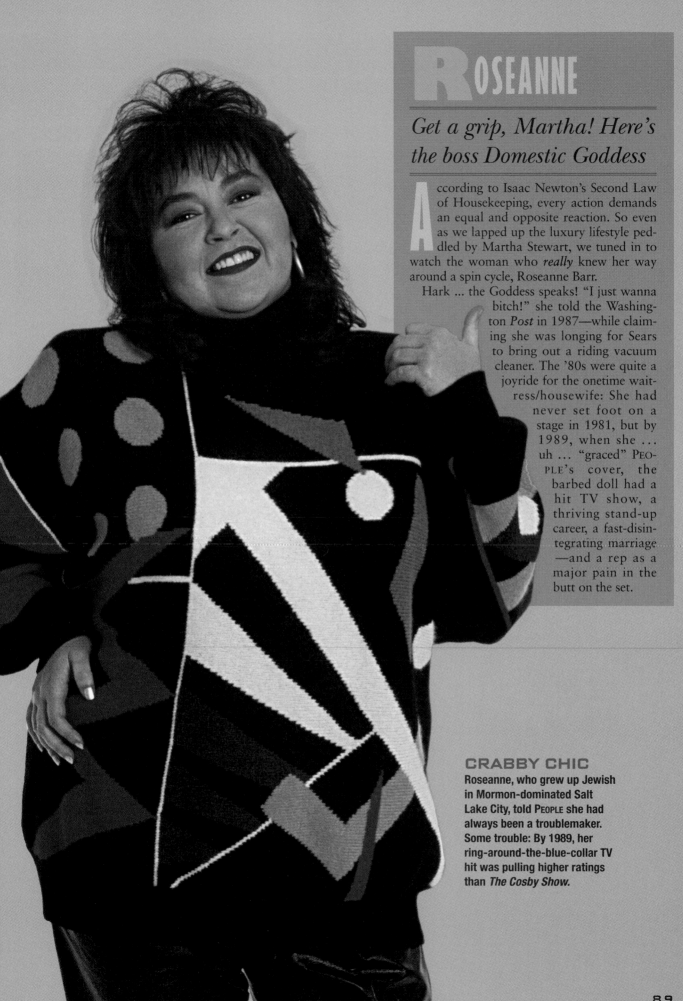

ROSEANNE

Get a grip, Martha! Here's the boss Domestic Goddess

According to Isaac Newton's Second Law of Housekeeping, every action demands an equal and opposite reaction. So even as we lapped up the luxury lifestyle peddled by Martha Stewart, we tuned in to watch the woman who *really* knew her way around a spin cycle, Roseanne Barr.

Hark ... the Goddess speaks! "I just wanna bitch!" she told the Washington *Post* in 1987—while claiming she was longing for Sears to bring out a riding vacuum cleaner. The '80s were quite a joyride for the onetime waitress/housewife: She had never set foot on a stage in 1981, but by 1989, when she ... uh ... "graced" PEOPLE's cover, the barbed doll had a hit TV show, a thriving stand-up career, a fast-disintegrating marriage —and a rep as a major pain in the butt on the set.

CRABBY CHIC
Roseanne, who grew up Jewish in Mormon-dominated Salt Lake City, told PEOPLE she had always been a troublemaker. Some trouble: By 1989, her ring-around-the-blue-collar TV hit was pulling higher ratings than *The Cosby Show*.

A LEAGUE OF HER OWN
O'Connor joined, from left, Harry Blackmun,
Thurgood Marshall, William Brennan,
Warren Burger, Byron White, Lewis Powell,
William Rehnquist and John Paul Stevens.

SANDRA DAY O'CONNOR

At last, a lady joined the Supremes

Just when Americans had Ronald Reagan pegged as the most backward-thinking President to occupy the Oval Office since the days of "Silent Cal" Coolidge, the Gipper delivered one of his most surprising, far-sighted policy gambits: In 1981 he named Sandra Day O'Connor as the first woman justice of the U.S. Supreme Court. The jurist was a child of the West who grew up on the Lazy B ranch, a 260-square-mile tract of dust and cactus on the Arizona–New Mexico border. Young Sandra attended Stanford Law School, where she met future husband John; they wed in 1952. She served as majority leader of the Arizona state senate before arriving in the nation's capital, where the ardent athlete found a new tennis partner—Vice President George Bush's wife, Barbara. O'Connor earned respect by weathering a public bout with breast cancer and a mastectomy in 1988.

MARGARET THATCHER

Maggie waived the rules

And you thought Winston Churchill was resolute! The grocer's daughter took power as Britain's prime minister in 1979. Before long, the unflappable Tory was bringing her own version of Ronald Reagan's conservative revolution to the U.K., picking (and winning) fights with organized labor and privatizing many of her nation's government-operated institutions. When Argentina invaded the obscure Falkland Islands in 1982, Maggie set her jaw, went to war and took 'em back. She outlasted the decade, resigning as P.M. in November 1990.

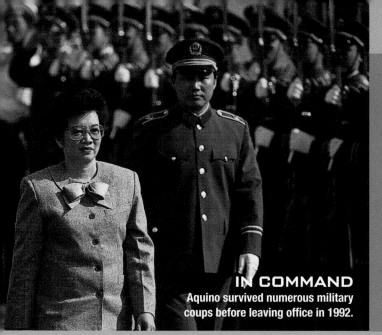

IN COMMAND
Aquino survived numerous military coups before leaving office in 1992.

CORAZON AQUINO

She personified People Power

She was an unlikely revolutionary, but after her husband, Benigno, an avowed opponent of Filipino strongman Ferdinand Marcos, was assassinated before her eyes, Corazon Aquino took up his mantle. She stunned Marcos when she won a 1986 presidential election he thought he had fixed, and when he refused to yield, she led a People Power uprising that drove the dictator from his perch.

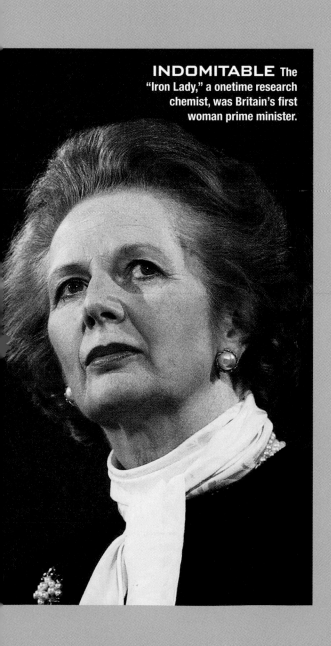

INDOMITABLE The "Iron Lady," a onetime research chemist, was Britain's first woman prime minister.

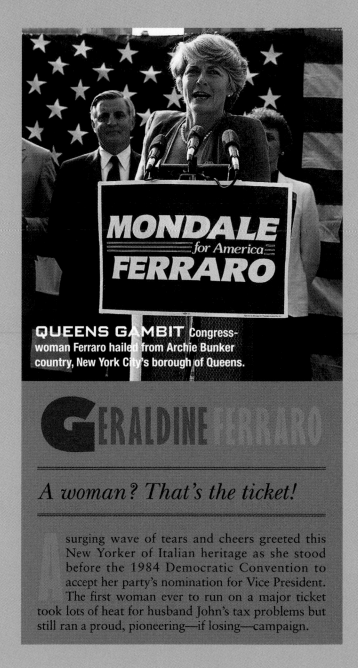

MONDALE *for America* **FERRARO**

QUEENS GAMBIT Congresswoman Ferraro hailed from Archie Bunker country, New York City's borough of Queens.

GERALDINE FERRARO

A woman? That's the ticket!

A surging wave of tears and cheers greeted this New Yorker of Italian heritage as she stood before the 1984 Democratic Convention to accept her party's nomination for Vice President. The first woman ever to run on a major ticket took lots of heat for husband John's tax problems but still ran a proud, pioneering—if losing—campaign.

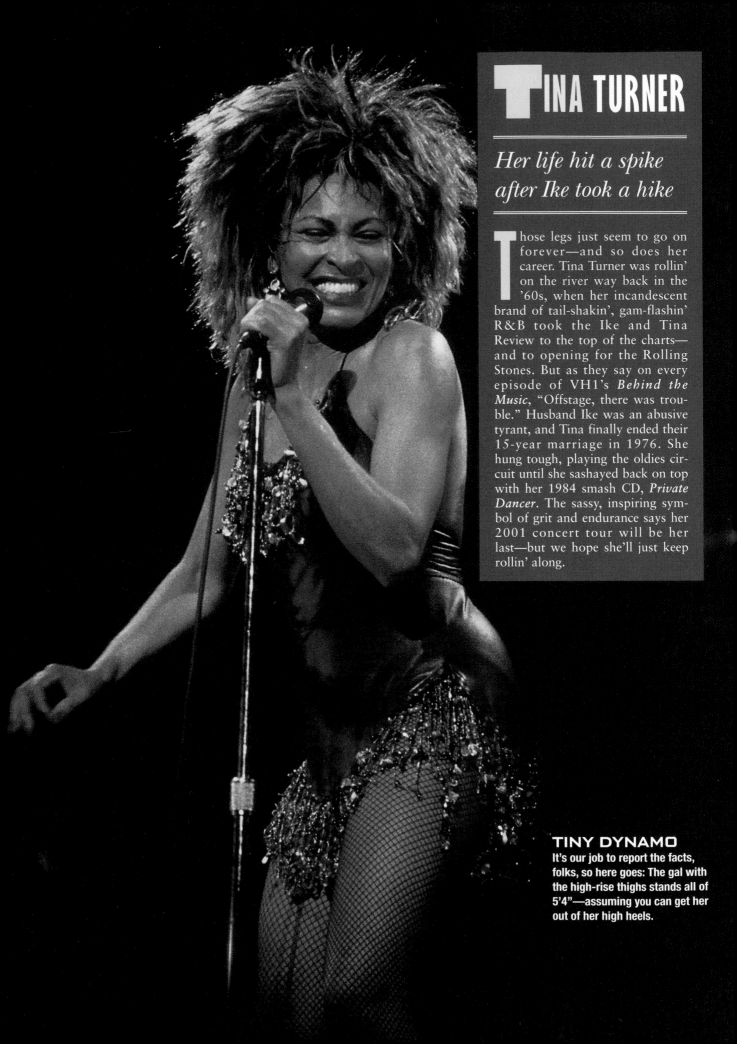

TINA TURNER

Her life hit a spike after Ike took a hike

Those legs just seem to go on forever—and so does her career. Tina Turner was rollin' on the river way back in the '60s, when her incandescent brand of tail-shakin', gam-flashin' R&B took the Ike and Tina Review to the top of the charts—and to opening for the Rolling Stones. But as they say on every episode of VH1's *Behind the Music,* "Offstage, there was trouble." Husband Ike was an abusive tyrant, and Tina finally ended their 15-year marriage in 1976. She hung tough, playing the oldies circuit until she sashayed back on top with her 1984 smash CD, *Private Dancer.* The sassy, inspiring symbol of grit and endurance says her 2001 concert tour will be her last—but we hope she'll just keep rollin' along.

TINY DYNAMO
It's our job to report the facts, folks, so here goes: The gal with the high-rise thighs stands all of 5'4"—assuming you can get her out of her high heels.

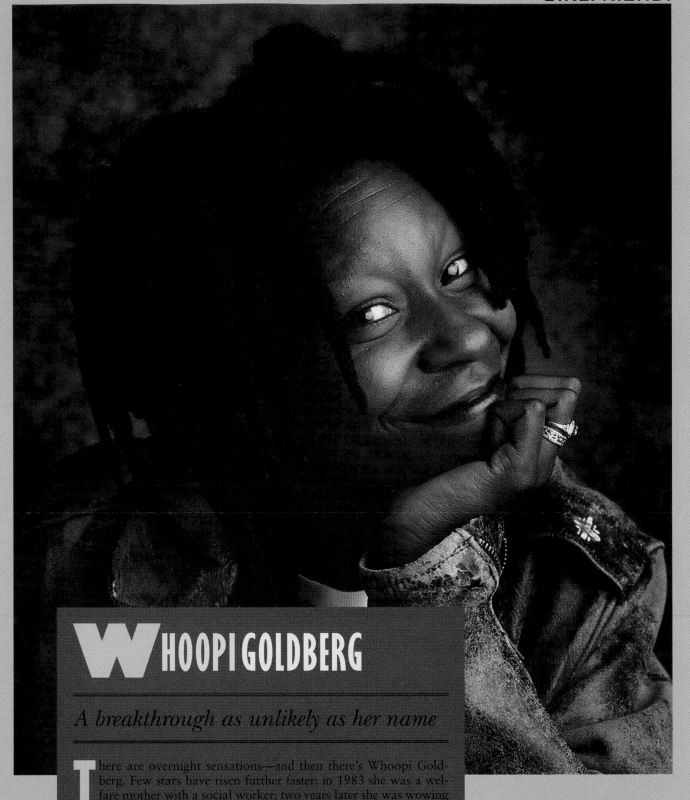

WHOOPI GOLDBERG

A breakthrough as unlikely as her name

There are overnight sensations—and then there's Whoopi Goldberg. Few stars have risen further faster: in 1983 she was a welfare mother with a social worker; two years later she was wowing Broadway, jivin' through an HBO special and playing the lead in Steven Spielberg's *The Color Purple*. An East Village hippie in the '60s, she drifted out of an early marriage and off to the West Coast, where she worked odd jobs—including a stint as a beautician in a morgue—while doing improv comedy. When she took her one-woman show with its cast of spaced-out characters—an airhead surfer, a junkie burglar—to New York City, critics hailed her, Broadway beckoned ... and next day on her dressing room they hung a star.

MAKIN' WHOOPI
Born Caryn Johnson in a Manhattan housing project, she adopted her whimsical showbiz moniker in the mid-'70s, when she first began acting in San Diego. "The name came out of the blue," she told PEOPLE.

RICHARD SIMMONS

Admit it: He made you smile

That curly hair! That silly grin! That exuberant spirit! And—yes—those god-awful short shorts. It could only be America's foremost proponent of breakin' out your beauty by shakin' your bootie, Richard Simmons. Already popular as the author of two bestselling diet books and as host of a syndicated TV exercise show, Simmons branched out in 1982 when he recorded his first CD of music to exercise by, *Reach*. Richard told PEOPLE, "I did one take of 'You Can Do It,' and the song meant so much to me I started to cry and had to be driven home." Imagine how his listeners felt.

JUMP IN THE LINE Say what you will, Richard has a gift for sharing his over-the-top exuberance.

LADY'S MAN To hone Tootsie's Southern accent, Hoffman played the role of Blanche DuBois in *A Street-car Named Desire* for an audience of one: Meryl Streep.

TOOTSIE

She went on a roll—and we ate it up

Talk about irony: Hollywood never seems to create enough good roles for women—and when a good one finally comes along, the part is stolen by a man! The result: *Tootsie*, the box-office phenomenon of 1983, in which Dustin Hoffman played an unemployed actor who impersonates a woman to win a part on a TV soap. To achieve his startling gender bender, Hoffman underwent a daily three-hour close encounter with the makeup crew. He told PEOPLE he based Tootsie's plucky character on his mother, Lillian: "her strength, her vulnerability, her vitality." Sadly, Lillian died at 72, before "her" movie opened.

DR.RUTH
WESTHEIMER

She had the R$_x$ for good sex

Maybe it was the accent: When Dr. Ruth Westheimer opened her mouth and uttered the naughtiest things you'd ever heard in public—well, it all sounded as innocent as something Donald Duck's weird uncle from Vienna might say. Whatever her secret, she rode her phone-in talk show to national syndication and a growing reputation as America's First Lady of Love. The 4'7" dynamo fled Nazi Germany for Switzerland in 1939, then did time on a kibbutz in Israel before studying psychology at the Sorbonne. In America, she found, "they talk about sex from morning to night." Soon enough, so did she—profitably.

NOW HEAR THIS "I'm like a Jewish mother," the good doctor boasted, "A Jewish mother who talks explicitly."

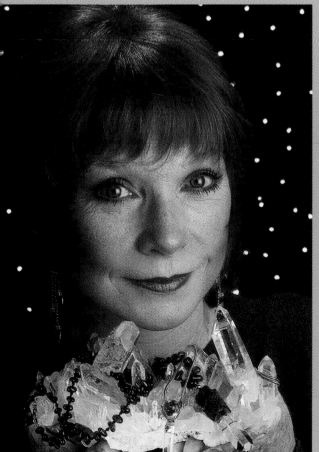

SHIRLEY MACLAINE

Her life was intense, in the past tense

Shirley surely lived the showbiz dream, finding fame after being plucked from the chorus line to replace Carol Haney on Broadway in *The Pajama Game*. But that was only in this life, you understand: It was in her 1983 book, *Out on a Limb,* that this veteran Hollywood star first revealed that she not only believed in reincarnation but also could remember many of her previous lives. By the time she played herself in a 1987 TV miniseries based on the book, she had become the much-lampooned poster gal for the crystal-embracing, aura-chasing brand of '80s spirituality we came to call New Age.

OLD SOUL? The longtime star won the Best Actress Oscar for playing Debra Winger's mom in 1983's *Terms of Endearment.*

Family Ties

FIRST COMES LOVE, THEN COMES MARRIAGE, THEN COMES PRIME-TIME ADULTERY ENDING IN BIZARRE DEATH

Dynasty

Happy families are all alike—boring. It's the crazed clans we need for trauma and drama

It was just another week in the life of Denver's wealthy Carrington clan: first a heart attack, then a fatal fight and finally a possible kidnapping. Not to worry: No humans were harmed in the making of the 1982 season-ending episode of *Dynasty*. Reality, however, showed stretch marks.

Prime-time TV in the '80s mined America's living rooms for every kind of show. Looking for laughs? Sitcoms like *Family Ties*, *Family Matters* and the ratings-ruling *Cosby Show* gave us domestic life as a nonstop cavalcade of nutty events. Seeking relationships? *Thirtysomething* caught the anxiety of young yuppies settling into parenthood. And for those craving over-the-top soap operas with a tongue-in-cheek twist, there were the great prime-time gangbangs: *Dallas, Dynasty, Flamingo Road* and *Knot's Landing*. The formula was simple: gorgeous guys and gals with gobs of money getting into heaps of trouble. When—Eureka!—*Dallas* ushered in the era of the cliff-hanger, ending its 1980 season with us asking, "Who shot J.R.?," the body count escalated. In 1981 *Flamingo Road* pushed Morgan Fairchild down a staircase, *Knots Landing* drove Don Murray off a cliff and *Dallas*, for an encore, drowned Mary Crosby. Now that's entertainment.

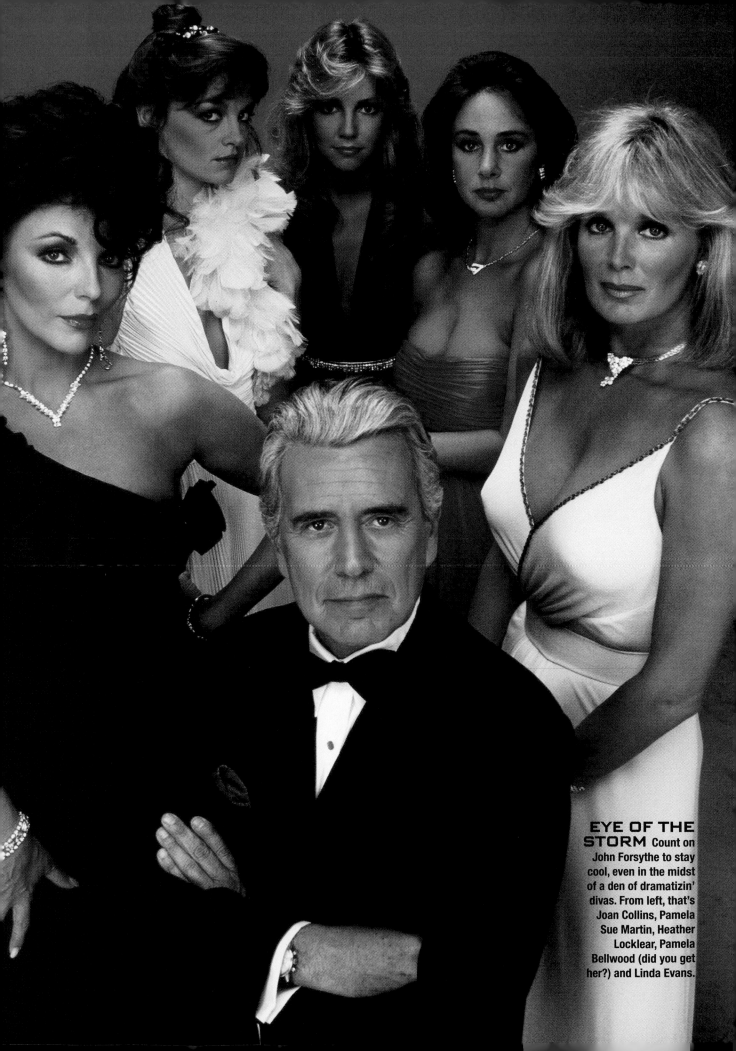

EYE OF THE STORM Count on John Forsythe to stay cool, even in the midst of a den of dramatizin' divas. From left, that's Joan Collins, Pamela Sue Martin, Heather Locklear, Pamela Bellwood (did you get her?) and Linda Evans.

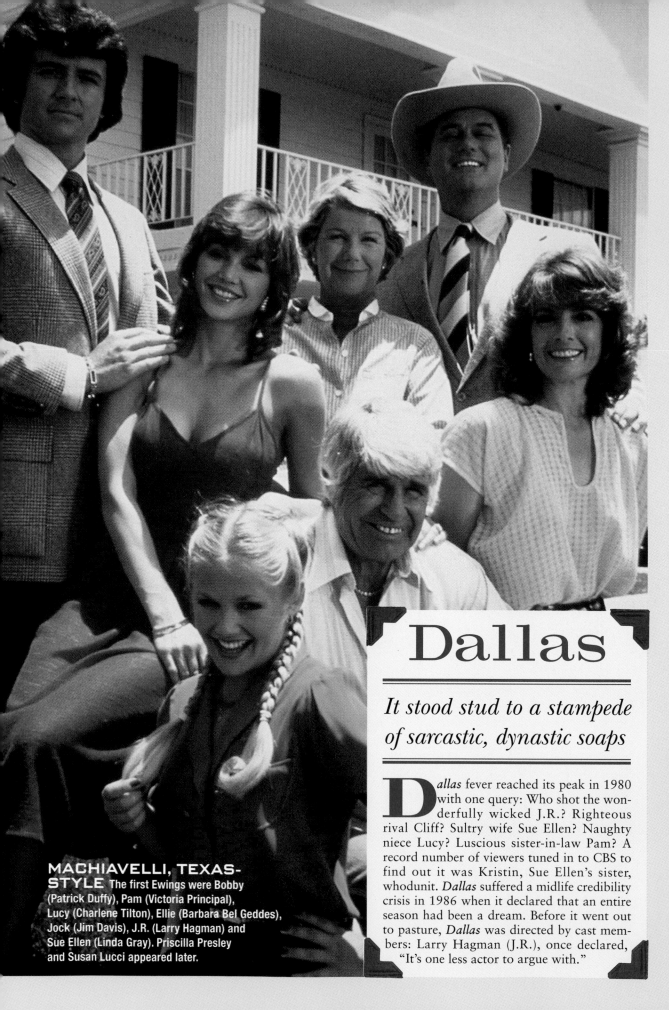

MACHIAVELLI, TEXAS-STYLE The first Ewings were Bobby (Patrick Duffy), Pam (Victoria Principal), Lucy (Charlene Tilton), Ellie (Barbara Bel Geddes), Jock (Jim Davis), J.R. (Larry Hagman) and Sue Ellen (Linda Gray). Priscilla Presley and Susan Lucci appeared later.

Dallas

It stood stud to a stampede of sarcastic, dynastic soaps

Dallas fever reached its peak in 1980 with one query: Who shot the wonderfully wicked J.R.? Righteous rival Cliff? Sultry wife Sue Ellen? Naughty niece Lucy? Luscious sister-in-law Pam? A record number of viewers tuned in to CBS to find out it was Kristin, Sue Ellen's sister, whodunit. *Dallas* suffered a midlife credibility crisis in 1986 when it declared that an entire season had been a dream. Before it went out to pasture, *Dallas* was directed by cast members: Larry Hagman (J.R.), once declared, "It's one less actor to argue with."

Knots Landing

A spin-off in a cul-de-sac

This suburban series, like *Dallas*, drew its enduring appeal from the usual sudsy shenanigans: affairs, politics, pregnancy and, especially, murder. The major troublemaker in Seaview Circle was evil Abby Cunningham, played by the deliciously witchy Donna Mills (seated in red). Fourteen years on the air, *Knots* outlasted the other prime-time soaps, perhaps because of its relatively literate scripts, focus on the younger characters and inspired casting (respected thespian Julie Harris was on for six years). One highlight was Alec Baldwin as a sexy TV evangelist. He enjoyed "sucking the lips off" co-star Lisa Hartman, but left the show abruptly in a death plunge, *Knots's* unique mode of cast downsizing.

POOR RELATIONS *Dallas's* Gary Ewing (left, actor Ted Shackelford with TV wife Valene, played by Joan Van Ark) was J.R. Ewing's black-sheep of a brother who went west and set up house in an upper-middle-class Southern California suburb. The focus was on cool cars instead of oil czars.

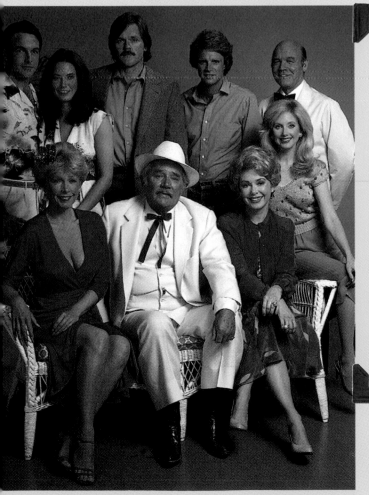

Flamingo Road

This knockoff boasted Southern belles—and a cast of ding-dongs

Set in Truro, Fla., this sex-and-power saga was based on a 1940s-era novel and movie about small-town corruption and was produced by the folks responsible for the lordly *Dallas*. Too trashy for many viewers, with a casino and brothel in the mix, the campy collage of revealing lingerie, vigorous groping and frequent cold showers failed to arouse watchers, and NBC dropped the show in 1982 after just two seasons. Mark Harmon (in jungle shirt), poorly cast as an adulterous politician, said big egos were a problem, along with thin scripts: "People were worried about their hair being out of place."

DEAD-END STREET Morgan Fairchild, the blonde in blue, claimed that appearing on *Flamingo Road* ruined her career. Considered a budding comedienne prior to the evening soap, she complained, "Now I'm a plastic bitch." The Rev. Jerry Falwell also singled her out for special mention—damnation!

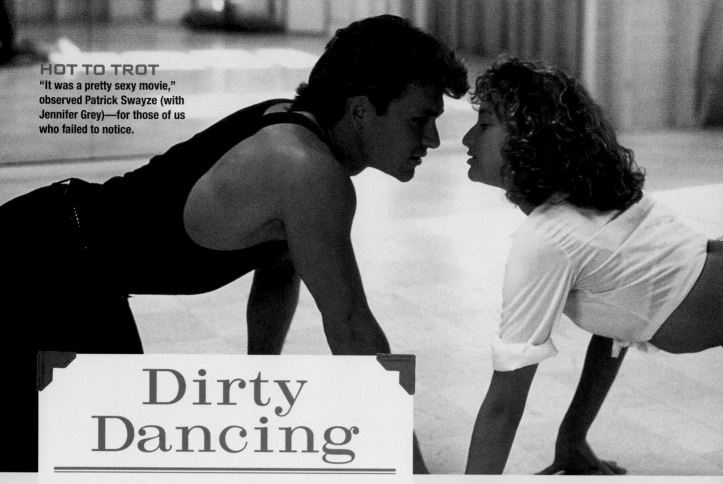

HOT TO TROT
"It was a pretty sexy movie," observed Patrick Swayze (with Jennifer Grey)—for those of us who failed to notice.

Dirty Dancing

Lazy, hazy, Swayze days of summer

A low-budget ($7 million) love story set in the Catskills circa 1963, *Dirty Dancing* starred two virtual unknowns: Patrick Swayze, a Joffrey Ballet vet from Texas, and Jennifer Grey, daughter of Broadway's *Cabaret* imp, Joel. Against all odds, the 1987 romance grossed more than $170 million, won an Oscar for the song "(I've Had) the Time of My Life" and remains a classic. Why? "The innocence of first love," said Grey. Well, that—and the thrill of first sex!

The Lambada

A sexy dance was a flash in the pan

Before the macarena, there was the lambada. With its Afro-Brazilian-Caribbean rhythms, this meat grinder of a dance was a smash with European couples at decade's end. But attempts to hype the "forbidden dance" to U.S. rug cutters via low-budget movies and frothy music resulted in a pop-culture "faux fad."

FORBIDDEN
We wish! B movies *Lambada* featu saucy lovers danc ascloseastl

Footloose

Wow! An actor raced a tractor!

Capitalizing on the box-office success of 1983's *Flashdance*, 1984's *Footloose* starred Kevin Bacon as a rebellious big-city boy fightin' to bring dancing and rock music to a stuffy, prudish Midwestern town. (Video tip: Watch for a young Sarah Jessica Parker in a small role.) The film was helped along by two Oscar-nominated hits, Kenny Loggins's bubbly title track and "Let's Hear It for the Boy." In 1998 the lightweight film became—a lightweight Broadway musical.

DOUBLE-JOINTED
Kevin Bacon at first balked at using a dance double, saying, "It's an assault on the actor's fragile ego." He gave in for the film's showier shots.

Flashdance

She had all the right moves

Sporting an artfully torn sweatshirt that launched a thousand rips, Yale University student Jennifer Beals soared to stardom in 1983's *Flashdance*. This improbable but lively tale of a Pittsburgh welder by day who tears up the dance floor at night changed the way movies were marketed: The studio used music videos in heavy rotation on MTV to help the film become a blockbuster. The catchy theme song, "Flashdance … What a Feeling," sung by Irene Cara, captured an Oscar.

SLIPPERY WHEN WET
Most of Beals's dance steps were performed by French stand-in Marine Jahan—but not this one.

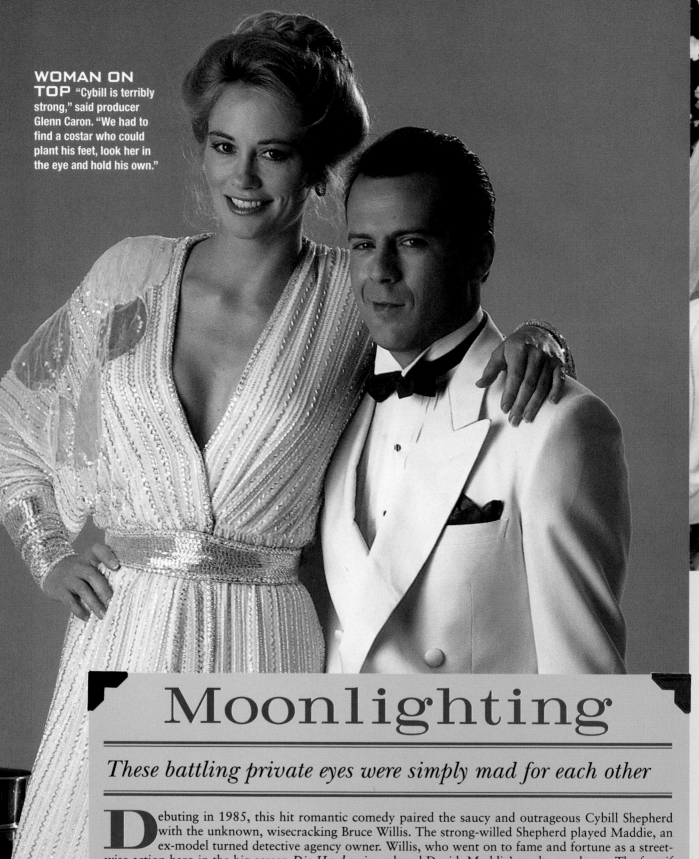

WOMAN ON TOP "Cybill is terribly strong," said producer Glenn Caron. "We had to find a costar who could plant his feet, look her in the eye and hold his own."

Moonlighting

These battling private eyes were simply mad for each other

Debuting in 1985, this hit romantic comedy paired the saucy and outrageous Cybill Shepherd with the unknown, wisecracking Bruce Willis. The strong-willed Shepherd played Maddie, an ex-model turned detective agency owner. Willis, who went on to fame and fortune as a streetwise action hero in the big-screen *Die Hard* series, played David, Maddie's cocky employee. The fun, if farcical, plots often had hip smirkmeister David lusting after sexy, madcap Maddie (though they reportedly clashed offscreen). Shepherd's pregnancy, which caused production problems and resulted in twins, was written into the show. Packing a .38 revolver in real life, the bossy Shepherd even dictated her wardrobe on the set, refusing to wear high heels, which she once called "a form of bondage."

General Hospital

The wedding of the century—not!

The world came to a halt one Tuesday in November 1981. From college campuses to executive suites, soap opera fans convened to watch Luke (Tony Geary), a legendary bad boy, and Laura (Genie Francis), his long-time love, walk down the aisle on *General Hospital*, the durable daytime series that debuted in 1963. Their wedding reception in the fictional Port Charles was a fiasco, with the groom ending up in a brawl and the bride leaving in tears. Not a good omen, but it wasn't surprising either for a couple whose relationship started with a date rape. Mysterious special guest Helena Cassadine (played by *GH* devotee Liz Taylor, who begged the producers for a part) put a curse on the couple for good measure. In the presence of Taylor's star power, Geary forgot his lines, explaining, "I got lost in her violet eyes."

HAPPILY EVER AFTER?
Laura (Francis) was gone from the series within the year, and Luke (Geary) was quickly upstaged by younger studs on the show.

Cheers

Forget the seven-year itch; they enjoyed a five-year tease

Shelley Long (who played uptight Diane to Ted Danson's all-man Sam) left the show five years into *Cheers's* marathon run on NBC. Three alternate endings of their parting were shot for 1987's season closer, all leaving room for her return. "I think the relationship had been done," said Danson. The gang was not exactly broken up over Long's departure—the witty sitcom continued its phenomenal success for another six years with Kirstie Alley joining the ranks, but Long returned for the classic show's finale, just in time to turn out the lights.

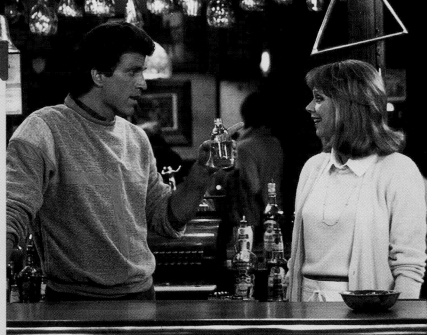

OPPOSITES ATTRACT
Former big-leaguer Sam (Danson) pitched woo to artsy grad student Diane (Long).

REPEAT OFFENDERS

"I never wanted to be the sex-god idol of the universe," said the humble Johnson, with "new" bride Melanie Griffith.

Don & Melanie

They gave love a chance ... then another chance ... and then ...

Don Johnson must be a softy. Just when he had reunited with one old flame, Patti D'Arbanville, he offered moral support to ex-wife Melanie Griffith when she entered rehab in 1987 while filming *Working Girl.* Talk about a long, strange trip: The two first met in 1972 on a movie set (her mom is actress Tippi Hedren), lived together the next year (she was 15, he was 23), married and divorced quickly, thought it over after her rehab, remarried (Griffith was pregnant) in 1989— then divorced again in 1995! Ah, Hollywood.

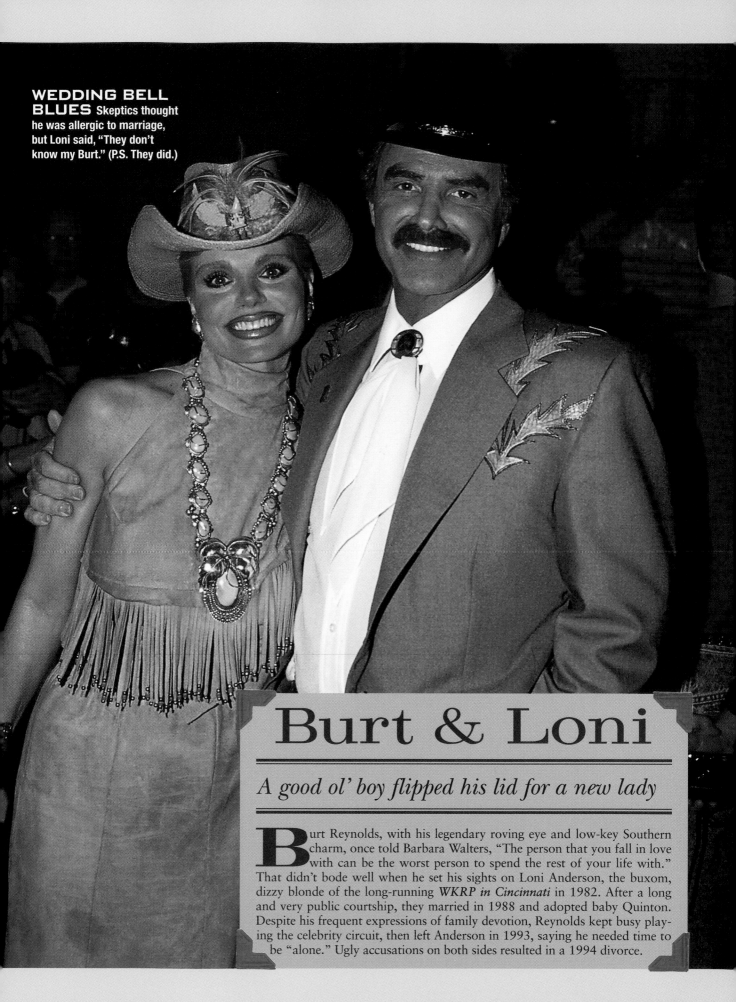

WEDDING BELL BLUES Skeptics thought he was allergic to marriage, but Loni said, "They don't know my Burt." (P.S. They did.)

Burt & Loni

A good ol' boy flipped his lid for a new lady

Burt Reynolds, with his legendary roving eye and low-key Southern charm, once told Barbara Walters, "The person that you fall in love with can be the worst person to spend the rest of your life with." That didn't bode well when he set his sights on Loni Anderson, the buxom, dizzy blonde of the long-running *WKRP in Cincinnati* in 1982. After a long and very public courtship, they married in 1988 and adopted baby Quinton. Despite his frequent expressions of family devotion, Reynolds kept busy playing the celebrity circuit, then left Anderson in 1993, saying he needed time to be "alone." Ugly accusations on both sides resulted in a 1994 divorce.

STONED AGAIN?

Mick and Jerry in 1987 on a not-so-heavenly vacation in Barbados; Hall had just been busted for pot possession. She was later cleared.

Mick & Jerry

A long tall Texan lassoed rock's Mr. Lips

For Rolling Stones frontman Mick Jagger, the early '70s were the era of Bianca—and excess. In the '80s he settled down with the lovely model Jerry Hall. A couple since 1976, they finally married in a Hindu ceremony on Bali in 1990. The union produced four little Stones—until 1999, when Mick's antics led to divorce. England's High Court ruled the Bali nuptials void: neither partner was a Hindu!

Hef & Kim

The top Playboy decided to play house

The groom wore a black tux. The bride was also clothed, which was more than you could say of her appearance the month before, when she was … uh … unveiled as *Playboy*'s Playmate of the Year. The July 1989 wedding was a shocker: Head Playboy Hugh Hefner, 63, had long been the sultan of sex without strings. Hef claimed he proposed to Kimberly Conrad, 26, over a romantic game of Foosball. But in the Age of Viagra, Hefner reverted to form: He split with Kim in 1998 and can now be seen squiring a posse of seven (count 'em) Young Things around Hollywood.

PARTY POOPER

After the vows, Kim put a stop to the Playboy Mansion's famed fleshfests; female guests began wearing swimsuits by the pool.

Billy & Christie

Wedding witness: the Statue of Liberty

Bon Voyage! In 1985 piano man Billy Joel married his "Uptown Girl," model Christie Brinkley, in New York Harbor on a (rented) 147-ft. yacht, the *Riveranda*, festooned with a thousand white tulips. Though Christie said the nautical nuptials reflected the couple's love of the sea (pre-wedding, they had been known to register at motels as "Rocky and Sandy Shore"), Billy admitted that the boat ride was to ditch the press. The couple met in 1983, shortly before Christie's ex-boyfriend, Olivier Chandon, a race-car driver and heir to the Moët & Chandon champagne fortune, was killed in a wreck. Daughter Alexa Ray was born in 1985, but the marriage hit the rocks in the '90s; they split up in 1994.

KEYED UP They met cute, when Billy was noodling at a piano in a hotel bar. Christie called him "Joe."

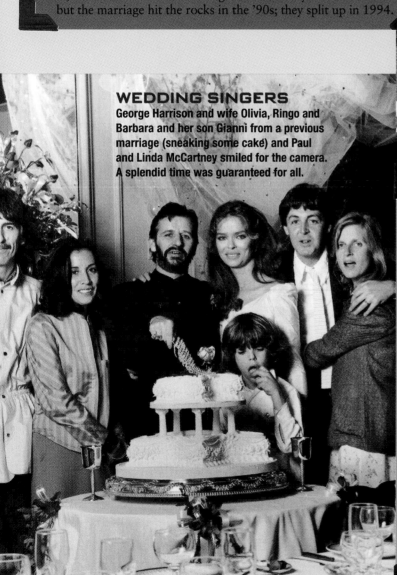

WEDDING SINGERS
George Harrison and wife Olivia, Ringo and Barbara and her son Gianni from a previous marriage (sneaking some cake) and Paul and Linda McCartney smiled for the camera. A splendid time was guaranteed for all.

Ringo & Barbara

Flash! Bach, Beatles unite

Of the four weddings shown here, this 1981 affair takes the cake: Ringo Starr and Barbara Bach are the only couple still together. Their romance blossomed after the two met on the set of 1980's *Caveman*. Paul McCartney and George Harrison joined the happy pair at the reception at Rags, a London club; it was the first reunion of the three remaining Beatles since John Lennon's tragic murder in 1980. And what a wedding band it was: Paul, George and Ringo jammed on piano, guitar—and a champagne bucket. Ringo and Barbara had some tough spells through the '80s but finally ditched their drinking problems together, in time for Ringo to mount the first of his many "All-Starr" tours in 1989.

Boy in the Bubble

He was isolated, but not from love

He was known to the world only as David and he was barred from touching others—physically. Known as the Bubble Boy, he spent all but the last 15 days of his 12 years in germ-free isolation, becoming the oldest survivor of a rare disorder, severe combined immunodeficiency. Even the mildest of germs in the air we breathe could have been fatal to him. It was the second time that his parents, David Sr. and Carol Ann, of Houston, had been touched by SCID. In 1970 their first son was diagnosed with the ailment when he was 5 months old, and died shortly thereafter. They decided to keep their second son isolated from birth (at a cost of $1.3 million, covered by federal and private research grants), buying him a few years of sequestered life. But after a bone-marrow transplant failed, the brave kid's body gave out in February 1984.

DON'T TOUCH Mom Carol Ann gave David a hug and kiss through the bubble; following his death, his parents were overwhelmed by letters of consolation from around the country.

Baby Jessica

All's well that ends well

The world seemed to stop for three days in mid-October 1987 as we watched the residents of Midland, Texas, struggle heroically to rescue Jessica McClure. When young mom Cissy had briefly stepped into her home, "Baby Jessica," busy playing in her backyard with four other toddlers, fell into an abandoned well. For long hours the 18-month-old was entombed, sometimes singing "Winnie the Pooh" to the frantic crews laboring to reach her by digging a parallel shaft. After 58 hours, the tenacious 21-lb. tyke emerged, safe at last.

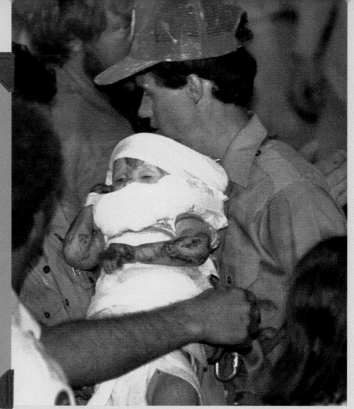

HOMEWARD BOUND Jessica's rescuers tried to reassure her help was on the way. Said one: "We promised her a Cadillac if she'd stop crying."

WHOSE CHILD IS IT? Surrogate mom Mary Beth Whitehead and husband Richard, right, called "Baby M" Sara Elizabeth; father Henry Stern, below with the infant, and wife Elizabeth called her Melissa Elizabeth. In 1987 Judge Harvey Sorkow called her the Sterns'.

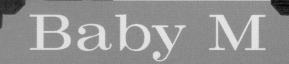

Baby M

She was trapped in a tug-of-war

Surrogate parenting: The newfangled idea seemed promising to New Jersey biochemist William Stern and his wife Elizabeth, a pediatrician, who carried the gene for multiple sclerosis. So they paid $10,000 to a surrogate, Mary Beth Whitehead, to bear William's child. But Whitehead decided she didn't want to give up the child—so her husband snatched the baby and ran to Florida. The Sterns sued to gain control of the baby. After 22 months of agony for all, and a 32-day trial, a judge ruled that the Sterns were the lawful parents.

Family Ties

Mom, Dad and the mini-Milken

This generation-gap comedy, reportedly President Reagan's favorite, showed the clashing values of liberal, '60s-era parents and their conservative, '80s-era kids. Yuppie-in-training Alex, played by Canadian unknown Michael J. Fox (who went on to *Back to the Future* fame), worshipped William F. Buckley Jr., while sister Mallory (Justine Bateman, whose career went flat) was an empty-headed mall rat. After seven hugely successful seasons, *Family Ties* signed off in 1989. Michael Gross, who had the "Dudley Do-Dad" role, said no sequels were in the offing: "We won't age as well as the Bradys." Lovable superstar Fox later sparkled on TV's *Spin City*, leaving in 2000 to battle Parkinson's disease.

GOODBYE, COLUMBUS Michael Gross and Meredith Baxter-Birney rode herd over the three Keaton kids, played by Tina Yothers, Michael J. Fox and Justine Bateman.

Mr. Mom

Mom works and dad's a jerk? Naah ... ridiculous!

Future Batman Michael Keaton quit the night shift and got a day job in this 1983 altered-ego comedy. *Mr. Mom*'s role reversal had him trading business suits for apron strings, playing a one-time workaholic, newly out of a job, who stayed home while wife Teri Garr became the breadwinner—complete with '80s power shoulder pads. Coping with housework, killer appliances and child care, this house-husband drove himself to drugs, drink and soap operas and became a fixture at a local poker game. Written by John Hughes, better known for his teen-oriented movies, the film struck some as anti-feminist propaganda disguised as belly laughs.

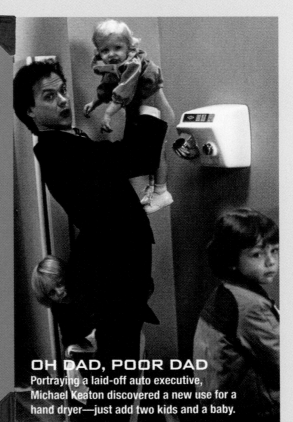

OH DAD, POOR DAD Portraying a laid-off auto executive, Michael Keaton discovered a new use for a hand dryer—just add two kids and a baby.

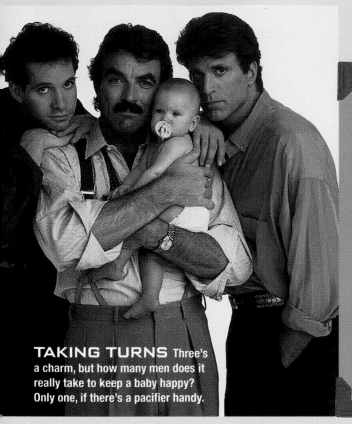

TAKING TURNS Three's a charm, but how many men does it really take to keep a baby happy? Only one, if there's a pacifier handy.

3 Men and A Baby

Fatherhood never looked so funny

An American remake of the hit French film *Three Men and a Cradle,* this 1987 feature charmingly cooed over an abandoned bundle of joy while it chronicled the misadventures of a trio of well-meaning but inept surrogate dads as they heroically attempted to change the baby girl's diapers. The sworn bachelors, sharing quarters and the swinging life in New York, were played by *Police Academy* mainstay Steve Guttenberg, *Magnum P.I.* star Tom Selleck and *Cheers* bartender Ted Danson—not a single nurturer among them. The 1990 sequel returned with the little lady and a snooty English "father."

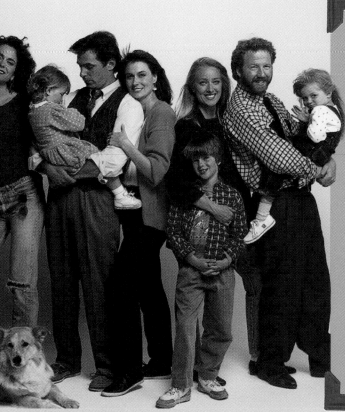

BABY BOOM Skipping the kids and dog, that's (from left) Peter Horton, Melanie Mayron, Polly Draper, Ken Olin, Mel Harris, Patricia Wettig and Timothy Busfield, starring in what ABC called "a new series about life today."

thirty-something

The Big Chill *hit the small screen*

The cult ABC series *thirtysomething,* which lasted just three seasons, followed a group of Philadelphia friends who bore a suspicious resemblance to the heavy-consuming baby-boomers the network was so eager to attract. Struggling with marriages, children, careers and life's mundane challenges, these intense yuppies struck fans as profound, poignant, even hip and funny. To skeptics, they were narcissistic and whiny—pampered parents and mate-hungry singles consumed by angst. Producer Ed Zwick said he knew there was a "whole group of people who tune in every week just to hate us." But critics and the industry loved the talky and intimate style, awarding the show numerous Emmys, including three in 1991—after it was canceled. Yet echoes of the show can still be seen on TV in Zwick's *Once and Again.*

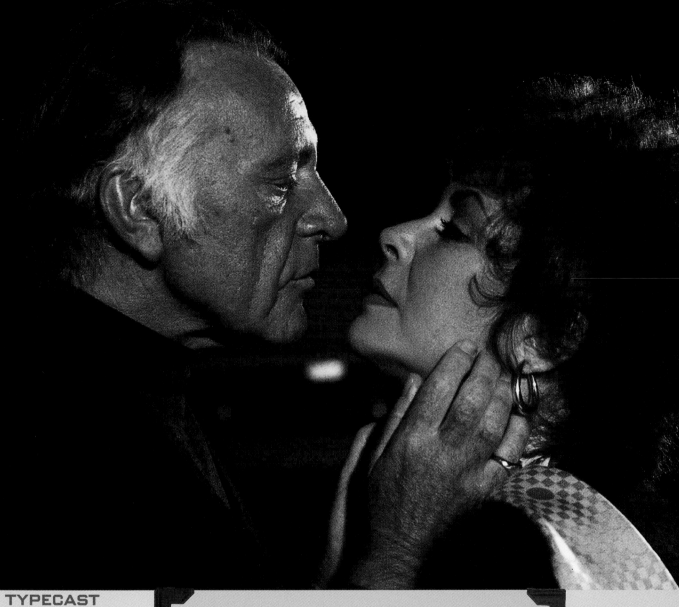

TYPECAST AGAIN A year after their London weekend, Burton and Taylor teamed up for the last time to play the on-again, off-again couple in Noël Coward's *Private Lives* on Broadway.

Liz & Dick

Legendary lovers shared a final fling

London, 1982: After almost 20 years, two marriages, two divorces, 11 movies together, countless quarrels, diamonds galore and enough newsprint to denude Oregon, they did it again: Richard Burton and Elizabeth Taylor reunited, just as Liz turned 50. She was just separated from Sen. John Warner; he had recently split from third wife Susan Hunt. Their romantic weekend sent Liz watchers into a dither, but this time around the combustible pair decided to remain apart, even though Burton admitted, "I bred her in my bones, and I love her passionately ... for some reason the world has always been amused by us two maniacs." Amused—and touched. Two years later, Burton died of a stroke at 58.

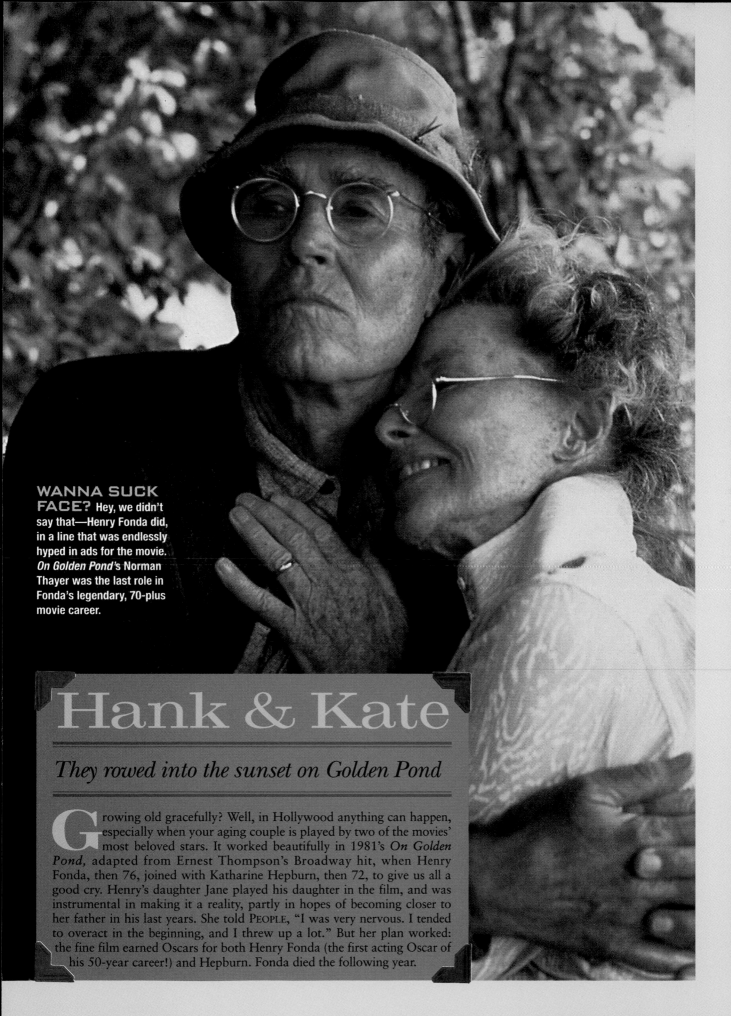

WANNA SUCK FACE? Hey, we didn't say that—Henry Fonda did, in a line that was endlessly hyped in ads for the movie. *On Golden Pond*'s Norman Thayer was the last role in Fonda's legendary, 70-plus movie career.

Hank & Kate

They rowed into the sunset on Golden Pond

Growing old gracefully? Well, in Hollywood anything can happen, especially when your aging couple is played by two of the movies' most beloved stars. It worked beautifully in 1981's *On Golden Pond,* adapted from Ernest Thompson's Broadway hit, when Henry Fonda, then 76, joined with Katharine Hepburn, then 72, to give us all a good cry. Henry's daughter Jane played his daughter in the film, and was instrumental in making it a reality, partly in hopes of becoming closer to her father in his last years. She told PEOPLE, "I was very nervous. I tended to overact in the beginning, and I threw up a lot." But her plan worked: the fine film earned Oscars for both Henry Fonda (the first acting Oscar of his 50-year career!) and Hepburn. Fonda died the following year.

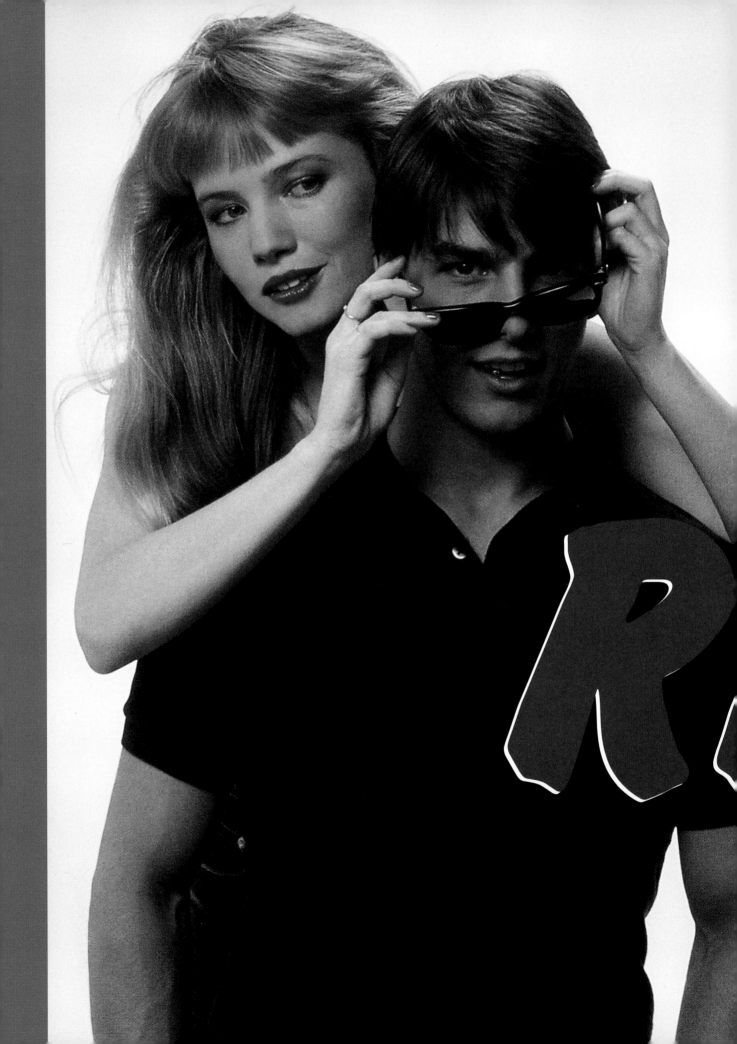

Rebecca & Tom

When Hollywood's youngest heartthrob met the world's oldest profession, sparks (and shades) flew

Ask John Milton or J.R. Ewing: Bad guys are just more fun than good guys. So when Tom Cruise's cool high-schooler teamed up with Rebecca De Mornay's call girl to bring a string of prostitutes to the Chicago 'burbs in 1983's *Risky Business*—well, it all seemed as innocent as Tom's famous Jockey-jivin' lip-sync to Bob Seger's "Old Time Rock 'n' Roll." But off-screen, the '80s featured some unfunny bad behavior, from tabloid fodder like porno pics of Miss America to serious substance abuse in the Hollywood Hills—starring the flashy drug *du jour,* cocaine. Presidential candidates were caught cavorting with party girls on Caribbean yachts, presidential advisers were investigated for trading arms for hostages, and a visionary auto tycoon turned out to be funding his dream car with coke deals. The hit song from *Beverly Hills Cop* caught the mood: "The Heat Is On."

ISKY BUSINESS

IN RONALD REAGAN'S GO-FOR-IT AMERICA, WE CHASED A DREAM OF LIVIN' LARGE—BUT SOME CELEBRITIES FLEW TOO CLOSE TO THE SUN

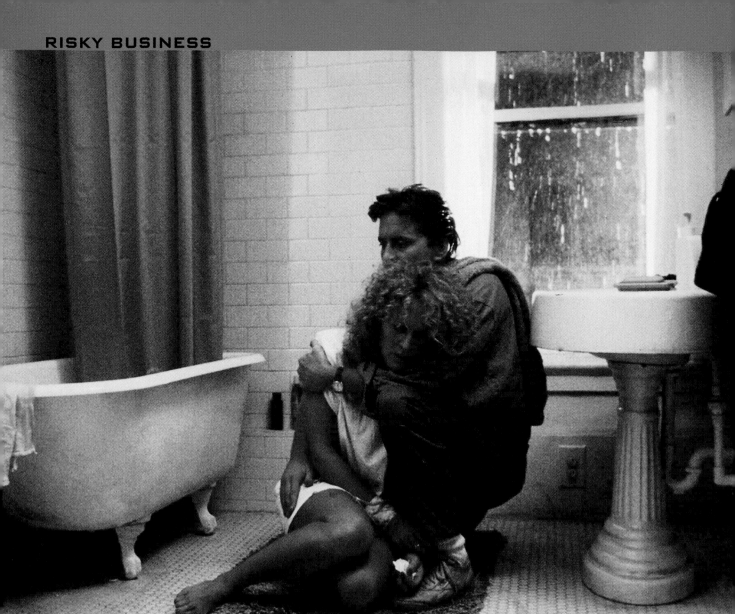

WORLDS COLLIDE

"I think of men and women as two different species," said Close, here with Douglas. She consulted three shrinks for her unhinged role in the 1987 shocker.

Fatal Attraction

A modern morality tale shattered the movie screen

Debra Winger turned it down, but Glenn Close admitted she "really campaigned" for the role of the spurned lover in *Fatal Attraction*. Casting off her stable image, the nearly 40-year-old, multiple Oscar nominee beat out a host of younger actresses to win the part, losing 15 pounds to develop a lean and mean look. In an era of AIDS awareness, Close's searing portrayal of a frightening single lawyer stalking a married philanderer (Michael Douglas) brought new meaning to the term "unsafe sex," and scared countless spouses back to the straight and narrow. "We didn't set out to make a heavy message picture," said co-producer Stanley Jaffe, "but it has struck a chord."

ARMANIED AND DANGEROUS "Don has a serious ego," admitted co-star Thomas (left). "But there is a lot of joy here."

Miami Vice

Crime-fightin' studs ... in designer duds?

Sporting unstructured jackets, pastel T-shirts, no socks and sexy stubble, Don Johnson became America's most-wanted cop as Sonny Crockett on the fast, flashy *Miami Vice*. Joined by equally natty partner Ricardo Tubbs (Philip Michael Thomas), Crockett foiled drug dealers and other baddies with more style than substance. Bolstered by Jan Hammer's trendy synthesizer score, *Vice* zoomed into TV's Top 10 in '85, its sophomore year, but later came in a distant second in a head-on ratings battle with *Dallas*. During its five-season run, *Vice* attracted off-beat guest stars, including Sheena Easton (as Crockett's ill-fated wife), G. Gordon Liddy, Don King and Lee Iacocca. Off-camera, Johnson was known as "Don Jaunson" for his womanizin' ways.

Donna & Gary

Their relation-ship? All Monkey Business

If you were a highly touted candidate for the Presidency seeking a romantic escapade with a Gorgeous Young Woman Not Your Wife, would you think twice before sailing off to Bimini in a ship called the *Monkey Business?* And would you update the definition of "self-destructive behavior" by inviting the press to "put a tail on me" and then continuing your shenanigans? Democrat Gary Hart, the Colorado senator often compared to John F. Kennedy for his intellect, vision and good looks, did just that in 1987. When pics of his Caribbean caper with party gal Donna Rice hit the papers, his campaign went kaput, though he tried a comeback late in the year. Dream on, Gary. Rice has more power in Washington these days, as (what else?) a crusader against Internet porn.

KODAK MOMENT
Gary Hart and Donna Rice watched the birdie in Bimini. The senator's official first mate, wife Lee, was not aboard ship.

Ollie & Fawn

A defiant duo brought derring-do to the West Wing

UNDER OATH
The pair's quest for secrecy bumped paper-shredding into the mainstream: North was once introduced as "the Edward Scissorhands of the Pentagon."

Was he "a national hero," as President Ronald Reagan declared? Or was he a "cowboy in the White House," as critics charged? Even today, your verdict probably reflects your political beliefs. What we all can agree on is that when Lieut. Col. Oliver North, a National Security Advisor to the President, testified before Congress in 1987 about his secret dealings, it made for gripping drama. Facing down his congressional inquisitors, North saw the enemy and let them have it: No, he was not sorry for his role in secretly selling arms to America's sworn enemy, Iran, and illegally funneling the resulting cash to the right-wing Contras fighting Nicaragua's left-leaning Sandinista government. His loyal secretary, the haystack-haired Fawn Hall, conducted a Tammy Wynette Defense, standing by her man and titillating us with tales of concealing essential papers under her skirt. Who knew the Reagan White House was this much fun? North lost a 1994 race for the Virginia senate but remains a well-known commentator for conservative causes.

Robin & Mike

Her burden was a heavyweight

Ah, the Good Life. A glass of champagne to swill, a Tudor mansion to fill—and the heavyweight champion of the world, dressed to kill. Actress Robin Givens, 23, star of the ABC sitcom *Head of the Class,* was the envy of a lot of gals when she snared "Iron" Mike Tyson, 21. They wed early in 1988, but within months rumors spread that Tyson beat his wife, and in September he smashed her silver BMW into a tree, reportedly after telling her he was going to kill himself. The couple divorced in 1989. Our decision on the troubled Tyson: no head, no class.

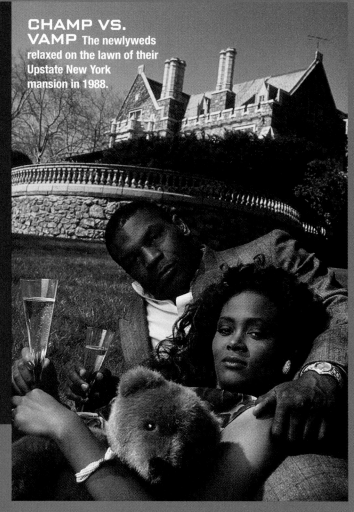

CHAMP VS. VAMP The newlyweds relaxed on the lawn of their Upstate New York mansion in 1988.

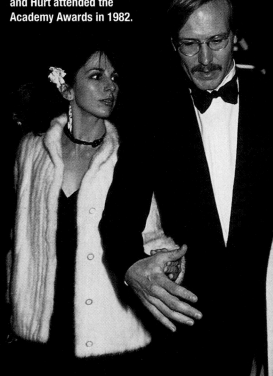

HAPPIER DAYS Jennings and Hurt attended the Academy Awards in 1982.

Sandra & William

Their woes made broadcast news

William Hurt gave memorable performances in some of the decade's best films, from 1981's *Body Heat* to 1983's *The Big Chill,* from 1986's *Children of a Lesser God* to 1987's *Broadcast News.* Along the way he divorced his wife of seven years, actress Mary Beth Hurt, then took up with ballerina Sandra Jennings, with whom he conceived a son during the filming of *Chill.* In 1989 their dirty laundry was aired: She filed suit, arguing she had been his common-law wife, asking for more child support and accusing him of alcohol abuse and physical harm. She lost the suit, but amid the PR damage Hurt almost lost his career and was last seen ... *Lost in Space.*

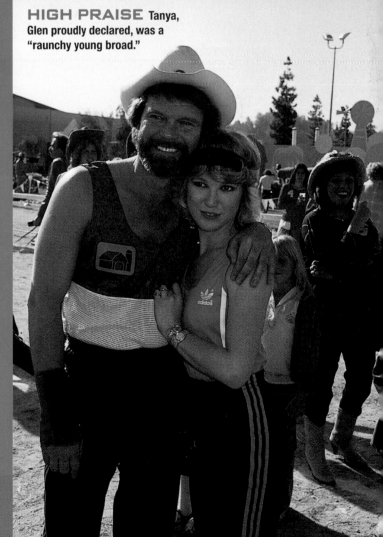

Sean & James

A *real-life* Fatal Attraction

Hate mail began appearing in his mailbox, along with pictures of corpses and dismembered animals. Then he found a mutilated doll at his door. A sequel to *Fatal Attraction?* Not quite. This drama took place in the lives of two of Hollywood's most talented performers, James Woods (*Salvador*) and Sean Young (*No Way Out*). When Woods broke off the affair they began while filming 1988's *The Boost,* Young seems to have gone haywire. Woods filed a $6 million harassment suit against the flighty actress; they settled out of court—and she skedaddled to Arizona.

TANTRUMS Woods and Young in *The Boost:* He broke off their affair at the urging of fiancée Sarah Owen, whom he wed in '89 (they split four months later).

Tanya & Glen

They failed math: 44-21=trouble

When the 44-year-old "lineman for the county" hooked up with Nashville's 21-year-old official bad girl, the result was a country-song staple: heartache. Mr. Campbell fell hard for Ms. Tucker, a country star since age 13—or for her glued-on jumpsuits. It was Texas-born Tanya, long a fan, who called Arkansas-born Glen after his third marriage (to Sarah Davis, former wife of crooner Mac) broke up. "I want to know if there's anything I can do for you," Tanya told PEOPLE she asked Glen. "Yeah, come over and let's sing some songs together," he replied. They didn't stick to music. For the lurid details of their fling, which ended in 1982, consult Glen's 1994 autobiography, *Rhinestone Cowboy:* Highlights include a zonked-out Tucker walking through a plate-glass window and Campbell's own near overdose from freebasing. Maybe that title should have been *Rhinestoned Cowboy.*

HIGH PRAISE Tanya, Glen proudly declared, was a "raunchy young broad."

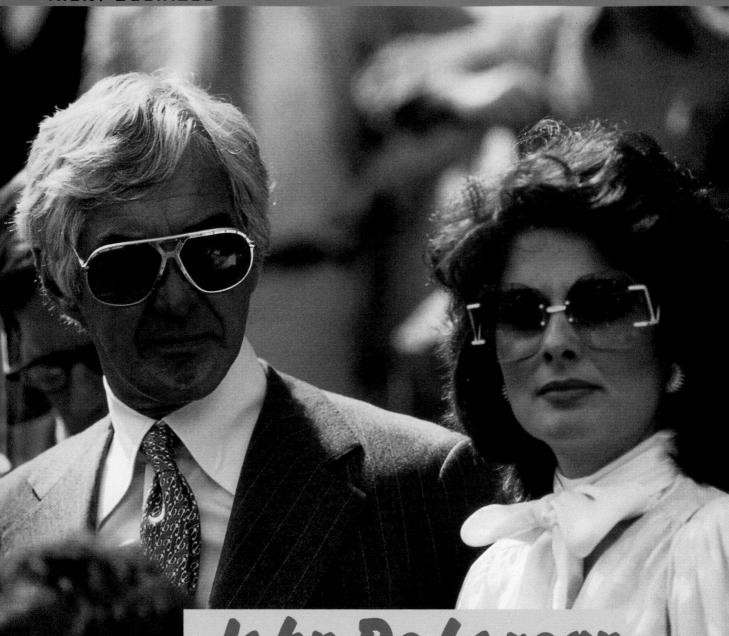

SHADY CAR DEALER

De Lorean's third wife, former model Cristina Ferrare, divorced him soon after cheerleading for him in court. "I hate that car," she said. "It's been the cause of all our troubles."

John De Lorean

This automotive visionary took a detour

Got a scratch on your De Lorean sports car? Just buff it out with steel wool. Yet it wasn't the practical that attracted buyers and investors to this gull-wing, stainless-hull vehicle: The ads for the $25,000 DMC-12 said, "Live the Dream." But in 1982, while searching for funds for his sinking company, charismatic, high-living former General Motors exec John De Lorean was living a nightmare: He was arrested in a drug sting. Though videotaped saying cocaine is "better than gold" (and found guilty in the tabloids) he was eventually cleared on trafficking charges. The company's assets were liquidated—the molds for the futuristic car were dumped in the Atlantic—and the 8,500 De Loreans became collector's items. Meanwhile, John De Lorean retired to private life; he is reportedly at work on a new car, the DII.

John Belushi

A gonzo comic pushed himself over the edge

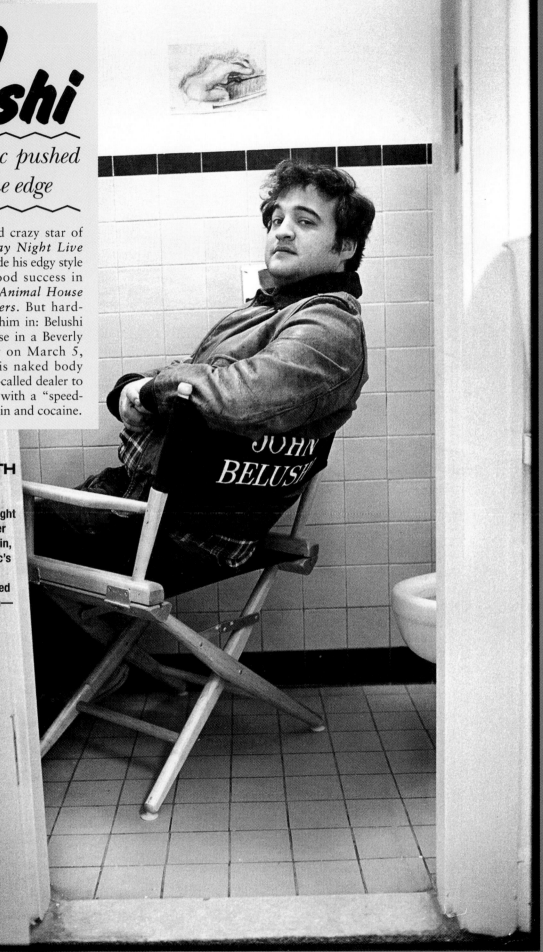

This wild and crazy star of the *Saturday Night Live* ensemble rode his edgy style to Hollywood success in *National Lampoon's Animal House* and *The Blues Brothers*. But hard-partying offscreen did him in: Belushi died of a drug overdose in a Beverly Hills hotel bungalow on March 5, 1982. Police found his naked body after Cathy Smith, a so-called dealer to the stars, injected him with a "speedball," a mixture of heroin and cocaine.

FLIRTING WITH DISASTER "If John hadn't died the week that he did, it might have happened another time," said Judy Jacklin, the party-hearty comic's widow. Fellow Blues Brother Dan Aykroyd led the funeral procession—on a motorcycle.

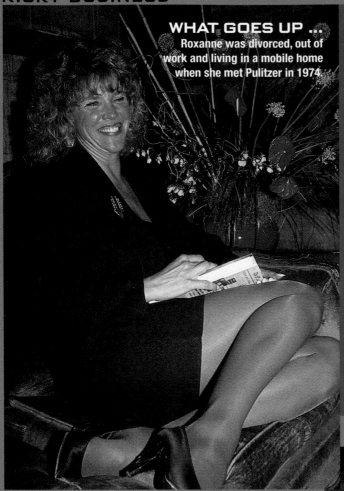

WHAT GOES UP ...
Roxanne was divorced, out of work and living in a mobile home when she met Pulitzer in 1974.

Roxanne Pulitzer

She made Body Heat *look dull*

She lost her marriage to publishing heir Herbert "Peter" Pulitzer Jr., her claims to his $12 million fortune, the custody of their 5-year-old twins, the Palm Beach mansion—and she was branded a marriage wrecker guilty of "gross moral misconduct." In her 1982 divorce case, Roxanne Pulitzer was accused of carrying on with a Grand Prix race driver, a real estate salesman, a drug dealer and a local French baker. And that was just the men. Her loves were also said to include at least one woman; tongues wagged that she had curious uses for musical instruments. Yep, "the strumpet with the trumpet" ... blew it.

Claus von Bulow

Guilty? Innocent? You decide

The case had it all: vast wealth, high society, adultery, nobility. And the facts were so tantalizingly inconclusive that the affair was turned into the haunting 1990 film *Reversal of Fortune.* The question: Did Claus von Bulow, a Newport, R.I., socialite, put his wife Sunny into an irreversible coma by injecting her with an overdose of insulin? Sunny's two children by her first husband, an Austrian nobleman, said yes: Von Bulow, they claimed, wanted $14 million from Sunny's will so he could start a new life with his lover, a soap opera actress. A 1981 jury agreed, but their verdict was overthrown due to poor police procedure. A 1985 jury said no—and Claus walked.

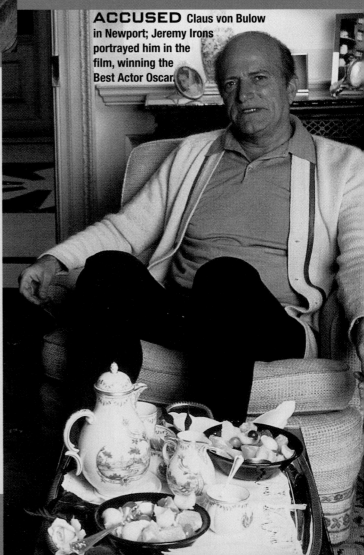

ACCUSED Claus von Bulow in Newport; Jeremy Irons portrayed him in the film, winning the Best Actor Oscar.

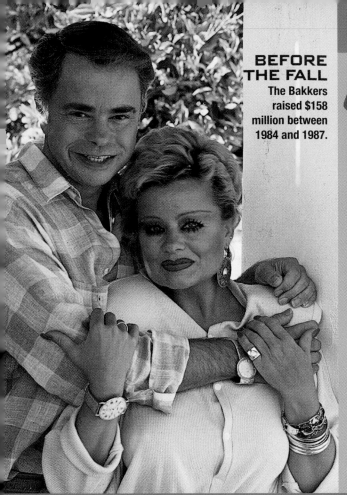

BEFORE THE FALL The Bakkers raised $158 million between 1984 and 1987.

Jim & Tammy Faye

Praise the Lord and Pass the Loot

As many Americans turned their back on the hedonistic days of the '60s and '70s and embraced more conservative values in the '80s, fundamentalist preachers entered the mainstream. These two were among the most prominent: Their *PTL* (Praise the Lord) *Show* peddled a smarmy, weepy brand of evangelism that was long on mascara, tears and organ music—and constant pleas to send cash now. As for the dough, the government argued in a 1989 trial that the Bakkers were mail-fraud grifters, diverting donations from their never-quite-finished Heritage USA theme park to buy preacher comforts—Rolls-Royces, minks and condos. Jim was convicted and served five years; Tammy divorced him, married his former No. 2 man and is back on TV, subsidizing America's mascara industry. Amen.

Jimmy Swaggart

How the mighty have fallen

He called himself an "old-fashioned, Holy Ghost–filled, shouting, weeping, soul-winning, gospel-preaching preacher." And that he was ... on the pulpit. But when he checked into a cut-rate motel along a seedy strip in Louisiana's bayou country with one of the prostitutes he favored, Jimmy Swaggart signed in with the lady's name. He admitted all when he confessed on TV in 1988 that he was a sinner and stepped down from his $150 million global ministry. And who caught Swaggart in the act? Why, a fallen preacher Jimmy had nabbed for adultery the year before. The Lord works in mysterious ways.

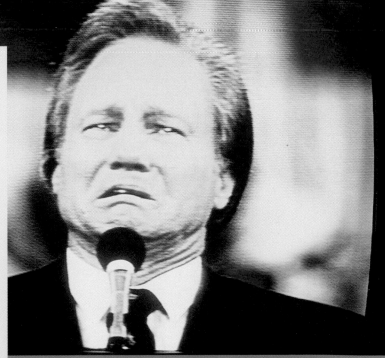

SINNER TUBE Swaggart tears up and 'fesses up on his TV show. As a child he sang in the church choir with his cousin, who later took the highway to hell—Jerry Lee Lewis.

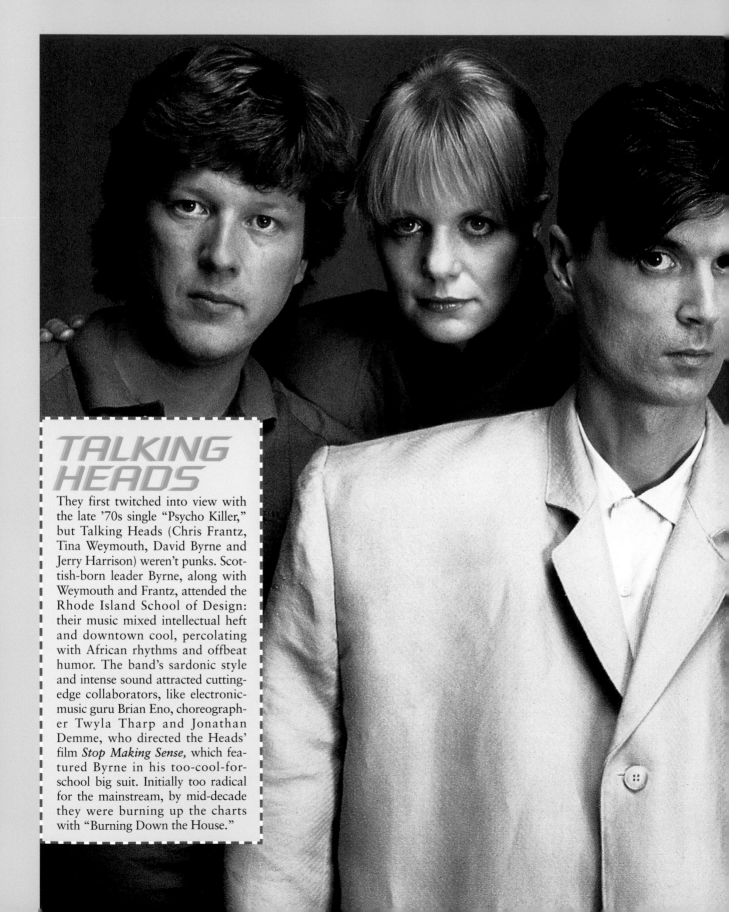

THIS AIN'T

TALKING HEADS

They first twitched into view with the late '70s single "Psycho Killer," but Talking Heads (Chris Frantz, Tina Weymouth, David Byrne and Jerry Harrison) weren't punks. Scottish-born leader Byrne, along with Weymouth and Frantz, attended the Rhode Island School of Design: their music mixed intellectual heft and downtown cool, percolating with African rhythms and offbeat humor. The band's sardonic style and intense sound attracted cutting-edge collaborators, like electronic-music guru Brian Eno, choreographer Twyla Tharp and Jonathan Demme, who directed the Heads' film *Stop Making Sense,* which featured Byrne in his too-cool-for-school big suit. Initially too radical for the mainstream, by mid-decade they were burning up the charts with "Burning Down the House."

NO DISCO!

SAME AS IT EVER WAS? NO WAY. EVEN NEW-WAVERS WENT HOLLYWOOD WHEN '80S KIDS HOWLED "I WANT MY MTV!" AND VIDEO KILLED THE RADIO STAR

MTV

Launched Aug. 1, 1981, MTV (Music Television) revolution-ized pop music. As cable TV took off, this video music channel found a huge audience its first year: its veejays received 100,000 letters a month. Suddenly, music was as much about how you looked as how you sounded. MTV made stars out of telegenic but minor talents like A Flock of Seagulls and sparked controversy by initially excluding black artists—until Michael Jackson's thrilling success shattered the network's color barrier.

DIFFERENT STROKES Spouses Chris Frantz and Tina Weymouth (left) stepped out of David Byrne's shadow to lead the funky Tom Tom Club (their hit was "Genius of Love"), while former Modern Lover Jerry Harrison, right, found success as a record producer.

NEW WAVE

Skinny ties, geeky guys, go-go shoes and beehive 'dos made pop fun again

DEVO

These jokers from Akron, Ohio, combined electronic rock with surreal humor to make groundbreaking music videos. Spouting a bogus theory of humanity's "de-evolution," Devo made an early splash via a hyperactive version of "Satisfaction" and scored its biggest hit in 1980 with "Whip It." Singer Mark Mothersbaugh, center, later composed for *Rugrats*.

ELVIS COSTELLO

Born Declan McManus, Elvis Costello, second from right, initially came on like a punk update of Buddy Holly with sharp-tongued songs like "Alison." Backed by the Attractions (Bruce Thomas, Pete Thomas, Steve Nieve), this former London computer nerd was hailed as the poet laureate of the new sound, but he didn't stand still, dabbling in country, soul and classical music, to the confusion of many fans. Later duets with senior faves Paul McCartney and Burt Bacharach raised suspicions that his aim wasn't true—but why corral a genius?

B-52s

The Athens, Ga., scene that spawned R.E.M. also hatched these weird, wacky dance-music mavens. The B-52s took their name from the beehive hairdos of their two female singers, and topped off the campy effects with go-go boots and oddball steps. Keith Strickland, Cindy Wilson, Kate Pierson and front man Fred Schneider (above, in '89) took a break in the mid-'80s when bandmate Ricky Wilson died of AIDS, but came back with "Love Shack," their biggest hit.

BLONDIE

This New York band both spoofed and celebrated female stereotypes, recycling glamorous images from music and movies. Fronted by ex–Playboy Bunny Deborah Harry, Blondie started with sleek power pop, then found success poaching other styles, including disco ("Call Me"), reggae ("The Tide Is High") and rap ("Rapture"). Harry appeared in such films as *Videodrome* and *Hairspray*, but her biggest contribution was influencing Madonna's early bad-girl look.

THE PRETENDERS

Ohio native Chrissie Hynde went on the road and became a smash in Britain. Wedding pop melodies to feminism, the Pretenders proved they were for real with catchy hits like "Brass in Pocket," but tragedy struck when two original band members died of drug overdoses. Meanwhile, the tough 'n' tender Hynde gave birth to a daughter by Kinks leader Ray Davies, married and divorced Simple Minds singer Jim Kerr and emerged as a militant animal-rights activist, saying she once firebombed a McDonald's.

THE CARS

Driven by spindly songwriter Ric Ocasek, who resembled a giant praying mantis, the Cars were built for hits. The Boston-based quintet offered slick electropop grooves and coolly ironic lyrics about love, plus vocals from the edgy Ocasek and crooner Ben Orr. While the Cars aimed for hipness, even making a video with pop-art guru Andy Warhol, singles like "Shake It Up" were really traditional Top 40 fun in a trendy new package. Ocasek cast his vote for old-fashioned romance by marrying supermodel Paulina Porizkova in 1989.

CATCH A WAVE

Fresh raves and old faves cashed in on the new-wave boom

WHAM!

Born Georgios Kyriacos Panayiotou, George Michael, right, parlayed smoldering good looks and a knack for catchy, soul-influenced pop into superstardom. Following Wham!'s initial splash in 1984 with the insipid "Wake Me Up Before You Go-Go," the ambitious singer-songwriter moved on to a sizzling solo career with snappy hits like "Faith," while ex-partner Andrew Ridgeley, left, plummeted into oblivion. Michael later endured a protracted dispute with his record label and an arrest on morals charges.

GENESIS

Progressive-rock handicappers gave Genesis slim chances for survival when singer Peter Gabriel split in the mid-'70s. But drummer Phil Collins, right, stepped up to the mike and steered the band to whopping mainstream success, aided by fellow founders Mike Rutherford, left, and Tony Banks. All three also enjoyed solo careers, with Collins's string of soulful pop smashes, including "Against All Odds," dwarfing Genesis's achievements.

U2

Returning idealism to rock in the wake of punk, Adam Clayton, The Edge (Dave Evans), singer Bono (Paul Hewson) and Larry Mullen strode out of Ireland brandishing heroic anthems. Though nonbelievers winced at U2's earnest style, soaring hits like "Pride (in the Name of Love)," a tribute to Martin Luther King, and "With or Without You" ignited an unforgettable fire in millions of hearts. However, even true believers had their faith tested by the band's self-indulgent 1988 feature-film documentary, *Rattle and Hum*.

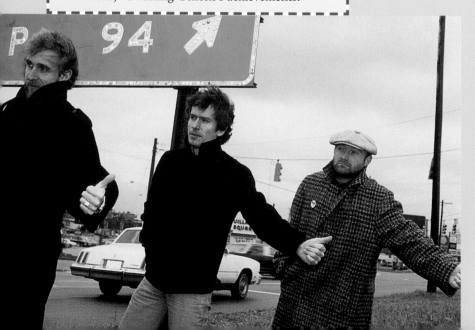

DURAN DURAN

They spearheaded Britain's New Romantics, taking their name from a character in Jane Fonda's sexy sci-fi flick *Barbarella*. Led by singer Simon LeBon, second from left, these pretty boys went stylin' on catchy hits like "Hungry Like the Wolf," striking it rich during MTV's dawn. Having their suggestive video for "Girls on Film" banned by many TV outlets only added to their mystique.

THE POLICE

More old wave than new, the Police boasted deep roots: Andy Summers, middle, had played with British Invasion vets the Animals; Stewart Copeland, seated, did time with art-rockers Curved Air; and Sting, a.k.a. Gordon Sumner, owed his vocal style to Jamaican great Bob Marley. Regardless, fans adored their fizzy white-reggae attack, watching every breath the Police took until Sting flew solo in the mid-'80s. But his performances in such dud movies as *Dune* and *The Bride* continued the tradition of rock stars becoming bad actors.

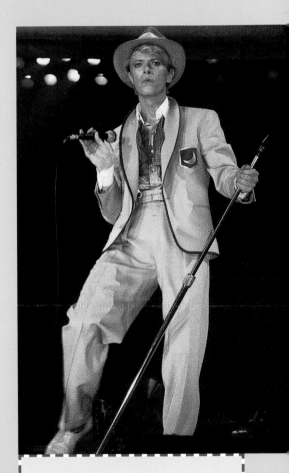

DAVID BOWIE

After playing such exotic roles as Ziggy Stardust and the Thin White Duke in the '70s, chameleon David Bowie starred as the Elephant Man on Broadway in '81, then teamed with Queen on the hit single "Under Pressure." Bowie lightened up on '83s *Let's Dance* album, scoring his first and only chart-topping hit with the funky title track, guitar courtesy of up-and-coming bluesman Stevie Ray Vaughan.

GOODBYE YELLOW BRICK ROAD

Rock Hudson

The last of the studio-grown heartthrobs became the first big-name AIDS casualty

Tall, dark and handsome Roy Scherer Jr., of Winnetka, Ill., was discharged from the Navy in 1946, got a glamorous Hollywood name and soon was leading a double life as a gay man playing romantic leads in movies and TV. Described by a friend as "the straightest homosexual I ever met," Hudson was worried about fan reaction when he learned he had AIDS in 1984: "I hope I die of a heart attack before they find out." But just weeks before his death in 1985 at age 59, the brave, ravaged actor admitted publicly that he was gay and dying. The revelation sparked nationwide support for increased research funding and an outpouring of compassion, as well as some misplaced alarm—was *Dynasty* costar Linda Evans at risk from his kiss? He died a hero for coming out of the closet—and bringing AIDS with him.

SOME LIKE IT HOT Hudson was known for his wholesome romantic comedy roles with Doris Day (right, in *Pillow Talk*), but Angie Dickinson said, "Rock really knew how to turn on the steam."

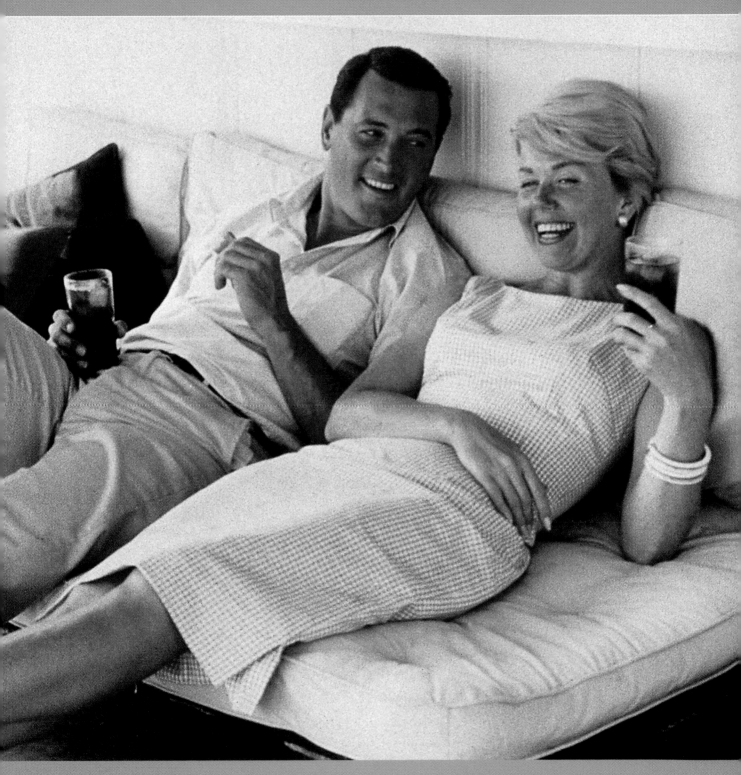

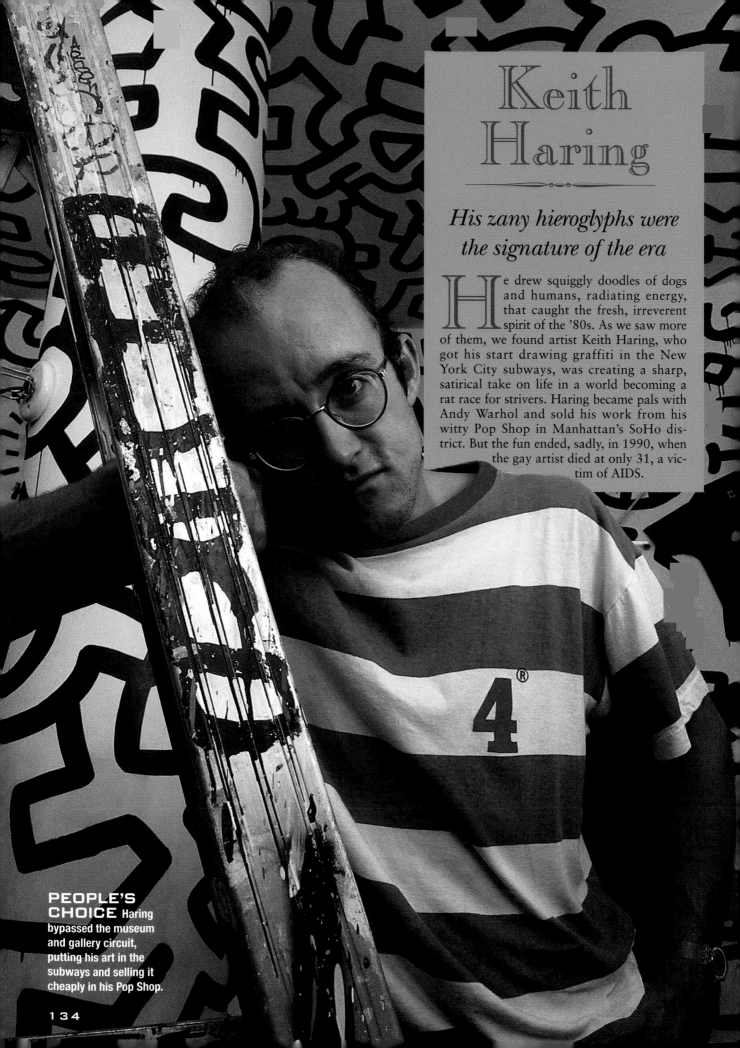

Keith Haring

His zany hieroglyphs were the signature of the era

He drew squiggly doodles of dogs and humans, radiating energy, that caught the fresh, irreverent spirit of the '80s. As we saw more of them, we found artist Keith Haring, who got his start drawing graffiti in the New York City subways, was creating a sharp, satirical take on life in a world becoming a rat race for strivers. Haring became pals with Andy Warhol and sold his work from his witty Pop Shop in Manhattan's SoHo district. But the fun ended, sadly, in 1990, when the gay artist died at only 31, a victim of AIDS.

PEOPLE'S CHOICE Haring bypassed the museum and gallery circuit, putting his art in the subways and selling it cheaply in his Pop Shop.

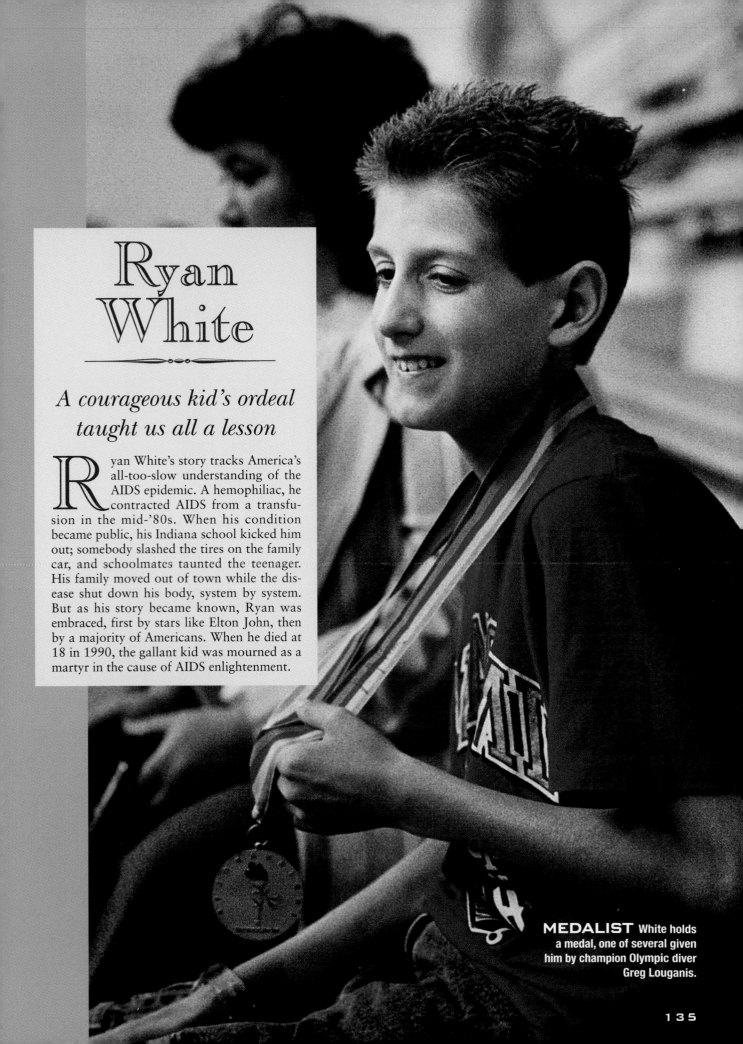

Ryan White

A courageous kid's ordeal taught us all a lesson

Ryan White's story tracks America's all-too-slow understanding of the AIDS epidemic. A hemophiliac, he contracted AIDS from a transfusion in the mid-'80s. When his condition became public, his Indiana school kicked him out; somebody slashed the tires on the family car, and schoolmates taunted the teenager. His family moved out of town while the disease shut down his body, system by system. But as his story became known, Ryan was embraced, first by stars like Elton John, then by a majority of Americans. When he died at 18 in 1990, the gallant kid was mourned as a martyr in the cause of AIDS enlightenment.

MEDALIST White holds a medal, one of several given him by champion Olympic diver Greg Louganis.

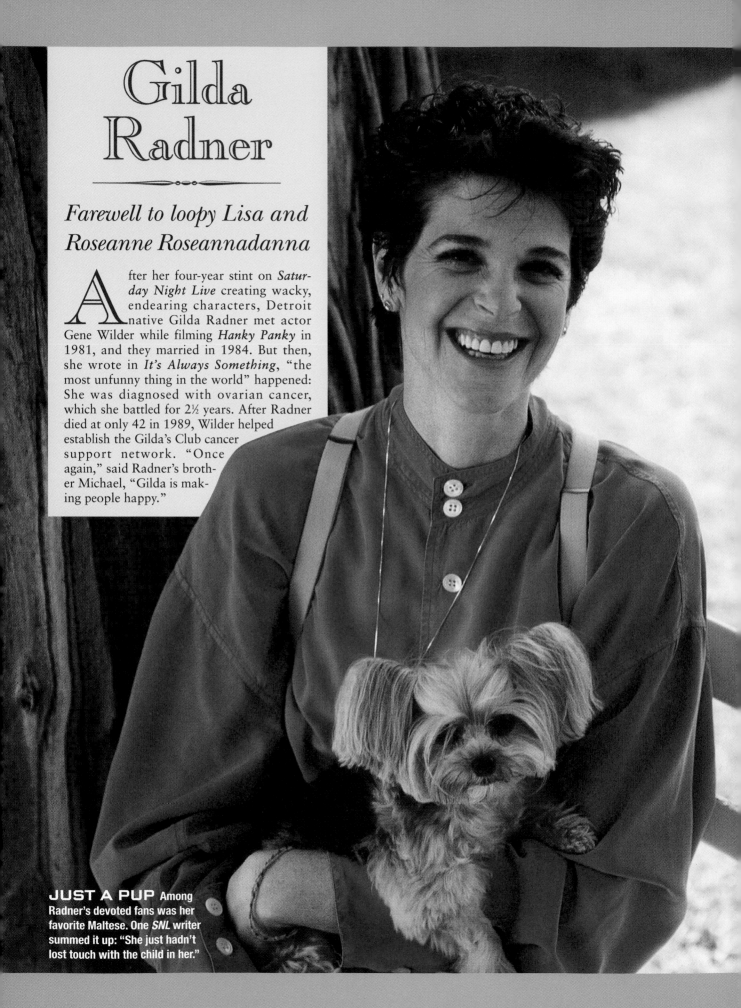

Gilda Radner

Farewell to loopy Lisa and Roseanne Roseannadanna

After her four-year stint on *Saturday Night Live* creating wacky, endearing characters, Detroit native Gilda Radner met actor Gene Wilder while filming *Hanky Panky* in 1981, and they married in 1984. But then, she wrote in *It's Always Something*, "the most unfunny thing in the world" happened: She was diagnosed with ovarian cancer, which she battled for 2½ years. After Radner died at only 42 in 1989, Wilder helped establish the Gilda's Club cancer support network. "Once again," said Radner's brother Michael, "Gilda is making people happy."

JUST A PUP Among Radner's devoted fans was her favorite Maltese. One *SNL* writer summed it up: "She just hadn't lost touch with the child in her."

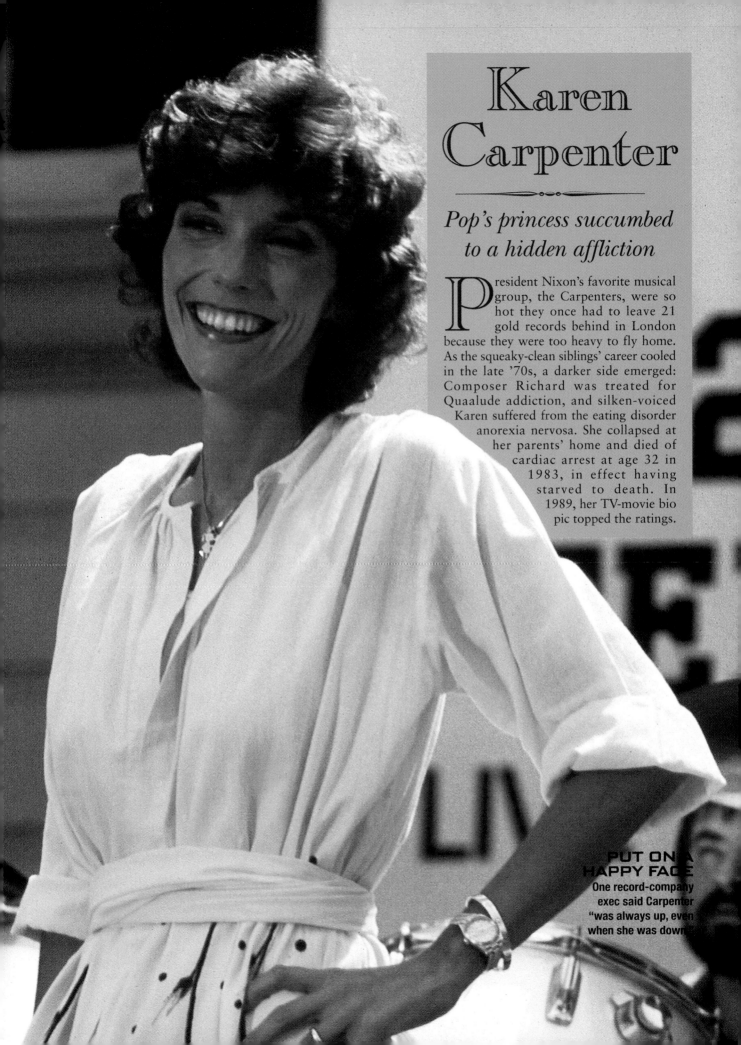

Karen Carpenter

Pop's princess succumbed to a hidden affliction

President Nixon's favorite musical group, the Carpenters, were so hot they once had to leave 21 gold records behind in London because they were too heavy to fly home. As the squeaky-clean siblings' career cooled in the late '70s, a darker side emerged: Composer Richard was treated for Quaalude addiction, and silken-voiced Karen suffered from the eating disorder anorexia nervosa. She collapsed at her parents' home and died of cardiac arrest at age 32 in 1983, in effect having starved to death. In 1989, her TV-movie bio pic topped the ratings.

PUT ON A HAPPY FACE
One record-company exec said Carpenter "was always up, even when she was down."

INDEX

PHOTO CREDITS

(Credits read from left to right and from top to bottom.)

COVER
Steve Schapiro/Liaison (Cruise and De Mornay), Ken Goff (Princess Diana), Shooting Star (Fox), Mike Fuller/Corbis Outline (Westheimer), Mario Casilli/MPTV (Cosby), Michael Childers/Corbis Sygma (Gibson), Kevin Horan/Corbis Outline (Winfrey), Howard Frank Archives (E.T.), Ken Regan/Camera 5 (Madonna), Rex USA (Ford), Will Crocker/The Image Bank (CD), Wallace Seawell/MPTV (Collins)

BACK COVER
Ted Thai/Timepix (Murphy), Neal Preston/Corbis (Retton)

TITLE PAGE
Globe Photos

CONTENTS
ii Globe Photos, Paul Natkin, ABC/MPTV, Mario Casilli/ABC/MPTV **iii** Steve Granitz/Retna, Douglas Kirkland/Corbis Sygma, Ken Regan/Camera 5, Youri Lenquette/Stills/Retna

IT WAS 20 YEARS AGO TODAY ...
1 Serge Lemoine/Liaison **2** Adam Scull/Globe **3** Henry Diltz/Corbis **4** Neal Peters Collection **5** Barry Staver **6** Ken Regan/Camera 5 **7** AP/Wide World, Corbis **8-9** ®Paul Goresh **10-11** Ken Regan/Camera 5 (crowd), Neal Preston/Corbis **12** Ken Regan/Camera 5 **13** M. Carrard/Liaison **14** Ross/Marino/Corbis Sygma, Reuters/Lee Celano/Archive/Liaison **15** Vestron Video, Liaison **16** Andrew Sackheim/Liaison **17** Rifkin/Liaison **18** Greg Gorman/Corbis Outline **19** Terry O'Neill/Corbis Sygma **20** Tom Arma/Corbis Outline **21** Laura Levine/Corbis Outline **22** Cinema Memories **23** Universal Studios/NPC **24** Rob Brown/Corbis Outline **25** Deborah Feingold/Corbis Outline **26** Pat Harbron/Corbis Outline **27** Douglas Kirkland/20th Century Fox/NPC **28** The Kobal Collection, Neal Peters Collection, Everett Collection **29** Nancy Ellison/Corbis Sygma **30** Debra Trebitz/Liaison **31** Ted Thai/Corbis Sygma **32** Rex USA **33** Ralph Nelson **34** Larry Busacca/Retna **35** Ross/Marino/Corbis Sygma **36** Everett Collection **37** Photofest **38** Martha Swope/Timepix **39** Martha Swope/Timepix, Joan Marcus, Martha Swope/Timepix

ONCE UPON A TIARA
40-41 Patrick Lichfield/Camera Press/Retna, **42** Rex Features (2), Snowdon/Camera Press/Liaison **43** Glenn Harvey/Stills/Retna, Corbis Sygma **44** Ken Goff/Globe, Glenn Harvey/Stills/Retna **45** Rex USA **46** Stills/Retna, Gerard Schachmes/Corbis Sygma (2) **47** Nancy Barr/Retna, Corbis Bettmann **48** Corbis, Ron Galella/Galella Ltd. **49** John Barrett/Globe, Ron Edmunds/AP/Wide World

BORN IN THE U.S.A.
50-51 Ken Regan/Camera 5 **52** Sygma, Bill Fitzpatrick/The White House **53** Dirck Halstead/Timepix, Ron Edmonds/AP/Wide World, Ronald Reagan Library **54** Heinz Kluetmeier/SPORTS ILLUSTRATED **55** Anthony Suau/Liaison **56** Tri-Star/The Kobal Collection **57** John Goodman/Corbis Outline **58** Heinz Kluetmeier/SPORTS ILLUSTRATED, Manny Millan/SPORTS ILLUSTRATED **59** Mike King/Corbis, Neal Preston/Corbis Outline **60** David Seelig/Starfile **61** E.J. Camp/Corbis Outline, Globe, Neal Preston/Corbis **62** Raeanne Rubenstein, no credit (2), Dan McCoy/Rainbow

63 Richard Melloul/Corbis Sygma **64** Al Freni, no credit, Ralph Morse/Timepix **65** Ross Marino/Corbis Sygma **66** Warner Brothers/NPC, Neal Peters Collection, Geoffrey Croft/Corbis Outline **67** Jeff Slocomb/Corbis Outline **68** A. Hernandez/Corbis Sygma **69** Douglas Kirkland/Corbis Sygma **70** Globe Photos **71** NBC/Globe Photos **72** Zimmerman/Liaison **73** Andrea Blanch/Corbis Outline

MASTERS OF THE UNIVERSE
74-75 Benno Friedman/Corbis Outline **76** Joe McNally/Corbis Sygma, Chantal Regnault/Liaison **77** The Kobal Collection, Warner Brothers/Neal Peters Collection **78** Timothy White/Corbis Outline **79** George Lange/Corbis Outline **80** Deborah Feingold/Archive/Liaison, Joyce Ravid/Corbis Outline **81** Aaron Rapoport/Corbis Outline, Adam Scull/Globe Photos **82** Ron Galella/Galella Ltd., George Lange/Corbis Outline **83** James O'Brien/Corbis Outline, Rob Brown/Corbis Outline

GIRLFRIEND!
84 Paul Natkin **85** Paul Natkin **86** Photofest, Geoffrey Croft/Corbis Outline **87** Charles/Liaison, Neal Peters Collection, Jack Mitchell/Corbis Outline **88** Elena Seibert/Corbis Outline **89** Lynn Goldsmith/Corbis **90** Penelope Breese/Liaison **91** Forrest Anderson/Liaison, Peter Jordan/Liaison, Globe Photos **92** G. Schachmes/Corbis Sygma **93** Deborah Feingold/Corbis Outline **94** Stan Gelberg/Globe Photos, Lester Glassner Collection/Neal Peters Collection **95** Mike Fuller/Corbis Outline, Ken Regan/Camera 5

FAMILY TIES
97 The Kobal Collection **98** CBS/E.T./MPTV **99** Neal Peters Collection, Herb Ball/NBC/MPTV **100** Neal Peters Collection, Photofest **101** The Kobal Collection, Everett Collection **102** ABC/Everett Collection **103** Everett Collection, Neal Peters Collection **104** Steve Granitz/Retna **105** Barry Talesnick/Retna **106** Mark Ellidge/Camera Press/Retna, P. Ramey/Corbis Sygma **107** Neal Preston/Corbis Outline, Terry O'Neill/Camera Press/Retna **108** Ron Edmondson/Liaison, Baylor College of Medicine **109** Eric Gay/AP/Wide World, M. Elizabeth Fulford/AP/Wide World, Mike Derer/AP/Wide World **110** Everett Collection (2) **111** Neal Peters Collection (2) **112** Martha Swope/Timepix **113** Neal Peters Collection

RISKY BUSINESS
114 WB/The Kobal Collection **116** Paramount/Neal Peters Collection **117** Photofest **118** National Enquirer/Liaison **119** Brad Markel/Liaison, Robert Trippett/Sipa **120** Bob Sacha/Corbis Outline, Ron Galella/Galella Ltd. **121** Hemdale/Shooting Star, Ed Geller/London Features **122** Tom Farrington/Sipa Press **123** Maddy Miller **124** Corkery/News/Globe, Maria Robledo/Corbis Outline **125** John Barr/Liaison, R. Maiman/Corbis Sygma

THIS AIN'T NO DISCO
126 Deborah Feingold/Corbis Outline **127** MTV **128** Barry Schultz/Retna, Timothy White/Corbis Outline, BBC/London Features **129** London Features (2), Peter Simon/Retna **130** Nomin/London Features, Tom Sheehan/London Features, Ross Marino/Corbis Sygma **131** Fin Costello/Redferns/Retna, Ilpomusto/London Features, Lynn Goldsmith/Corbis

GOODBYE YELLOW BRICK ROAD
132 V. De Wal/Liaison **133** JSP/Shooting Star **134** Joe McNally/Corbis Sygma **135** Rich Miller/Liaison **136** Michael O'Neill/Corbis Outline **137** Globe Photos